LEGENDS AND LORE

OF THE

HUDSON HIGHLANDS

LEGENDS AND LORE

OF THE

HUDSON HIGHLANDS

JONATHAN KRUK

THE
History
PRESS

Published by The History Press
Charleston, SC
www.historypress.com

Bottom front cover image "From World's End," by Thomas Locker, 2006. *Used with permission from the artist, courtesy of R. Michelson Galleries, Northampton, Massachusetts, www. rmichelson.com.* Top front cover image "Hudson River Valley View from Fort Putnam, West Point," by George Henry Boughton. *Courtesy of the New-York Historical Society, gift of John V. Irwin and William F. Irwin.* Back cover image, *left*, "The Heer of Donderberg," by Todd Atteberry, 2017. *Courtesy of www.historytrekker.com.*

First published 2018

ISBN 9781540235251

Library of Congress Control Number: 2018936084

CONTENTS

FOREWORD

The relationship of people and place is only partly about landscapes and resources. Around the world, it is stories that bind communities to the geography and ecology around them and shape their relationship with their environment.

That's why I was so happy to see Jonathan Kruk break away from storytelling to write down the deep insights he's gained through recounting our Valley's tales over the quarter century I've known him. His account, told with the same mix of wit and wisdom he delivers when impersonating a figure from history, spins through the remarkable characters, legends and geological features that make the Hudson Highlands so extraordinary.

There's the "Cow-Boy" Claudius Smith, the Loyalist "Scourge of the Highlands" who was hanged in 1779, long before the cowboys of the West made that term stick. You'll meet Deering Ayres, who in 1849 blasted a famed geological feature, Turk's Head, only to die in a similar blast in the Palisades years later. There's the ghost "prisoner's pig" and, of course, Thomas Davenport's famous runaway bull, which marauded in the Highlands until it is said to have leaped from the crag now called Breakneck Ridge. That ridge is now one of the most popular day hikes in America.

I began to absorb the power of regional stories far from here and long ago. In 1989, I'd returned from four months of nonstop reporting in Brazil and was writing my first book, *The Burning Season*, on the conflict between cattle ranchers encroaching on the Amazon rain forest, the Indians and the rubber tree tappers who'd found ways to thrive there without cutting the

trees. The ranchers I'd interviewed used the Portuguese word *limpar* (which means "to clean") to describe the process of cutting and burning the forest to transform the land into pasture.

When I traveled by motorized canoe up the Jurua River in areas yet unreached by the muddy roads eating into the region, I met a rubber tapper, Antonio, who had exactly the opposite view of the world. "If they cut the trees, how can anyone live?" he wondered aloud, sitting in the night near the chalky flow of that Amazon tributary. Antonio had just told me about a nocturnal encounter with a jaguar that refused to retreat from his tree-tapping trail—and how he had had to ask its permission to get home. It complied. "Can you imagine a country that has only pasture and cattle, without trees and man?" he said. "That is no country. Nothing will grow there. There is no game there. The ranchers will die in that kind of country."

In the Amazon, tension between those two stories continues to play out, with some regions now protected as much by the Indians and other forest communities as by formal demarcations of parks and preserves. The global story of that forest's astounding biological diversity and power to shape its own weather now helps provide a shield as well.

I moved to the Hudson Highlands in 1991, one year after I finished writing that book. I quickly began learning, and reporting on, a new set of stories, draped in layers on the ancient stone foundations of these knobs and crags like the soil, moss, underbrush and wind-stunted oaks cloaking Storm King Mountain.

The boom and rattle of artillery and rifle fire in the summer exercises and war games at West Point echoed not only off the slopes but also back in time to pivotal Revolutionary War skirmishes. On a cold windy morning seventy-two hours after dust from the murderous destruction of Manhattan's two great towers blotted out the sunshine and warmth of September 11, 2001, I became a humble witness to a momentous change in the story of the U.S. Military Academy at West Point. In classroom after classroom, professors scrambled to flip lesson plans to focus on an inverted war. Here's how I put it in the *New York Times*: "Not since Pearl Harbor had the campus been rocked so powerfully by events, senior officers said. But in 1941 the enemy was clearly defined: across an ocean, over the next ridge. Now everything was as gray as a cadet's uniform."

At noon, all four thousand cadets headed down toward the Hudson's banks to a prayer service. "Capes flapping, they flowed like a wind-tossed river in the shadow of Storm King Mountain, where they listened to

biblical passages about 'terrible happenings' as storm clouds scudded from the north."

The waters have had their own layered narratives of loss and renewal. John Cronin, an environmentalist, professor and friend, described the vanished shoals of shad, the adhesive and dyes that coated shores decades earlier where tape and textile plants once stood. But that story was, happily, history now. Our great folk bard and Clearwater campaigner Pete Seeger sang of a river "that may be dirty now but it's getting cleaner every day" as he danced through shoals of children gathered on Little Stony Point, once a quarry dock and now a park.

And all through these years, the stories of our region have been collected and mesmerizingly recited by Jonathan. Those he shares in this welcome volume will cause you to laugh, marvel, wonder and sometimes hold back a tear. Hopefully, they will cause you to share Highland's history and lore with others. In doing so, you will not only help sustain this region's weavings of natural wonder and cultural change, but you could also help determine the nature of the landscape and ecology for generations to come.

ANDY REVKIN
Nelsonville, New York, April, 2018

Andrew Revkin, one of America's most honored environmental journalists, has reported for more than three decades from the North Pole to the Equator, mostly for the New York Times. *He is strategic adviser for environmental and science journalism at the National Geographic Society. His most recent book, co-written with his wife, Lisa Mechaley, is* Weather: An Illustrated History, from Cloud Atlases to Climate Change *(Sterling Publishing, 2018).*

PREFACE

My heart is on the hills. The shades
Of night are on my brow:
Ye pleasant haunts and quiet glades,
My soul is with you now!
I bless the star-crowned Highlands…!
—George Pope Morris, Hudson Highlands songwriter and poet, 1860

The Hudson River, an arm of the sea flowing both north and south, takes a twist and turn on its odyssey to the ocean. An ancient arc of convoluted mounts embracing mighty metropolitan New York City makes us pause in wonder. Every hill has a story to tell. Here the local heritage helped shape the United States. This is the legacy of the Hudson Highlands.

Standing more than one thousand feet above the river, these "aspiring mountains" reach about fifty miles north of Gotham to form the city's natural boundary. Buttresses vaulting from water to sky, they offer brooding beauty and a profusion of tales. A billion years old, they once stood taller than the pointed Rockies. They make up the core of the Appalachians. They are the worn-down great-grandfathers of the larger neighboring Catskills, Adirondacks, Berkshires and Poconos.

These Highlands nurtured three revolutions—in government, industry and the environment. Further, they inspired a radical new school of painting. They gave haven to native hunters, colonial trappers, anxious pirates and Revolutionary spies. These hills still seclude industrialists, iconoclasts and spirited imps.

The wonder of living in the Hudson Highlands has been mine for more than twenty-five years. They provide an enchanting sanctuary, a sympathetic community and a large part of my livelihood. Performing as a professional storyteller, I've carried tales from here to entertain and educate people far from this cottage above Cold Spring on Hudson. People listen and immediately sense the mystery, the history, of these storied mountains. The Hudson Highlands always lead to wonder.

These hills are legendary for concealed treasures, crenelated castles and curious ghosts. They have engrossed, among many, Henry Hudson, George Washington, Washington Irving and Pete Seeger. The ultimate offering lies in their beauty, especially when autumn's elementals put forth colors ethereal and profound.

My immersion in these storied hills blesses and confounds. Tracking down tales of the Hudson Highlands got me fairy-led. The primary sources proved elusive, rare and conflicted. The real story lies in layers of fact and fiction melded inextricably. This stretched my quest to collect and collate these tales, postponing the book release date. Fortunately, The History Press staff understood. It encouraged me to hone in on tales reflecting the essential feel of the region.

This book draws together historic fact and folklore, from primary sources and local legends, to create a story map of the hills flanking "America's first river." The sixty images contained in this slender volume give but a glimpse of the land's singular character and distinguishing charm. Look here for an anthology of stories shorter than Washington Irving's "Sketchbook" but richer than a hiking guide. All my efforts still leave behind some gold in these lore-laden hills.

This work will engage locals and tourists, hikers and historians, river lovers and dreamers. Enter now these pages for an expedition to mine the treasures and climb to the viewscapes for a sense of the guardians of a majestic river en route to the mighty city.

ACKNOWLEDGEMENTS

The Hudson Highlands inspirited me to write this book. Many people and organizations, however, truly helped with the task of getting this volume to you. My gratitude goes first to my wife, Andrea Sadler, for all her encouragement, support and love. My daughter, Zosia, merits praise here, urging me on with this project.

I'm also grateful for the editorial help and guidance from Amanda Irle of The History Press. My publisher also deserves a tip of my hat for patiently waiting for me to complete my performance adventures while writing this book.

Many people inspired my passion for these Hudson Highlands and nurtured me along the path to create this collection of lore and legends: He-Who-Stands-Firm, Dan Delaney, Mark Forlow, Russ Cusick, Rich Bala, Rick Gedney, Dave Rocco, David Dasch, Amanda Epstein, Trudy Grace, Jen McCreey, Mike Turton, Evan Pritchard, Jeff Amato, Richard and Karen Shea, Jordan Dale, Andy Revkin, Dar Williams, Jan Thacher, John Curran, Owen Pataki and Alicia Kruk. I commend, too, the artists and photographers graciously lending their works for this book: Todd Atteberry, Joe Dieboll, Michael D'Antuono and Mario Mercado.

I deeply appreciate help from the R. Mickelson Galleries, the Jean Saunders Seventh Grade History Competitors, David and Kathy Lilburne of Antipodean Books, Jennifer Palmentiero and Matthew Shook of the Palisades Interstate Park Commission, Robert Delap of the New-York Historical Society, the staff of the Desmond/Fish Library, the Fishkill

Historical Society, the Friends of the Fishkill Supply Depot, Continental Commons, Mindy Krazmien and Preston Pittman of the Putnam County Historical Society, the New York Public Library, the Butterfield Library, the Howland Library, the Beacon Historical Society, Cornwall on Hudson and West Point. I'm eternally honored to have had these mentors, now "manitous," spirits on the Hudson: Pete Seeger, Vic Schwarz, Thomas Locker, Mackey and Betty Budney, Scott Webster, Donald MacDonald and Jean Marzollo.

And to the moon and stars,
whose pools and shadows pierce the ethereal veil in these lands.
The same moon and stars that long ago inspired this lore,
inspires your storyteller too.

INTRODUCING THE HUDSON HIGHLANDS

A View from Cro' Nest

A billion years of time and toil are etched in these old hills.
Carved by ice and dynamite, but they stand firm here still.
Seen tomahawks and cannon fire, and mighty industries.
…these Hudson Highlands will endure when we are history.
—*Andy Revkin, songwriter/environmentalist*

A billion-year-old branch of the Appalachians bends above New York City. Three distinct revolutions rose from these ridges. A great chain stretched during the fight for independence and held together the new United States. "A devil driving a sawmill" through these heights and a state-of-the-art foundry here helped launch the industrial age. These wild eminences provoked a radical shift in art with a beauty so iconic they sparked the modern environmental movement. The history of Hudson Highlands revealed through its legends and lore offers a unique vantage and vision.

Many volumes and guides written about the river recount events, note important people and locate landmarks. Look here for stories that proclaim the essence of Hudson Highlands. Relying on myriad sources, from primary documents to the oral tradition, this work unites fact and fiction to give the true feel of the Highlands. This book, like these "aspiring mountains," concentrates nearer to the water. Gathered here are tales from the river

communities of Cold Spring, Beacon, West Point, Peekskill, Cornwall, Newburgh, Highland Falls and Garrison. Included too are vignettes from Fishkill, Putnam Valley, Kent, Mahopac, Highland Falls, Haverstraw and Stoney, Little and Jones Points. All catch the thundering voices echoing about since the days of the European explorers.

The Hudson Highlands, the river's crown and glory, reflect the awe felt by the native Algonquin peoples who first settled these "endlessly rolling hills," this "misty place" of the "Great Spirit." Wequehache, Nochpeem and Man'toh together describe this realm as ineffable and otherworldly. Immediately, we wonder: What are these mountains? Why are they significant? Where does this range officially begin and end? Again, turn here for the answers in these stories but understand that many remain unending and untold in the rolling hills.

A rugged realm spanning from northern New Jersey almost to Connecticut, these misty mounts peak dramatically above the Hudson River at West Point and Cold Spring. Imagine a grand pair of shoulders emerging from a head of water flowing both ways. The Highlands stretch into two well-defined

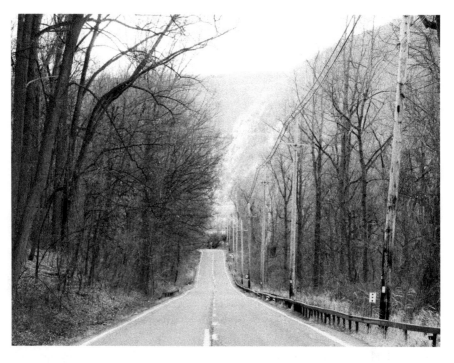

"The Fall & Rise of Storm King," by Daniel Delaney, 2017. A strike of serendipity on the road south from Beacon.

arms. The west branch is generally called the Ramapos. The eastern branch is known as the Manitous. Reaching west and south at Mahwah, the "cross road," they head off into New Jersey's Highlands and Watchungs. They roll east on through much of Putnam County, New York. Meeting the Taconics, they almost touch Danbury, Connecticut.

The dense folding slopes of the Highlands isolated southern regions of Orange and Dutchess Counties. This geography forced the state of New York in 1798 and again in 1812 to break off and form the counties of Rockland and Putnam. It also contributed to the confusion of New York and New Jersey's border. The range's highest peak, South Mount Beacon, measures just 1,610 feet. Vaulting abruptly more than 1,000 feet from the banks of the Hudson, these hills and the river defy each other. Here is the widest waterway to cross any branch of the Appalachian range, as well as the only one at sea level. Thus, the Hudson, a tidal river drowned by the Atlantic, flows fjord-like to a tidal estuary. The river is an arm of the sea. Deeper than the Mississippi, with slopes steeper than those along the Rhine, this river's highlands start the stuff of legend.

What's in a Name?

The storm king has seen us from above,
Rising up on the starboard bow
He knows the turning of the years
I am the storm king now.
—*Dar Williams, singer/songwriter*

Once upon about a billion years ago, Amazonia crashed into Laurentia. These ancient ancestors of North and South America released a super-colossal flow of magma. Iron-laden granite, sparkling with mica and quartz, congealed to form the core of the "crystalline Appalachians." Spanning from Alabama to the Maritimes, they once reached heights rivaling today's Himalayas. The Hudson Highlands now appear overshadowed by younger and taller neighboring ranges. The hills along the Hudson, however, are the exposed heart of the great East Coast mountains.

An unscientific count of the Hudson Highland mounts yields roughly sixty named entities. Many ridges, however, lack an official designation or share one with several others. What's in a name? Ask Shakespeare, Charles

Dickens or our local hero, Washington Irving, and the answer is "much." Every mountain here, from Donderberg to Beacon, tells a tale. First, take a brief tour in tales of some of the prominent peak namesakes. Later chapters will retell the landmark stories.

The monarch of the Hudson Highlands, Storm King, earned its craggy crown. A grand dome softened by oak trees presides over the river. The frown carved across the king's crinkled granite visage is actually Route 218. It took three construction companies nine years to blast through the road, which opened in 1922. Snows, ice and deaths have often closed it in the winter. The gustatory colonial Dutch saw an immense lump of butter, prompting them to label the height "Boter-Berg," meaning Butter Hill. The higher rise west of that mount retains the English name. Sloop skippers, however, looked on the great rock meteorologically. Jutting above the water, its silhouette against the sky gives sailors a better take on any coming clouds.

Indeed, the ancient Dutch mariners looked out for a weather-making witch between the Butterhill and Cro' Nest. Known as "Mother Kronk," she shakes her apron to conjure thunder, lightning and rain. Hudson River compendium-makers like J. Benson Lossing and Arthur G. Adams cited "Klinkersberg" as the first European designation for the Highlands' most distinguished landmark. They say the glistening rock caught Henry Hudson's eye too. *Klinken* in Dutch, however, means latch. Seventeenth-century Hollanders referred to the gusts pouring between the mountains there as the "Wey-Gat," or wind gate. They'd wait in their sailing sloops for the stony "Klinker" to open the door with a burst of air. Later, these tales moved nineteenth-century writer and lover of the Highlands Nathaniel Parker Willis to petition the New York State legislature. He detested the buttery Dutch designation. Parker wanted to ennoble the mariners' tradition of looking to the promontory to see how it ruled the weather. The government, wanting to draw tourists, accepted Parker's appellation of "Storm King Mountain."

The poetic Parker also altered the designation for a rise above the Village of Cold Spring to Mount Taurus. Long known for a legendary escaped male bovine, the local "Springers" (people born and raised in Cold Spring) still know it as "Bull Hill." Traversed by carriage roads and well-marked trails, Bull Hill and Breakneck Ridge stand out as among the most popular hiking destinations in the United States.

Across from Bull Hill, just south of Storm King and above West Point, a pair of crags called "Old Cro' Nest" watch the river flow both ways. This mountain has drama. Two dragon-like rock spines emerge from the body

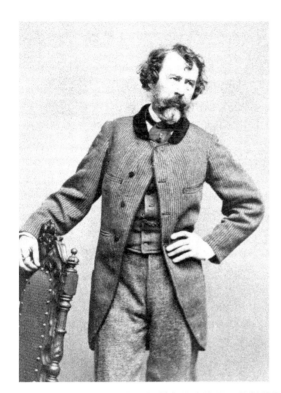

Left: Nathaniel Parker Willis, Gurney & Son, circa 1855. *From www.thehighlandstudio.com.*

Below: "Eyes of Storm King," by Daniel Delaney, 2017.

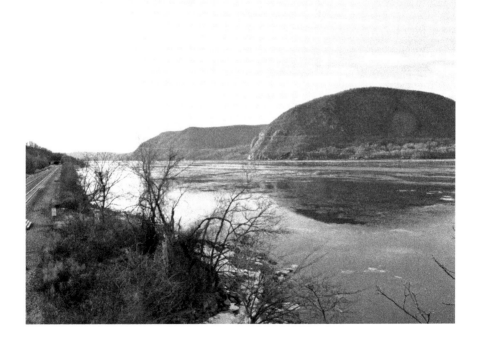

of the ridges. The exposed stone sparkles in the sun and glistens when rainwater courses through a cleft separating the nests. Over the centuries, the Cro' Nest has attracted more than birds. It works with the power of a Celtic ley line. First described in the 1920s by Alfred Watkins as magnetic landmarks on ancient pathways, this roost has drawn pirates, British Loyalists, loggers, cannon fire, a Tolkienesque wanderer, artists and faeries.

A wild tidal island helps West Point interrupt the river. Once known as Martelaer's Rock, perhaps for family of French fishermen, the name is more likely a Dutch description of the "struggle" sloops faced in the treacherous waters there. Echoing this sentiment is nearby "World's End," the epithet for the deepest drop in the river. Here on April 30, 1778, American Revolutionaries set the Great Hudson River Chain to thwart British warships. Earlier in the spring of 1775, they reminded their king and Parliament of the right to self-determination by renaming it Constitution Island.

North and South Beacon Mountains harken to the signal fires readied on top of these precipices during the American War of Independence. Set ablaze, they'd warn all of the approach of redcoats, calling to arms the local militia. Fort Montgomery honors the Irish-born husband of Janet Livingston. Major General Richard Montgomery led a successful assault on British Canada at Montreal in 1775. He fell heroically while attempting Quebec City. Fort Clinton, now overrun by the Bear Mountain Park Zoo save for the west redoubt, recognizes George Clinton, a general in the Continental army and New York State's first governor. The hero of the Battles of Ticonderoga; Quebec City; Valcour Island; and Ridgefield, Connecticut, as well as the "turning point" at Saratoga, once had the fort across from Constitution Island named for him. When unmasked as a turncoat, Benedict Arnold became synonymous with "traitor," not a military citadel. The Revolutionaries in 1780 renamed this Fort Clinton. Now there stands a monument to another hero of the American Revolution, Thaddeus Kosciusko.

The names of the Timp, Donderberg, Listening and Stormville—as well as, of course, Storm King—all reverberate with the wild weather of the Highlands. Other titles like Sour, Sugar Loaf, Cranberry and Butter Hill evoke taste. Breakneck, Misery, Rattlesnake and Rascal warn of the region's danger and woe. The legacy of iron mining is found in Hogencamp, Daters, Nickel, Pine Swamp and Black Mine Mountains. Native phrases also grace these hills. Manitou, of course, acknowledges the Great Spirit. Wappingers is a corruption of the nickname "little possum face"; similarly, Tuxedo refers

to "the round footed ones." Wiccopee, now a hamlet in Fishkill, comes from the tribe of the heroic Captain Daniel Nimham.

The Dutch gave us more than cookies, boss, booze, Brooklyn, Yankees and Knickerbocker. The "kill" in the Hudson Highland communities of Peekskill and Fishkill stems from an archaic Dutch word for "stream." Seventeenth-century settlers from Holland gave us many mountain names. Donderberg means thunder mountain. Precipitous Popolopen is a tongue-in-cheek "doll's walk." Danzkammer tells of Dutch shock over native dance rituals held just north of Newburgh. Pyngyp is an onomatopoeia for the ringing of rain in these river mounts. The hikers' haven, the vanished Doodletown, recalls the firewood once gathered there for nearby mines. Native, Dutch, Revolutionary and other namesake stories follow. Canopus Hill provides a perch for Appalachian Trail hikers to ponder the second brightest star in the sky named for an ancient Greek navigator.

The tale of the Hudson Highlands extends beyond names. The measure of beauty here translates into parkland. Add up all the preserved places here from Harriman (the second-largest park in the state) to the many small parcels set aside by groups like the Hudson Highlands Land Trust, and the region's "green lands" total about 460 square kilometers. That's almost the size of New York City! The United States Military Academy at West Point also keeps more than eighteen thousand acres for the education of army officers.

This rugged, protected realm is home to more than 100,000 people. Hikers love it here. Trails.com puts six Hudson Highland hikes in its top one hundred. Given a view-scape of five states plus New York City, it's easy to see why it ranks Breakneck Ridge number one. Even from the vantage of the highest hiker, it's hard determining where these misty mounts range.

AN ATTITUDE OF LATITUDE

[A]n observation was then made of the latitude and mark'd with a Pen Knife on a Beech-Tree standing by a small Run or Spring of Water that Run down the North Side of the Place where I think Merrett's House afterwards stood. Sometime Early in the Beginning of the year 1691. I went and Remark'd the said Tree but do not Remember what was the Latitude that was mark'd thereon. They went afterwards to a House to the Southward of a Place Call'd Verdrietige Hook....I cannot particularly

Remember whether observations was made at one or both these Places—but I was told They there did Agree that the Mouth of Tapan Creek should be the Point of Partition on Hudsons River.
—Robert Morris, New Jersey colonial governor, to the Board of General Proprietors of the Eastern Division of New Jersey (1753–55)

The "Remark'd" of a "Pen Knife" did not spark the long border dispute between New York and New Jersey. Blame lay with "endless rolling" nature of the Ramapo branch of Hudson Highlands rubbing off on its settlers. Wandering claimants led to many skirmishes between "Yorkers" and "Jersey-Men." Once the British took the New Netherlands from the Dutch in 1663, they declared around 1684 the Hudson River at "latitude 41, 40 minutes" as the New York–New Jersey boundary. Local native peoples knew this as the place where their grandparents traded on board Henry Hudson's ship the *Half Moon* on September 12–13, 1609. Colonial surveyors on both sides of the border agreed that the line began near today's Peanut Leap Falls just south of Piermont, New York. The trouble was they disagreed on where the line ran.

Yorkers claimed that the line ran to the Delaware River just south of Minisink Island. Jersey men stuck their border farther north at Cochecton. Crossing right through the middle of an unsettled boundary, the Ramapos exacerbated the confusion. This led to disputed claims, land grabs and crop burnings, culminating in a 1765 battle. Leaders of the New York contestants, a Major Swartout and a Captain Johannes of the Orange County Militia, worshiped in the Machackemeck Church near Minisink. When the Jersey Blues got wind of this, they surrounded the invading Yorkers. When services ended, a brawl broke out. Showing deference to the Sabbath, both sides fought without weapons. One hundred years later, Charles Stickney described the scene: "The place which a few moments before was a perfect pattern of Sabbath quietness, was changed as if by the enchanter's wand into a complete pandemonium. Frightful sounds of discord, kicks, cuffs, blows and maddened yells of victory or pain, mingled with the tones of entreaty, sobs, and screams, filled the air. The green was covered with a crowd of terrified women and maddened, struggling men."

When the Blues hauled the Yorker officers off to a New Jersey prison, the colonial governors finally agreed to set the boundary once and for all. The case helped set a newly minted lawyer toward his future as the first Supreme Court chief. John Jay, the distinguished jurist, could not definitively define the boundary, however. That did not happen until 1835.

NO PASSAGES FROM PROVIDENCE
BUT GABBRO VEINS

The perpendicular rocks on the sides of the river are surprising, and it appears that if no passages had been opened by Providence for the river to pass through, the mountains in the upper part of the country would have been inundated. Query, why does this river go in direct line for so considerable a distance?
—Peter Kalm, Finnish/Swedish economical botanist and traveler through the Highlands, June 11, 1749

Once upon a time, about thirteen thousand years ago, melting glaciers created inland seas larger than today's Great Lakes. Lake Albany once inundated the upper Hudson Valley from Newburgh to Troy. When the waters blasted through natural dams, a Gargantua of a waterfall seven times the size of Niagara roared one hundred miles out from Verazzano Narrows. Cutting through the Hudson Highlands, the flood created an ocean chasm as grand as the Grand Canyon. The ocean rose four hundred feet. The Hudson River's antediluvian ancestral bed once meandered through the Palisades at Sparkill Gap, flowing on through Paterson, New Jersey, en route to the Atlantic. The force of the icemelt deluge softened

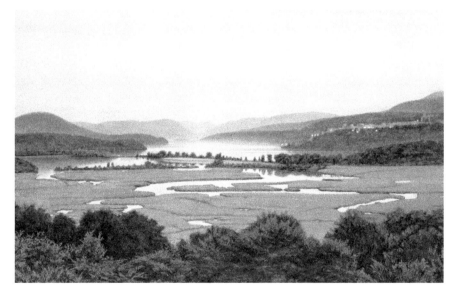

"Perspective from Boscobel," by Rick Gedney, 2012. View south toward Bear Mountain, with West Point on left.

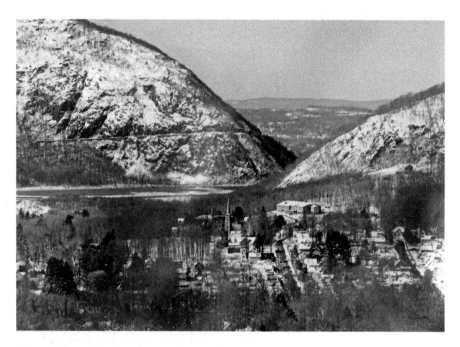

"Winter View of Cold Spring," by Russell Cusick, 2012. *From www.reflectionsonthehudson.com.*

only at West Point. There the steadfast Highlands turned the drowned river into the fjord it is today.

Today's geologists might answer the botanist Kalm's query by stating that the river's course resulted from the biblical proportioned blast of water. Later in this book, we explore the mythic description provided by the native peoples. The power of iron, however, is best told here by Kalm on November 5, 1749: "Iron ore is said to be found everywhere and in great quantities in this country, which everyone with whom I have conversed on this subject has confirmed as if with one voice."

Hikers in the Hudson Highlands are welcome to seek iron ore the olde colonial way. Use your compass to locate the ferrous-rich magnetite running along gabbro veins. First get a bead on the magnetic North Pole while standing away from stones. Place your device near a prospective mineral line and watch the needle flicker. This often means that you've struck pay dirt. One legend tells of a gold mine tucked away near High Tor Mountain and others of a silver mine in today's Harriman State Park. There may be a vein of truth here. These Highlands really offer only iron. Using simple pickaxes, shovels and muscle, miners once pulled large amounts of ore from these hills.

"Long Pond Lookout," A. Kappe and E.C. Willmorse, circa 1880. *From www. thehighlandstudio.com.*

Once extracted and hauled off in horse or donkey carts, great rock and later brick furnaces refined the rough mineral lode down to iron. This required copious amounts of charcoal. Add in demands made by steamboats, and by the mid-nineteenth century, we see "Bare Mountain" rather than the current ursine form on the maps. When iron found in the Midwest in the late nineteenth century proved easier to extract, the Highlands were producing 17 percent of the nation's ore. Today, wanderers here are hard-pressed to traverse the Highlands without happening on the pits, the shards of stone and excavations left from mining.

SUNSHINE WIGWAM

May the sun shine on your wigwam, and your moccasins never get wet.
—old Munsee saying

The mines and quarries of the Hudson Highlands tell of more than ore and gravel. Twelve thousand years ago, hunters gathered in a rock shelter beneath Lookout Mountain in Monroe, New York. They left behind their stories found in fluted stone blades by archaeologists in the 1960s. Further, they witnessed the great cataclysm that formed today's Hudson River and shaped its Highlands. Often, the First Peoples—here the Algonquian speakers, the Delawares, the Leni-Lenapes, the Mahicans, the Munsees, the Wappingers and the Noch-peems—described what happened better than the scientists.

MAHICANITUCK

Once between Pasquaskeck, the mother mount, and the bad rock, Matrumpsek, there slept a giant. Slow and steady, water gathered against his enormous body, forming a lake. Long the giant slept.

He called in his dreams to animals, inviting them to come live near him. Along scurried squirrel, skunk, mink, muskrat and raccoon. Snapping turtle, frog, salamander and snake followed. Then there arrived moose, deer, bear,

wolf, crow, eagle and many other creatures. The great mastodon came to the giant too. Long the giant slept.

The People felt the giant's dreams too. They followed, hunting and gathering. The land by the giant and his lake always provided enough skins, nuts, herbs and berries to fill their baskets. Long the giant slept.

The old women heeded the giant's dream of three sisters. They planted sister corn with sister bean and sister squash. Corn grew tall. Bean twined round her sister. Squash sprawled on the ground about her sister's feet. Long the giant slept.

"En-Na-Shee!" The People thanked the giant every day at sunrise. During the winters, they snuggled into their wigwams to listen to the wise women tell tales of times when the giant walked about, wrestled the thunder beings, tricked the Manitou and did chores for the Great Spirit. Long, long the giant slept.

Imperceptibly, as if on bobcat paws, came change. Trees sprouted in between the giant's toes. Rock and moss covered his legs. His body grew brittle. The giant's arms dug valleys and flowed with streams. His hair rooted fields of flowers. His head hardened like a boulder. And children swam in water pooled above the giant's sleeping eyes.

How long had the giant slept? Now some people questioned: was that a giant? Some saw only a kind of mountain. They planted fields and placed wigwams near. They claimed, "There is no giant. He is just an old woman's wrinkle-tongue tale! Why thank a mountain?"

Eventually, few recognized the giant. Most stopped showing gratitude. When the grandmothers became Manitous themselves, no one told the slumbering leviathan's story. Long the giant slept without thanks or tales. He sent dreams of warning, yet no one took heed. The giant's heart then broke. Waking, he raised an arm to crack a hole through the sky. Rocks falling, trees snapping, streams tearing out of his eyes, he stood up. The lake roared through the giant's opened legs and into an ancient riverbed. Raging, the water roiled, gouging a deep path with but one bend. The torrent swept animals, people and all the mastodons into the ocean. Only a few survived.

The lake stretched into a river. Twice a day it breathed in and out of the ocean. The giant vanished, and a long time passed before new people found this unusual river. They called it "Mahicanituck," meaning "the river that flows both ways." These new settlers simply called themselves "Leni-Lenape," or the People. Later, others called them the Delawares and Mahicans. When they were here in great numbers, the Lenapes turned

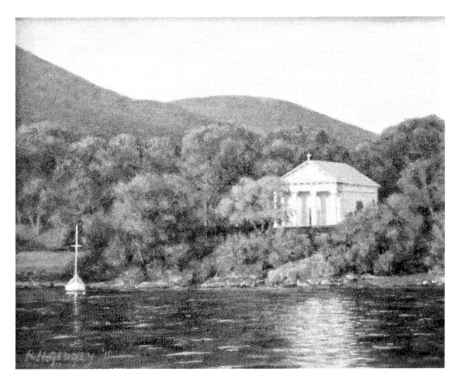

"The Chapel of Our Lady Restoration," by Rick Gedney, 2011. Cold Spring on Hudson.

their faces to the sun rising over the river to give thanks. The Mahicanituck, an estuary, arm of the sea, we know today as the Hudson River.

The "giant" stood up right around the time people left their fluted stones in Lookout Mountain. This anthropomorphic dam of glacial ice and debris once "slept" between Storm King and Breakneck Ridge, creating Lake Albany. A 160-mile-long body of meltwater from the end of the last ice age, it inundated the upper Hudson Valley from Newburgh to Troy. Again, only West Point in the Highlands put a wrench in the river's mighty flow to the Atlantic. The ocean, of course, pushes into this drowned river with her tides all the way to Troy, New York, thus the river flows both ways. This native creation myth best shares the scientific truth of the Hudson River's formation.

MANTEO'S FALL

First encounters between North American natives and European migrants sparked a clash of cultures. Misunderstandings, especially over land, often led to tragedy. Misjudgment over the course of love brought sorrow and solace to the Indian Brook waterfall tumbling near today's Constitution Marsh Audubon Sanctuary in Garrison.

When Henry Hudson sailed on the eponymous estuary seeking the legendary Northwest Passage to Cathay, the sight of the Hudson Highlands moved him to proclaim this is "a river of mountains." Far off the course promised to his sponsor, the Dutch East India Company, Hudson and his *Half Moon* crew found themselves in a strange, bountiful land. The ship's master mate, Robert Juet, described the native peoples as "loving," though frequently carping, "We darest not trust them." A local doleful tale illuminates this conflicting view, although somehow Juet omitted it from his journal. Manteo saved one of Henry Hudson's Dutch sailors. He led a small shore party to gather wild grapes on a peninsula now called Denning's Point. Wappinger warriors spied the strange band. Shrieking and shooting warning arrows, they drove them back to the *Half Moon*.

Jacobus Van Horen, bleeding from a leg wound from a stray shot, got left behind. His auburn beard, billowing woolen clothes, brass buttons and cheesy body odor caused some of the Wappinger tribe to declare, "This is an animal masquerading as a human." Others disagreed: "He's one of the calamitous Manitous the elder woman saw in their dreams. Keep away from this spirit!"

Manteo, however, noticed fear and confusion crossing the stranger's pallid face. She proclaimed, "He is human!" Then she took healing herbs and bound his wound to her fate. The tribal council scoffed and chuckled. "He will not hunt with the men!" "He will not plant with the woman!" They agreed to grant this chieftain's daughter thirteen moons to prove that this peculiar creature was indeed a real man, worthy of being "Lenape," or one of the People.

The gushing streams, or "kills," as Van Horen called them in his native Dutch, provided a way. Jacobus could set fishing weirs for the Wappinger people. He gave his catch to the only one who would see him, Manteo. She taught him Algonquian. Eventually, they could swap stories. She told how the river flows both ways to care for the animals and her people. He told of his home in a city across the salty waters and his skipper Henry Hudson's quest to find a water passage to lands still farther away. Manteo wondered,

"Manteo's Falls, Indian Brook," by Tom DiMauro, 1999. *From http://thomasdimauro. photoshelter.com.*

"Why? My Jacobus, my man, do clouds pass through your eyes?" Van Horen smiled at this lovely woman who saved him from a tortuous execution. Could her heart save him from the slow death he imagined living in this forlorn land? He stared into the moving river.

"What do you seek?" asked Manteo. "Home," replied the marooned sailor. "There is a way home," offered Manteo. "The river flows many ways. Drink the waters of these falls. They flow to Mahicanituck, to the Great

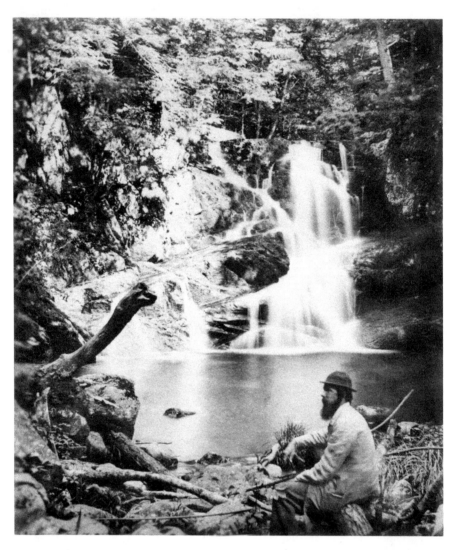

Manteo's Falls, Indian Brook, unknown photographer, 1870. *From www.thehighlandstudio.com.*

Ocean, and on to your Holland, then back, here to our home." She opened her arms to him. The waters coursed the two into a passion. Manteo, a Wappinger princess, and Jacobus Van Horen, a Dutch mariner, loved. "Now, these waters are ours," Manteo stated. "Let's drink in together what we share. Then, to our waterfall, we shall always return!"

Van Horen, however, just lighted his fingers on the woman's cheeks and smiled. Manteo invited him to drink many times. "Van Horen, don't you

want to always return to this beautiful place?" The clouds left his eyes. Van Horen embraced her. "Nieder-landt," he whispered.

One morning after many months, a French fishing vessel appears in the river. "My way home!" he cried, ecstatic. Beckoning to the passing ship, he plunged into the water and swam away from his one love in this forlorn land. Manteo wailed, "Jacobus!" Her keening echoed off the ancient river hills. Her voice froze Van Horen in the water. The sailors urged their fellow European to keep swimming. His heart breaking, the Dutchman yearned to look back to offer an explanation or at least a farewell wave. But fearing that the sight of his lover would forever keep him imprisoned in a wilderness, he slogged on. Boarding the boat and coughing over tears, he concocted a tale of captivity. The winds rose, tearing Jacobus Van Horen's new great canoe away. Manteo stood on the shore, transfixed, as the vessel slipped south toward the ocean.

Where the Mahicanituck turned west, taking her lover away forever, Manteo decided to take the only course left to a disgraced chieftain's daughter. She strode toward to the falls above the pool where she offered her beloved a drink. The tears coursing down her cheeks left a trace of forget-me-nots blossoming in her wake. She had to return to the Creator. Her body fell quickly, breaking open on the stones, releasing her spirit to the sky. Her blood flowed into Indian Brook and on to the Mahicanituck. Then

"Hotel Manteo, Cold Spring," postcard, circa 1910. *Mark Forlow Collection.*

it merged with the great sea to arrive on the shores of distant lands. Manteo became a "manitou," a spirit wish-giver. Visitors to Manteo's Falls still sense her presence in the quietude.

Did disinterest or embarrassment move Hudson and Juet to neglect to note Van Horen's "capture" by the Wappingers? Could this tale be just a Victorian-era fabrication reflecting the doctrine of American Manifest Destiny over North America's First Peoples? Visitors to Indian Brook's Manteo's Falls get a different impression. There, within the cascade, lies Manteo's beatific form. The oral tradition has it early settlers found native people there in prayer to a kind of wish-granting naiad. Today, she soothes all who come to commune with her but offers a special solace to the lovelorn.

DANSKAMMER

The people of the Countrey came aboord us and brought some small skinnes and Trifles. This is a very pleasant place to build a Towne on.
—*Robert Juet, journalist, the* Half Moon, *September 30, 1609*

On a pleasant rise, Henry Hudson's mate, Robert Juet, foretold of the coming city of Newburgh. It was a market hamlet when George Washington made the Hasbrouck House there his headquarters in 1782. River trade and light industry made it "the most thriving city on the Hudson." Now, worn down by global markets, the town turns to the river's beauty for revival. Near this place of trade juts a more storied spit of land. Covered over by a power plant since the 1930s, this small peninsula has the Dutch title of Danskammer. "Dance chamber" is the translation, but some New Netherland colonists, fearing what they could not understand, sensed "De Duyvel" in there too.

The Waoranek Leni-Lenapes gathered there for sacred trance dances to celebrate the change of season and to call on the Great Spirit for strength. Moving bodies move spirits too. This, however, struck the encroaching European colonists with misunderstanding and dread. Ceremonies involving frenzied dance, fire jumping, self-induced pain and other intense religious practices left the Dutch frightened and fascinated.

Once, a Dutch couple eluded native guards and encroached on a ceremony. When looking for a sign from the animal spirits, the Waoraneks were enraged to find disrespectful strangers stumbling into their practice. They grabbed the pair and dragged them into the ceremony, perhaps wondering what to

do with them. The Dutchman feared his captors' rage and stabbed one of them with a knife. This violence provoked some of the natives to burn the offender in the ceremonial fire. The woman was held and later ransomed. The Europeans never really grasped the significance of Danskammer but were willing to "let the devils have their due."

Mah-ho-pac

"The Duke's Law will be imposed," proclaimed Richard Nicolls, the first British governor of the newly conquered colony of New-York, in 1665. The year before, only the Dutch director Peter "the Headstrong"/"old Silver-nail" Stuyvesant opposed the end of Dutch rule of the New Netherlands. The daunting Hudson Highlands had scarcely been settled. Now, Nicolls wanted that to change. He sent out colonial agents to acquire land from the native peoples to fill with English settlers. One such scout, a dubious fellow known as "Joliper," accosted a community of Wappingers about twelve miles east of the river and renamed "Hudson" after the English explorer. Joliper and his agents planned to prove British dominance not only in name but also with land deeds. Near the bear-flats, or "Mah-HO-pac," Joliper encountered an unexpected prize. Maya, a young woman, bright and beautiful, daughter of the tribal chief, came to confront the invaders. "Spare us any entreaties," she declared. "My people will not accept any gifts or aggression." Desire immediately moved the opportunistic Joliper.

"Lovely lady, be my wife and save your people," he entreated. "Marry me and I shall leave these lands to your people."

"I am already betrothed to Omayao!" proclaimed the princess.

"You shall do better in these times with a man like me. I am half Native and half European."

"I want a whole man!" the woman insisted.

Angered, the "half man" left Maya to find Omayao. Contriving a tale that he had captured his Maya, Joliper coaxed the young sub-chief away from the village and into the hands of a patrol of British soldiers. Once out of sight in the endless hills, Joliper ordered his captive tied to a tree. "Give me Maya in return for your lands!" The prospective chief refused. The agent ordered the woods around the recalcitrant man set on fire. Meanwhile, he had ordered an attack on his prisoner's people. Maya had secretly followed Omoyao. When the agent and soldiers left to join

the battle, Maya freed her beloved. They ran to aid their tribe. Unaware of their ordeal and thinking they had betrayed them to their enemy, the people of the bear-flats ostracized the couple.

"My love," Omayao told Maya, "the Great Spirit gives us only each other." The musket-bearing British drove many of the Mahopac natives off into the Wechache hills. The couple fled to the council chamber above this lake visited by bears. There, the native Romeo and Juliet took themselves away from woe. They leaped with love to the Great Spirit. Their bodies were dashed on the rocks below. The British eventually secured their lands. The couple endures in the beauty still present at Lake Mahopac and its falls.

VIEW SHED, 1685

Long, long before hordes of twenty-first-century day-trippers discovered Mount Beacon on Meetup websites, long before Pete Seeger sang to save the Hudson from his Highlands homestead, before William Thompson Howell trail-blazed these storied hills and almost ninety years before American Revolutionaries set a signal fire to warn of coming redcoats, the most fabled hike occurred in the Hudson Highlands. It must have been a mystifyingly sultry day in August 1683 for nearly twenty Wappinger chieftains when speculators Francis Rombout and Gulian Verplanck invited them to venture up Great Sachem Mountain in the endless Wechache hills. Graced with a land deed from colonial governor Thomas Dongan, they had gifted the leaders with the following payment in a clever real estate bargain:

> *One hund Royalls, One hund Pound Powder, Two hund fathom of Wirite Wampum, one hund Barrs of Lead, One hundred fathom of Black Wampum, thirty tobacco boxes ten holl adges, thirty Gunns, twenty Blankets, forty fathom of Duffills, twenty fathom of stroudwater Cloth, thirty Kittles, forty Hatchets, forty Homes, forty Shirts, forty p stockins, twelve coattis of R. B. & b. C, ten Drawing Knives, forty earthen Juggs, forty Bottles, forty Knives, fouer ankers rum, ten halfe fatts Beere, Two hund tobacco Pipe?. &c. Eighty Pound Tobacco.*

Determining the extent of their patent required Francis and Gulian to first inveigle their Wappinger chiefs with a portion of the "ankers" of rum. Unaccustomed to the European concept of landownership, the jollified

"Breakneck Hikers Haven," unknown photographer, circa 1890. North view. *From www. thehighlandstudio.com.*

natives acquiesced to the Dutch request for "all the land they could see." Thus, the fateful hike began. Rombout and Verplanck lead a real estate group up the highest of the Highlands for a better view. Standing 1,610 feet above sea level on today's South Mount Beacon, they spied about eighty-five thousand acres in what is now the city of Beacon, village of Fishkill and much of the towns of Fishkill and Wappingers.

There's some consolation in this dastardly deal. The Wappingers treated their land sale like a rental. They lingered in Dutchess County for decades, hunting, fishing and planting. The high-tech goods received in the form of metal tools and the wampum helped soften the blow of this cheat. It would be almost twenty years before a daughter of Rombout actually

started a European settlement. Eventually, a descendant of those sachems known as Nimhammau contested this land grab in colonial courts. Judge Cadwallader Colden, wanting to appease the powerful Philipse family, ruled against the native's claim. Later, during the American Revolution, one of his descendants, Captain Daniel Nimham, stood up not only for his people's rights but also for the rights of all Americans. He sacrificed his life for the cause of independence.

Camboan

Camboan Road, Upper Nyack, Rockland County, in the southern reaches of these Hudson Highlands, holds yet another bittersweet native story. The odd namesake originates with the native refugee whose tribe fled Brooklyn to Staten Island to wind up in "Nyack," a jut of land hooking into the Hudson where the Tappan Zee Bridge now hits the west shore.

Herman Douwese arrived in 1675, daring to farm in what became Rockland County. Followed by his family, the Tallmans, and other Dutch settlers, their plows, churches and poxes eventually drove most of the native folk off into the Ramapos. A visitor to Nyack in the mid-eighteenth century would have found clapboard homes with stoops and double Dutch doors. There remained in a neat farm village near Brookside and Broadway one wigwam. The holdout was a whitehaired medicine man known as Camboan. The Dutch not only accepted him but also relied on his woodland knowledge. Whenever the Dutch needed to know where to hunt, fish or find a lost cow, they turned to Camboan.

One evening after a thunderstorm, an English couple galloped into Nyack, hollering, "Camboan! Where is Camboan?" The Dutch *vrowen* clucked their tongues, telling them to hush. They would not cease until directed to Camboan's wigwam at the end of the Broadway. There, a young lass with braids bouncing guided the frantic couple up Hook Mountain. They discovered Camboan chanting over a cedar fire. He lifted his leathery face, sensed the couple's worry and spoke, "I will help."

The couple had lost their two children while berry picking. A sudden cloudburst drove them into a swamp near the Nauraushaun Brook. Camboan immediately followed the desperate parents to where the children were last seen. Bending down to study bent blades of grass, the old sachem began a meticulous tracking.

The last native of Nyack scoured the marshy lands. Sleuthing for three days, the determined scout encountered two terrified children beneath a sheltering stone. They asked, "Are you the angel of death?" He smiled and scooped them onto his shoulders. Soon, Camboan had delivered them back to the happy parents. Tearful, they promised a worthy reward.

A few months later, the couple returned with their children to Nyack. Finding the chieftain in his wigwam, they offered "the best reward a soul could have! Baptism in our church!" Camboan respectfully declined. "My church is the sky. My altar is mother earth. The Great Manitou moves along Mahicanituck."

A few years later, encroaching English settlers found Camboan's wigwam uncivilized. When this judgment was made on Nyack's last native, he vanished. Many claimed that he simply joined the Ramapo Mountain people, who had a tradition of taking in wayfarers. Others noted that he went to High Tor, a mystical crag above Haverstraw on the southeast edge of the Highlands. However, children lost in the lands rising above the river, rolling into the hilly Highlands, often told another story. They described an old leather-faced Indian who guided them back home. Today, elderly Nyackers share stories of Camboan helping when they were lost as youngsters. When the new high school got built on property once the site of the spirit-chieftain's cedar fires, technicians reported the stage lighting boards going inexplicably dark at times—perhaps it was Camboan's spirit making adjustments to remain remembered.

THE RAMAPOUGHS AND CHIEF KATONAH'S CHILDREN

One story from the other edge of the Highlands shows the enduring resourcefulness of the First Peoples. Travel south from Mahopac into Westchester County, pass through Amawalk and arrive at Muscoot Mountain, lording over the reservoir created by damming the Croton River in 1906. Chief Katonah, or "mountain of a man," traded a sixteen-mile square of land, now the town of Bedford, in a series of land deals from 1680 to 1722. Local legend states a tree fell on the big fellow's family after he signed the final deed.

His descendants, however, continued to live for well over one hundred years near the village bearing that sachem's name. Adrian Quick in the

1950s recalled his parents telling of Katonah's great-great-grandchildren coming down from Muscoot Mountain to sell handwoven baskets to travelers crossing Wood's Bridge where the Croton River flowed by the hamlet of Cherry Street. It is plausible long after the Europeans came through the Hudson River Highlands, from Nyack to Katonah, native Lenape people remain in these isolating hills.

AN OLD TREE DIES WHERE IT FALLS

On August 31, 1778, Captain Daniel Nimham, the last Wappinger sachem, crawled off to die near Tibbetts Brook in what is now Van Cortlandt Park in the Bronx. Thus ended his passionate fight to restore his tribe's lands. This American patriot's life bought a piece of the liberty, independence and pursuit of happiness enjoyed in the Hudson Highlands and in the nation.

When the French and Indian War broke out in the 1750s, Chief Nimham, a Christian allied with the British, decided to help fight against the French encroachment. He rallied warriors, prudently taking the rest of his tribe, the Wecaques, out of the eastern Highlands north to live with a kindred tribe near Stockbridge, Massachusetts.

They returned after the war to a shocking surprise: their homelands were filled with European settlers. Nimham, with help from Samuel Munro, a "Leveller lawyer," confronted the tenants, demanding and often receiving rent. This riled the colony's wealthiest family, the Philipses. Claiming that they rightfully owed all the lands in southern Dutchess (today's Putnam) County, they sued. Respectful of the laws of the British, Nimham, rather than taking up arms, took up the issue in colonial court. Attorney Beverly Robinson, a Philipse son-in-law, opposed the native's claim. The venerable judge Cadwallader Colden presided over the court of chancery. This judicature, consisting of men with large royally granted estates, could not find a lawyer to defend the sachem.

Nimham argued that his people had no knowledge of ever selling their land to the Philipses. Robinson objected and quickly produced a patent. It showed that in the early 1700s, Philipses purchased the land from Nimham's tribal ancestors. Nimham noticed some lines crossed out. The document originally granted the Philipses about two miles of land along the shore of the Hudson. While the tribe was off fighting the French, the Philipses grabbed land all the way to Connecticut, or most of today's Putman County.

Nimham objected to the patent, which is not a sale. He also produced a witness, an elder named "One-Pac." The man described in Algonquian that Nimham's ancestors noted on the deed were Pockemon and Houndstooth. They were not authorized to make a sale of land—they probably were drunk. Robinson objected to the use of 'Indian gibberish' in a court. He cited a rule giving the king the right to supersede patents and deeds in order to settle lands. Judge Colden asked Nimham to approach the bench. He politely and somberly explained, "Robinson's got you. You are resourceful, why not just go live among the rocky places of the Highlands as your people are wont to do."

Resourceful Nimham traveled to Great Britain to petition a higher authority. There is some evidence that he earned money in London posing for portraits. His case did not go far. Learning of the revolt in the American colonies against the British, he decided to return to help with this fight, feeling that it would help in his struggle to regain his people's land and liberty. John Jay helped arrange Nimham's commission with George Washington. The commander in chief felt wary about some native peoples serving in the American army. Iroquois nations knew Washington as Conotocaurious, or "Town-Destroyer." They largely sided with the British. The Wappinger Confederation, on the other hand, their land stolen by British policy, found reason to rebel against a distant king. A Christian, a seasoned solider and his people's leader, Nimham naturally signed on to fight for American independence.

Nimham was charged with hindering the progress of the feared dragoons or cavalry lead by Colonel Banastre Tarleton. This British "nobleman" occasionally ordered his men to bayonet surrendering American militiamen. He also ordered the burning of Bedford, New York. Five hundred cavalrymen, commanded by England's fiercest officers, Banastre Tarleton and his second lieutenant colonel, John Simcoe, ambushed Nimham's one hundred foot soldiers. Thirty-seven Indians, including Nimham and his son, Abraham, perished in the battle.

Simcoe saluted Nimham later in his journal. "The Indians fought gallantly. They pulled the [mounted dragoons] from their horses." A Hessian officer, mopping up after the action, noted that Nimham's unit's untrained "rebels" defended themselves while surrounded and run down "like brave men." The German mercenary went on to praise the dead Wappingers: "One could see by their faces that they perished with resolution."

The morning after the battle, a Tibbetts Brook farmer found his dogs scavenging the fallen patriots' bodies. He quickly gathered together the

Chief Daniel Nimham Monument, Carmel, New York, 2008. *Putnam County Tourism.*

remains and covered them with stones. A monument stands today in Van Cortlandt Park to Nimham and his freedom fighters.

Daniel Nimham showed his resolve years earlier when he took on the powerful Philipse family. When a bullet burned into his chest near Kingsbridge, he called to his warriors to return to their ancestral lands here in the Hudson Highlands. Nimham's men, however, raced to their leader's side, offering to carry Nimham home too. The dying chief replied, "Nay, an old tree dies where it falls."

THE REAL RAMAPOUGHS IN THE RAMAPOS

Misconstrued land deals and disease decimated the native peoples of these endless hills. The Ramapough Lunaape Nation, a tribe officially recognized by the State of New Jersey, remains today in these Hudson Highlands. The Ramapos, or "slanted rock" lands, isolated an exotic, independent people keeping close to the earth, far from the influence of nearby New York City. Perplexed by native, African and Dutch people living in a community between Mahwah, New Jersey, and Hillburn, outsiders concocted tales to try to explain this unusual band. The story claimed that Tuscarora Indian War refugees found haven among the Hackensack natives in the early 1700s. They had given sanctuary to Dutch colonial Africans both free and slave. The story of this tribe's existence in the Ramapos grew woolly when outsiders grew disturbed by the rainbow of hair, eye and skin color found among this community of just about five thousand souls. This prompted those who could not accept people of different races loving and having children together to concoct an explanation. When the American Revolution was ending, the Ramapoughs took in Hessian soldiers and weary prostitutes enslaved by a British officer named Jackson.

When John C. Storms, a 1930s newspaper editor, wanted to sell more papers, a friend of his declared that the pressman would "make it flowery so people would read it." Thus, he advanced this racist, bogus story of the origins of this tribe in the Highlands. He and others perpetuated an old slur, calling the Ramapoughs "Jackson Whites." Today, the tribe still struggles for full national recognition while still acting as guardians of the southern gate to the Highlands. The Ramapo Pass near the crossroads of Mahwah once provided access for American Patriots delivering iron and other supplies during the Revolution. Now it is a crossroad occupied by Routes 287 and 17, with meeting grounds now occupied by a Sheraton Hotel. The Ramapoughs, enlightened by a prophecy of coming environmental doom, declare that "there is good medicine in these hills." They continuously fight for their survival by preserving what is in these Highlands.

REVOLUTION IN THE HIGHLANDS

KEYED TO REVOLUTION

Three disparate figures in the American Revolution—George Washington, John Adams and John Burgoyne—all agreed on one point: the Hudson River was "the key" to the cause. Colonial communications, transportation, supplies and morale were all linked together on New York's waterway. Shortly after the first salvos were fired for independence in Massachusetts, the Continental Congress turned attention to New York. It asked in May 1775 where best to chain up and lock down the new nation. Looking at "Hudson's River," it resolved, "to discover where it will be most adviseable and proper to obstruct the navigation."

Many great minds offered vigorous plans on the necessary stronghold. Future Supreme Court chief justice John Jay decreed that hordes of soldiers mounted on Anthony's Nose could dislodge boulders into the river, making the channel too shallow for only "an Albany sloop" to slip. He missed the brief explaining the river is 150 feet deep at that location. Another high court justice in the making, Henry Brockholst Livingston, while a teenage Continental officer, looked to fortify Con Hook. This high tide island, just a few hundred yards south of West Point, was once an anchorage for Henry Hudson's ship the *Half Moon*. Brockholst declared this would make a "practicable" place for a protective "boom across" the river. Major General Philip Schuyler looked to the same hook, which he called "Tancanten," and

Washington's Headquarters, Newburgh, C.A. Palmer, circa 1870. *From www.thehighlandstudio.com.*

proposed making a blockade by sinking "sloops filled with stone." General Israel Putnam wanted the experimental "Bushnell," a pedal-powered submarine, to surreptitiously blow up British ships harbored in the Hudson. "God curse 'em!" Old Put snorted. "That'll do it for 'em."

James Clinton, big brother to New York's first governor, George Clinton, a denizen of Newburgh, proffered a plan to literally unite the colonies. He was first to suggest a mighty chain stretched across the river from West Point to Constitution Island to stop the British from cutting the new country in half.

When Maryland firebrand Samuel Chase declared that the new nation must "defend New York, [and] fortify upon the Hudson River," even the contentious and cash-strapped Continental Congress consented. Further, Washington agreed with Colonel Clinton. The key American bulwark would be "a Post in the Highlands." Described by army chaplain Timothy Dwight as "majestic, solemn, wild and melancholy," these hills made fortification a redoubtable task. What the Patriots needed was a savvy military engineer.

46

BERNARD'S BASTION ON THE HUDSON

Bernard Romans—an experienced surveyor, topographer, botanist, writer, sketch artist, philosopher and marketer—arrived in these Highlands during the summer of 1775 with a winning letter of reference in hand from Benedict Arnold, the lauded captor of Fort Ticonderoga. Eloquent and confident, the Dutch-born and British-trained Romans had convinced the Continental Congress that he could create a "Gibraltar on the Hudson" to fortify the defense of the Highlands. He had grand designs on these hills. Thus began Romans's Ichabod Crane–like run through the hollows of the Highlands.

The antediluvian gneiss and granite crystalline mountains known as the Hudson Highlands defy the river's straight course to the ocean. When the last glaciers melted some twenty thousand years ago, the vast wall of melting ice could not wear through West Point. There, right across the river, about a half mile south of today's Cold Spring village, stands a 160-acre peninsula backed by a swamp. This tidal island rises right above World's End, a submerged channel more than two hundred feet deep at high tide. Dutch mariners found this spot the deadliest on the river, designating it Martelaer's (Martyr's) Rock. They designed a special sloop with a moveable keel board to navigate the treacherous tidal Hudson. The Continental Congress's fortifications commissioners, hoping to remind the British Parliament of the rights spelled out for all subjects of King George, rechristened the forlorn enclave "Constitution Island." Bernard Romans selected this gloomy landmass for his bastion to guard the new nation.

The undefended Highlands rankled the rebellious colonial leaders at the start of the struggle. Thomas Jefferson worried that the British would soon take New York's arm of the sea to "cut off all correspondence between the Northern and Southern colonies." Schuyler cried, "Every Object... sinks to almost nothing" compared to "the securing of Hudson's River." Historian Lincoln Diamant, author of *Chaining of the Hudson*, described the Dutchman's plan as a "flight of fortification fancy." Romans, however, found inspiration in the rising chorus of concern. He proposed a "Grand Bastion," a "Gibraltar on the Hudson." Romans declared "a less or more imperfect plan would only be beginning a stronghold for an Enemy." It soon became apparent his fortress was just a castle in the air.

The engineering architect's imperfect plan overlooked the colonies' dearth of financial resources. Further, he failed to see the possibility for British artillery aiming down on his Constitution Island bulwarks from Crown Hill or Cro' Nest. Mr. Romans situated the citadel on the island's

south-central shore, not far from where the historic Warner Sisters House now stands. His blueprint called for an extensive barracks with many guardhouses, a lengthy rampart and an elaboration of multifaceted walls made thick with local brick. Eighty-one hard-to-come-by cannons would provide "a most terrible Crossfire, to make it totally impossible for a vessel to stand." The construction would take the hard labor of hundreds of skilled men working for four months into the winter. The costs calculated by Romans "at the lowest rates" to New York's young legislature came in at £4,645. The real "soul of the works" was the grandeur of Romans's ambitions.

Right after breaking ground on the island for his octagon fortress, problems rose steeper than the Highland slopes. Confessing to being "entirely ignorant of the cost for the project's 150,000 bricks," Romans omitted that key line item from his budget. Working the unforgiving rocky terrain through the winter proved even more daunting. The laborers completed little more than their barracks. Worse, the team of commissioners sent by the Continental Congress in December 1775 quickly pointed out where enemy cannons placed above West Point could pulverize the fort. Thomas Palmer reported, "Romans completely ignored Eminences overlooking the works." Romans retorted he had "but lately thought of that." Determined to carry out his vision, the Dutchman tried to go around the commissioners by arguing for his plans before the Safety Committee. He offered to create a cannon battery above the banks of "Pooploop's kill" across from Anthony's Nose if the committee made him a colonel.

Romans's map of the Highlands misaligned the river's course and, therefore, his cannons' sight lines. Congress found the fort it was funding "does not command the Reach to the Southward, nor can it injure a Vessel turning the West Point." Finally, it agreed with Palmer's commission, citing Bernard's bastion "is much exposed to an attack by Land." When General William "Lord Stirling" Alexander told Washington that Romans "displayed his genius at a very great expense and to very little publick advantage," the engineer ran out of these Highlands. The artful Dutchman, however, like Washington Irving's supple-jack schoolmaster, managed to land a new job. Bernard Romans became a Pennsylvania artillery captain. Fate caught up with this impetuous fellow in 1780. Apparently, someone murdered Romans while he was a prisoner of war on a British ship.

"A Chain Across Ye River at This Place"

Montgomery, a village on the northwest edge of the Hudson Highlands, holds a unique parade every September. Locally made motorcycles promenade through town with fire trucks and blaring bands. Uniformed Boy and Girl Scouts march. There's a soapbox derby, blooming onions and fireworks. A retired history teacher—garbed in a blue frock coat, sash and sword—portrays celebrated local figure General Richard Montgomery.

"Men of New York!" the bold officer cried at the snowy gates of Quebec City on New Year's Eve 1775. "You will not fear to follow where your general leads!" Noble Brigadier Montgomery, along with Colonel Benedict Arnold, led hundreds of liberty-minded militiamen to conquer almost all of consequential Canada. When a shot from a drunken sailor tore through Montgomery's lower abdomen, the rebels soon lost their leader, their nerve, the battle and Canada. The cause for American independence, however, found a martyr.

Three months later, after a winter spent sliding supplies across the frozen Hudson, a redoubt of stone, log and earth stood above the Hudson

"Remains of Fort Clinton, Bear Mountain," by Daniel Delaney, 2017.

and Popolopen Creek, just north of Bear Mountain. The construction commissioners, Thomas Palmer and Gilbert Livingston, sent the first letter from "Fort Montgomery." Many independence leaders felt they now held the key to keeping the British at bay. The Clinton brothers, however, demanded more protection for their Highlands. George had just been elected both New York's new governor and lieutenant governor. Congress also appointed him a brigadier general to boot. Letting Pierre Van Cortlandt take the "L.G." job, Clinton called for another bulwark near Fort Montgomery. Washington and Congress agreed to build a "Fort Clinton." Unlike Bernard's bastion, languishing on Constitution Island, this redoubt would be constructed with thrift and speed. Employing at least four twelve-pound cannons to guard the river south and Fort Montgomery north, they relied on the "high, inaccessible mountains" to prevent a land assault. Next Washington, the Clinton brothers, Lord Stirling and Generals William Heath and Israel Putman all wanted a great chain across the Hudson to hold together their new nation.

Machinations to obtain about two thousand feet of two-inch-thick chain set in Highlands began in 1776. Robert Erskine starting producing iron at Ringwood Furnaces. General Charles Lee and Robert Livingston Jr., sensing fame and profit, jumped on the project. Lee got a forge in Mount Hope, New Jersey, producing some of the iron bars. Livingston tried to take advantage of the new state's need by charging twice his peacetime fee. The whole works required a contingent of "artificers": carpenters, laborers, teamsters and sailors. Above all, they needed a hands-on construction engineer. George Washington asked the Massachusetts legislature to send to New York its best builder, Lieutenant Thomas Machin.

The Clinton brothers quickly set Mr. Machin to work. Curiously, they often referred to their new engineer as "Machine," asking him to "use your best Endeavours by all means in your Power" to complete the twin forts and build another Fort Independence, above Peekskill's Roa Hook. Machin jumped in June. By October 1776, just as the Battle of White Plains heated up, the Secret Committee urged its crack engineer to "prepare a place at each Side of the River at Fort Montgomery, to fasten the Ends of the intended Chain." The "Machine" was ready.

In early November, after Washington kept his Continentals and militias from falling to General William Howe's redcoats and Hessians, at White Plains, attention turned to the Hudson Highlands. General William Heath's forces were sent to reinforce the key region. Arriving around that time, too, was the final order for Ringwood-made chain. Machin organized a dozen

teamsters with oxen-pulled wagons to haul the chain up the "Furnace Road" (probably today's Sterling Mine and Seven Lakes Drive) to New Windsor. There he organized the linking and bolting of the rings, cobbling together from a few sources a 1,800-foot-long chain. The clever Machin found a lighter pine best served to support the chain several feet below the river's surface. He rafted the chain and wood floats down to Fort Montgomery. The exact day Machin stretched the first chain across the Hudson remains a secret. What happened, however, was a big bust. The tide poured some sixty-five million gallons of water per minute through the "Devil's Horse Race" between Anthony's Nose and Bear Mountain. The water soon snapped the link like a Yankee pumpkin vine. Machin's artificers rapidly hooked and winched to shore the two broken sections. The bad connector replaced, they set the chain out again. Again, snap!

THE BLUE CAMLET

Brigadier General Alexander McDougall took command of Continental forces at Peekskill on March 12, 1777, during a grim winter. General William Heath, McDougall's superior officer, lamented, "[My men] were so destitute of shoes that blood left on the rugged frozen ground showed the route they had taken." Troops literally camped in hovels dug into Saint Mary's Hill near present Oakside School. These farmers turned fighters huddled around fires without coats or blankets, with only thick bread and dreams of liberty to fill them. The ragged soldiers had been marched out into the cold to witness, with warning, the execution of Daniel Strang, a local Tory spy, at what then became the "Hanging Tree." Until recently, it shaded lounging students on the grounds of Peekskill High School. Strang got caught in December 1776 with recruiting papers from the notorious Tory Lieutenant Colonel Robert Rogers, "Commandant of the Queens Rangers." The grim oak also served a place of punishment for another Westchester Tory, Edmund Palmer. Forging for the British in what is now Yorktown, New York, Palmer fell into the hands of forces commanded by Israel Putnam. Palmer was charged with "[p]lundering robbing & carrying off Cattle, Goods…& for being a Spy for the Enemy." When the Brits petitioned Palmer's release, Old Put pronounced that his prisoner would be brought to the Gallow's Hill tree to suffer the "Pains of Death…by hanging him up by the Neck till he is dead, dead, dead!"

Heath's superior, General Charles "Boiling Water" Lee, known for his testy temperament, came to Peekskill's Birdsall House in the spring of 1777. Lee intended to take away from the defense of the Highlands those two thousand ragged troops. Heath held him off. Later, wanting to warn us about the likes of Lee and remind us of the hardships endured in the Highlands, the better general begged, "Remember these things, ye Americans in future times!"

McDougall arrived at Peekskill with little military experience. Having previously dealt with trumped-up British libel charges, prison and New York City's 1773 "Tea Party," however, made him street smart. A recently freed American prisoner of war told the new general that the British planned to attack Tarrytown. McDougall, the clever old privateer, sensed the Highlands as the target and saw through the redcoat ruse. He began ordering his men to move supplies out of the tiny village of Peekskill on Hudson. The Patriots carted munitions up the Old Post Road to a secluded mountain hollow, now called Continental Village.

Ten days later, more than a dozen of the king's warships with hundreds of soldiers appeared in Peekskill Bay. They hauled cannons up Drum Hill, blasting the rebel's supply houses. They burned the Lent House and chased the Patriot militia up Jockeyville and down Welcher Roads. Historian Otto Hufeland reported a militiaman named Daniel Brown paused to drink from a spring at today's "Soldier's Spring" only to suffer a mortal wound from a British cannonball. When the Patriots licked their wounds that night at Roa Hook, Lieutenant Colonel Marinus Willett approached McDougall. "General, I beg permission to attack the d----d Redcoats while they sleep. They camp at Gallows Hills. Let that be the end of their advance."

"Sounds foolhardy," replied he at first. The ardent American, however, soon gave Willet his consent. Bayonets fixed, the Continentals charged into the darkness, succeeding at driving off about one hundred redcoats. The next day, however, before leaving Peekskill, the Regulars burned American supplies. A British officer recounted, "Above one hundred fifty new wagons were committed to the flames together with a vast collection of intrenching tools, carpenters tools, and an immense quantity of beef, pork, flour, rice, biscuit all in casks, and above four hundred hogsheads of rum…chests of arms, nails, twenty boxes of grapeshot, slit iron…[a] conflagration…easily imagined to have been prodigious."

This serious blow to the Americans could have been far worse had Willet failed to drive the redcoats off Gallows Hill. The British planned to seek the stash in Continental Village. If discovered, the Patriots would have had little

left with which to defend the Highlands. These supplies were a large part of the "key" to the Revolution.

The Americans did not go off after the Battle of Peekskill empty-handed. Among the spoils left by the fleeing Brits was a vibrant blue cloth. This "blue camlet" taken from Peekskill went on to great glory. One of Willet's officers, Captain Swartout from Dutchess County, received the cloth as his share of the gains. It would not go to waste or wantonness.

Later that summer, Willet, Swartout and company got trapped in Fort Stanwix along the Mohawk River. There the British under Lieutenant Colonel Barry St. Leger appeared to work their vaunted "Three-Pronged Attack." General "Gentleman Johnny" Burgoyne orchestrated a triple threat of troops to conquer the Hudson and divide the rebellious colonies. General Howe would charge north from New York City. St. Leger would sweep from the west along the Mohawk River. Then Burgoyne would march down from Canada. The rebellious colonies divided, the redcoats would meet in Albany to toast their victory.

The Patriots hoped to signal their defiance to the surrounding redcoats and beckon Benedict Arnold, who commanded the approaching American relief troops. Congress had just approved a design for the new American flag: thirteen stars on a field of blue, with red and white stripes. They made creative use of materials on hand. Fort artillerymen tore the linen from the shirts on their backs to provide the white. One of the many female cooks in camp turned her apron into red stripes. The final color, blue to field the stars, proved hard to find in those trying times. The bright-blue camlet from Peekskill transformed into part of the first American flag to ever fly in battle. The siege at Fort Stanwix turned into an American victory.

Pyramids of Fire

Once upon a time, American army general officer Israel Putnam killed a wolf with his bare hands, survived an attempted burning at the stake and steadied farmer-fighters at the Battle of Bunker Hill by lisping to them, "Don't fire till you see the whites of their eyes." The fall of 1777 found this man of sixty commanding American forces at Peekskill, living up to his new nickname of "Old Put." Apparently, his eyes had been weakened by years of battle. Did he not see where the British went when they landed at Verplanck Point, or was it across the river at King's Ferry? The Clinton brothers also

let their confidence in the "inaccessible" Highlands cloud their vision of its defensibility. George Washington, however, when inspecting Peekskill in November 1776, suggested another defensive post between Donderberg and the Timp. Both Putnam and Clinton skipped Washington's tip. This oversight helped the British attack on Forts Clinton and Montgomery during the Battle of the Hudson Highlands.

Major General William Howe maneuvered his military like a game of chess fueled with a fine claret. Reluctantly, he agreed to lead Great Britain's expeditionary forces to quell the "unnatural rebellion." He felt showing the rebels his thirty-two thousand redcoat Regulars and fierce Hessians would impress the contentious colonists to accept his offer of "full protection of their persons and properties." A year of chasing, confronting and hoping to "confer" with these colonials, however, convinced him to accept Burgoyne's plan for the "Three-Pronged Attack." Hesitantly, he sent his second in command, Major General Sir Henry Clinton (a very distant cousin to James and George), up the river Hudson with three thousand soldiers. They were to break the lock the rebels set in the Highlands and then rendezvous with Gentleman Johnny and St. Leger in Albany.

Sir Henry kept the Americans guessing about the next British strike. Which island would be attacked: Long, Staten or Constitution? Washington ordered 2,500 of Putnam's men down to Philadelphia to counter Howe's move there. The change of seasons late in September saw a shift in Sir Henry's forces. They began gathering north of New York City on the Hudson. When 3,000 redcoats arrived at Verplanck's Landing on October 5, 1777, Old Put got flummoxed. He demanded George Clinton send reinforcements. New York's first governor and general cursed but sent hundreds of men from his twin forts to Peekskill. A concerned "Old Put" rode up to Fort Independence above Roa Hook to catch the enemy's approach.

The imps of Donderberg appeared to work for the British by providing a dense fog. The redcoats rowed forces east and west, with the mists keeping their movements a mystery. Cannon shot and then beacon fires sounded the alarm from Peekskill. What was the British objective? Under cover of night and fog, a clandestine British force of two thousand infantry, grenadiers, dismounted dragoons, Hessian chasseurs and Provincial Loyalists landed at King's Ferry just above Stony Point. Colonel Beverly Robinson, leader of the New York Tory regiment, knew the way through these "inaccessible" mountains. Married into the Philipse family, wealthiest in all the colonies, Robinson hailed from nearby Garrison. Three years later, his estate served

as headquarters when Benedict Arnold launched his conspiracy to give the American fortress West Point to the British.

Colonel Robinson picked a tenant of his, Brom Spingster, to serve as the British expedition's point man. Together they guided the king's army over a wildly rugged path behind Donderberg and its legendary imps. The men marched just three abreast over what is today's "1777" hiking trail. On the morning of October 6, they passed beneath mountains Buckberg, Coleberg and Pyngyp. Where Washington once suggested a militia post between the Timp and Donderberg, the British detached a unit to protect their communications line.

Governor Clinton returned the day before from Kingston to find the beacon signal fires and cannon shots mustering his militias from four counties. He dispatched through the western Ramapos the reliable Major Sam Logan, who returned to first report on the British surprise attack. All the king's men got sneakier. Lead by the hot-headed Lieutenant Colonel Mungo Campbell and the ruthless Major General John Vaughan, along with Loyalists under Robinson and the last royal governor of New York, William Tryon, they divided at Doodletown to conquer the Twin Forts. Campbell went west behind "Bear Hill." Vaughan took a river trail. Had his Highland generals heeded Washington's earlier suggestion to place an American guard on Donderberg, the redcoats may have been stopped.

George Clinton at Fort Montgomery and brother James at Fort Clinton took heed of Logan's report. They sent a Lieutenant Jackson with thirty men down toward Doodletown. Gunfire from the resulting skirmish prompted the Clintons to dispatch one hundred men. Thus the battle for the Hudson Highlands began in earnest. General Sir Henry Clinton, meanwhile, kept America's senior general, Israel Putnam, guessing. He ordered the warships the *Preston*, *Mercury* and *Tartar* to feint attack on Fort Independence. His Majesty's ships the *Crane*, *Dependence* and *Spitfire* continued up the Hudson. Sir Henry intended to bombard the forts and cut through the Yankee pumpkin vine set again by the ever-ready Machin. Anticipating the British assault, George Clinton sent Silvester Waterbury and a few other messengers to Putman. Essentially, they wanted back the troops they had sent earlier down to Peekskill. The riders all arrived late or not at all. An American officer cursed Waterbury as an "infamous Scoundrel." Washington Irving branded him a spy. "Old Put," in the words of historian Steven Paul Mark, "stayed put."

When the Clinton brothers heard the Jackson muskets, they also called their artillery commander, Colonel John Lamb, to roll out the fort's lone

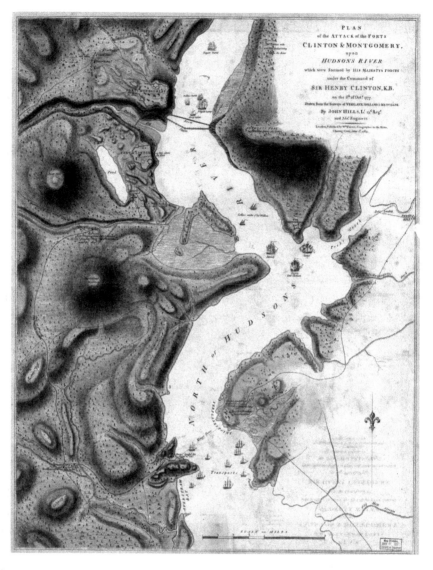

Plan of the attack on Forts Clinton and Montgomery on the Hudson River, which were stormed by His Majesty's forces under the command of Sir Henry Clinton on October 6, 1777. *Antipodean Books.*

field cannon. Captain Ephraim Fenno's men hauled the brass piece above Polopopen Falls to a craggy roost up in the Torne. There they fired grapeshot, converting the ravine today's West Point cadets call Hell Hole into a "slaughter hole." Vaughan closed in on American defenders lined just south of Sinnipink Lake (now Hessian Lake). The Fifth New York Regiment

surprised Vaughan's men with its tenacity, but the British outnumbered the Americans in this battle three to one and drove them back to Fort Clinton. The Clintons and Lamb sent out the twelve-pounder to give Mungo's men "annoyance." Brits fell, but so did both big guns.

Finally, Old Put got an earful of Sir Henry's plan as he heard the cannons blasting upriver. George Clinton sent three pleas to his boss for help. Apparently, a Tory lass distracted Old Put from his duties with her beauty in a game of chess. When he finally sent reinforcements, they came too little and too late. Colonels Samuel Wyllys and Return J. Meigs arrived with their troops to watch uselessly from Beverly Robinson's Landing on the eastern shore while the twin forts fell.

Meanwhile, at those ramparts and redoubts, the six hundred or so American forces fought like lions. Sir Henry ordered his naval captain Sir James Wallace to row his warships into place to bomb the forts. The *Dependence* fired more than one hundred rounds from twenty-four-pound cannons. Mungo Campbell saw the outnumbered and outgunned rebels as foolhardy. Waving a white flag of truce, he approached Fort Montgomery. George Clinton dispatched the brash Lieutenant Colonel Brockholst Livingston with the tenacious Captain Thomas Machin to parley. Mungo made a recommendation to this effect: "Sir, may it please you rebels to note, surrender to prevent an effusive bloodshed." He went on to add, "You can all expect to be treated with the King's mercy."

To this Livingston replied, "Surrender, indeed, to our Patriotic American force, and enjoy liberty from the King's tyranny." Enraged, Campbell returned to his men, immediately ordering an assault. Vaughan ordered his men to attack Fort Clinton with only bayonets. They clambered over one another at the walls to enter the forts. The British renamed their new stronghold on the Hudson Fort Vaughan.

Among British and Hessian soldiers, 41 died and 142 suffered wounds. Those who lost their lives included Sir Henry's Polish aide-de-camp, Count Grabouski, and Mungo Campbell. The Americans endured about 90 killed or wounded and 263 captured. Machin took a wound to the upper chest and James Clinton the thigh. The forts fell to the king's army, while the Clinton brothers slid down Bear Mountain into the river for a harrowing escape.

A few more blows hit the Patriots. Tryon hit Continental Village and "burned Barracks for 1500 men, several Storehouses, and many wagons." A rapid tide helped them cross the chain, "breaking it like a pipe-stem." The Revolutionaries lost sixty-seven cannons and irreplaceable supplies. Vaughan sailed north to burn down most of New York's capital at Kingston.

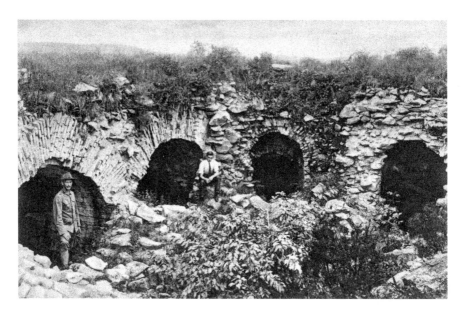

"Old Fort Putnam" at West Point, photographer unknown, circa 1900. *Mark Forlow Collection.*

Important papers there were spirited away in a young maid's aprons. British captain and future historian Charles Stedman illuminated the funereal scene concluding the fall of the twin forts in the Highlands:

> *The flames suddenly broke forth: and, as every sail was set, the vessels soon became magnificent pyramids of fire. The reflection on the steep face of the opposite mountain, [Anthony's Nose], and the long train of ruddy light that shone upon the water for a prodigious distance, had a wonderful effect: whilst the ear was awfully filled with the continued echoes from the rocky shore, as the flames gradually reached [for] the cannon. The whole was sublimely terminated by the explosions, which again left all to Darkness.*

THE BITTER PILL

The day after the fall of Forts Clinton, Montgomery and Constitution, British Sir Henry Clinton composed a little victory missive for his fellow general, John Burgoyne, fighting rebels near the upper Hudson River: "Nous y voici,

and now nothing between us but Gates. I sincerely hope this little success of ours may facilitate your operations.…I heartily wish you success."

Success, however, finally smiled on the American cause. The Patriots had won the biggest and most important battle in the Revolution. Lead by Major General Horatio Gates and Benedict Arnold, Gentleman Johnny surrendered at Saratoga. The British defeat in due course became the famed "turning point of the American Revolution." Henry Clinton's message never reached Burgoyne.

Sir Henry ordered Lieutenant Daniel Taylor to deliver his note carried in a little silver pill capsule. Traveling north through the Clinton brother's homeland of Little Britain, he got a little lost. Fortune led him to soldiers in red coats. When they took Taylor, he told them to bring him to General Clinton. They did indeed, delivering the messenger to General George Clinton. Apparently, the American Clinton's militia remedied its ragged condition with found British uniforms.

Taylor, realizing his mistake, quickly pulled out his pill and swallowed. Clinton caught the dodge and ordered a doctor to "administer a very strong emetic, calculated to operate either way." It produced the intended effect, but clever Taylor performed the same trick. Clinton growled, "Give me that ball or else I hang you up and cut it out." Clinton also pretended he knew what the note said. Stung by their defeat and angry at Taylor's attempt to hide evidence of his mission, New York's first governor had the redcoat tried for espionage. One week later, the soldier of misfortune was hanged from an old apple tree in Hurley, New York.

Fishkill Supply Depot

This is how the war was fought in Fishkill. No quick merciful death greeted those brave men, no drums and fifes urged them into battle. Yet they suffered and persevered.
—*Rich Goring, director, Fishkill Supply Depot Historical Research Project, 1972*

Sour, Lamb and Rapalje Mountains lounge like spellbound trolls overshadowing the amalgamation of big-box businesses lining Route 9, the Albany Post Road. Heading south into those Hudson Highlands, signs of the nation's Revolutionary heritage are scarce until Fishkill. Gustatory Dutch

settlers found "vis" in the "kill" above Madame Brett's Homestead, hence the community is known as Fishkill. Efforts by PETA to pacify the name to "Fishsave" failed in the 1990s.

People passing by often fail to notice that this northeast realm of the Highlands once harbored a site as significant to American independence as Valley Forge and Morristown. The Fishkill Supply Depot served as the hub of the Revolution. It sprawled from the village at the intersection of the Albany Post and Fishkill Landing (Route 52) roads to Isaac Van Wyck's homestead and a few miles south to Snow Valley. Once upon a Revolutionary time, this depot bustled more than today's nearby Walmart.

Late in the summer of 1776, British forces took hold of New York City. Soon, the Regulars and raiders marched out again on Connecticut, New York, New Jersey and Pennsylvania. The American Revolutionaries needed a safe base. Again the rises and folds of Hudson Highlands offered a haven. Following the Battle of White in late October 1776 until Washington announced the end of the war in April 1783 from the New Windsor Cantonment, Fishkill furnished the new United States with munitions, food distribution, clothing storage, a muster point, barracks, a court, a spy nexus, stables, an armory, blacksmiths, hospitals, headquarters, a prison and a sanctuary. Granted, Fishkill was no Lexington-Concord, Saratoga or Yorktown. This supply depot made the American Revolution possible.

It hosted almost six thousand men when General William Heath commanded in the Highlands late in 1776. Usually, a few thousand soldiers operated and guarded the industries there. Units came from all over New England to muster, get inoculated for smallpox and be sent to battle posts. When Burgoyne lost his army of thousands at Saratoga in October 1777, the Fishkill Supply Depot kept them as prisoners of war.

The Van Wyck Homestead, a landmark still proudly standing by Route 9 and relentless Interstate 84, once hosted key figures of the Revolution. Washington often stayed at the nearby Brinckerhoff house but preferred to confer with his officers at Van Wyck's. So did Generals Heath, Gates, Lord Stirling, Putnam, MacDougall and the Clinton brothers. Alexander Hamilton orchestrated troop movements and witnessed a mutiny there. The Marquis de Lafayette recuperated from a serious fever in Fishkill. Marinus Willet judged courts-martial there. John Jay chaired in Fishkill his Secret Committee of Correspondence and enlisted American's top spy, Mr. Enoch Crosby. He also kept his family safe at Theodorus Van Wyck's home in East Fishkill. Major General Friedrich "Baron" von Steuben, the Revolution's renowned "drill sergeant" and morale officer at Valley Forge, headquartered

at nearby Mount Gulian, now a Historic Landmark in Beacon, New York. There he helped establish with Washington and Kosciuszko the Society of Cincinnati, the first fraternal organization to help war veterans. He described the village of Fishkill as the "last place in the world for mirth."

The task of creating a nation based on "the pursuit of happiness" required strenuous efforts by those at the supply depot. MacDougall roasted an ox there to celebrate the American victory at Saratoga, but "mirth" was not the prime object of those at Fishkill. Gathering, organizing and providing took a toll. The first time the nascent New York government met in the village's Trinity Episcopal Church, its members found it fouled with fowl droppings. They soon moved into the more commodious Dutch Reformed Church. Both churches remain proudly active today. Trinity cleaned up its act and served for the Revolutionary years as a hospital. An elderly woman in the 1860s recalled a horrific sight from her childhood during those "trying times." As a child during the Revolutionary War, she claimed, she saw "bodies stacked like cord-wood" by the church. This particular horror may have been the result of the decision to bring some of the casualties suffered by the Americans after the Battle of White Plains to Fishkill.

Battle casualties weren't the only tragedies haunting the town. The epidemic of smallpox was a grim reality at the depot. It struck in waves: January 1777, April 1778 and 1781. Historian Stefan Bielinski calculated that about four hundred soldiers endured the pox at the Fishkill Supply Depot during the war. Many others suffered with it in the village. Usually in those days, about 30 percent died from the disease. Inoculation with a vaccine derived from cowpox, according to Elizabeth Fenn, author of *Pox Americana*, prevented many people then from getting the full-blown disease. Still, Bielinski noted that "discontent among the troops in Fishkill prompted General MacDougall to suspend inoculations. He acquiesced to his men's fear the shots would get them sick. MacDougall asked Clinton if there 'were laws to suspend [the innoculations].' Apparently, they compromised by ordering the barracks to be 'cleansed of infection.'"

The officers could not cleanse the Fishkill Supply Depot of discontent, especially in the winter. Earning the glory of the new United States meant many braved hardships. Rich Goring, an early researcher of the site, created a picture of depravity: "Men and boys as young as fifteen stood huddled and shivering around fires, picking apart horse bones to eat the marrow inside so they might keep from starving....Soldiers lie all about us, many almost entirely without clothing, coughing, cursing, moaning... amputation is fairly common....The stump is not stitched or bandaged,

but covered with tar....Cries of pain and a call for war...the overpowering stench of sweat and vomit...is inescapable."

The Patriots at Fishkill tried to escape misery. They endeavored to construct barracks to keep out the cold and the damp. They patched together their clothes until, rag upon rag, they literally fell off their backs. They foraged mounts Sour, Bald and Breakneck for wild game to fill stew pots. Grim conditions drove them to desperate actions. McDougall, Putnam and other commanders issued orders against pilfering the villagers' gardens and rain fences. Some soldiers stripped planks off the Presbyterian church. Prisoners tunneled twenty feet beneath the stockade to flee Fishkill. When Enoch Poor's unit returned from firing the decisive shots in battle at Saratoga, it was rewarded a posting at a vermin-invested Fishkill. Hamilton reported to Washington that the men there had not been paid for "six to eight months." They may have missed McDougall's ox roast, but Poor's men tried to soften their blow with rum. Hamilton recounted the results in part to Washington, but Private Joseph Gray detailed the event best:

> *A portion of the army, being unfit for duty, were sent into barracks, drawing suitable provisions, and large supplies of New England rum. Not satisfied with their situation, forty of these soldiers, under the exhilarating effects of the intoxicating liquor, mutinied, shouldered their baggage, paraded, chose a corporal for a commander and started for their homes. Immediately information was communicated to the officers, who ordered Capt. Beal of Portsmouth to persuade them to relinquish their design and to return to their encampment. Capt. Beal girded on his sword in haste, met them and requested them to halt, intimating that he wished to speak with the corporal who commanded them. Talking him* [the corporal] *aside, he* [Beal] *drew his sword and ran him through; the corporal at the same instant discharged his piece, which took effect. Both expired before morning.*

Putnam tried to quell the rebellion by imprisoning the conspirators and trying to get them a pay loan. Did Old Put send out the sword-stabbing Beal? Hamilton wrote to Washington after the incident demanding he dismiss the ailing general for his "blunders and caprices are...endless." Earlier, of course, Putnam had failed to send troops from Peekskill to reinforce the Clinton brothers at the Twin Forts.

Valley Forge in 1777 endured one bitter winter. Efforts to provision troops from Fishkill for the duration of the Revolution seemed endless. Villagers lamented that it took "all day" to traverse the roads crowded with food

wagons. Thousands of tons of precious gunpowder from France went out from Fishkill. There developed peculiar conditions concerning clothing. One account lists more than eleven thousand pounds of clothes arriving at the depot, but the order was strictly to supply forces in the south. When a French dignitary visited Fishkill in 1780, he marveled at the new Patriots' ennobling of nakedness: "American armies every solider who is unfit for service is called an invalid; now these had been sent here behind the lines because their clothes were truly invalid. These honest fellows, for I will not say unfortunates (they know too well how to suffer, and are suffering in too noble a cause) were not covered, even with rags; but their assured tearing and arms in good order seemed to cover their nakedness, and to show only their courage and patience."

General Putnam addressed this delicate matter too. When clothing became too scarce for those stationed at Fishkill, he ordered a special barracks built probably a few miles south of the main camp again at Snow Valley. There they could better quarantine the sick, their prisoners and those "several hundred men…rendered useless for want of necessary apparel." The Fishkill Supply Depot kept a house for the naked.

A SUPPLY OF FISHKILL DEPOT STORIES

Tales detail how hardship in the Highlands during the American Revolution hit not just soldiers. Those times tried every soul. Here are but a handful of stories from sources ranging from journals carefully kept to the supernatural. Threats to the new nation's largest supply depot sparked Washington to take preemptive actions. He once ordered Putnam to remove all stores from Fishkill no matter the cost. When British POWs passed through Fishkill, Washington sent additional troops to guard against an attempted breakout. The tight, tough conditions endured by redcoat prisoners, however, failed to dim their view of the commander in chief of the Continental army. They said that Washington's only flaw was that he "served against the King."

A Perfect Patriot Fury

Frederika Baroness Von Riesdel followed her husband, Frederick, to America to lead German forces serving King George. Captured after the fall

of Saratoga, she was taken with her little daughters to Fishkill Landing (now Beacon, New York). Frederika, and all British serving officers, paid their own room and board while transported to their internment. Her journal best tells how the transgressions suffered by the Patriots moved some of them to despise even the most gracious of Loyalist guests:

> *Upon reaching the banks for the Hudson River, we were quartered at the house of a boatman, where we were given as a mark of special favor, a half-finished room without windows. We hung our bed clothes before them and slept upon straw....Our landlady, a perfect fury, finally allowed us on the following morning...[I]t was the month of December, and we could not make a fire in our room...we were unable to induce her to let us have a table to ourselves; and we were not once permitted to sit down to hers, until she and her children and servants had finished breakfast. They left us a filthy table, which we were obliged to clean...they insisted we replace the cups and saucers in a perfectly clean condition. At least remonstrance they pointed us to the door. She did this all to torment us, for she was an anti-royalist.*

"Cannon Watch" from West Point over Steamboat Passing, Constitution Island, postcard, circa 1900. *Mark Forlow Collection.*

The baroness goes on to describe waiting out one of the Hudson Highlands' infamous storms. The captives managed to find a little sailboat. Lacking a proper pilot, they floundered for hours until reaching the homestead of a Colonel Osborn, who finally took in the Tory refugees.

Secret Service Suffrage

Isaac and Betsy Van Wyck hosted American generals, French diplomats and the occasional spy. The spring of 1781 brought a singular visitor to their open home. A beardless youth from Massachusetts all but collapsed from exhaustion arriving at a firepit on the plains of the Fishkill Supply Depot. Betsy revived the recruit with water. "Best you stay vit us tonight," she insisted. "Share the bed vit myne husband." The soon-to-be solider, who introduced himself as Robert Shurtleff, looked shocked, but the Dutch *vrow* saw that the youth was too tired to disagree. Isaac let the weary soul from Massachusetts share one side of his bed.

The next morning, Captain George Webb, looking to fill his infantry ranks with those who looked quick, picked out the beardless youth. Robert Shurtleff joined the Fourth Massachusetts. This private proved quick on foot and also with the sewing needle, an oft-needed soldiering skill. Sent down to the no-man's-land of central Westchester County, the Fourth Massachusetts soon tangled with a band of "Cow-Boys." Loosely under the command of the Loyalist brigadier general Oliver Delancey, this group raided rebel farms, taking cows and whatever else they could steal "in the name of the King." They'd then deliver the cattle to feed British troops stationed in New York City all throughout the rebellion. Shurtleff received two wounds: a grazing but bloody head wound and a lead ball in the upper thigh. The young solider managed to find treatment from a doctor in Crompond in Patriot-held Upper Westchester. There the private waved off treatment for the lower wound. Later at night, employing those agile fingers, the soldier secretly used sewing needles to remove a ball of lead from that wounded leg. Shurtleff also secured help for a fellow wounded private from a Dr. Ebenezer White.

Once healed back in Fishkill, Shurtleff joined forces lead by Hamilton and Lafayette overrunning British redoubts at the decisive Battle of Yorktown. The private deftly deflected bayonets from enemy soldiers and witnessed the surrender of Lord Cornwallis's army to Washington. Returning to post in the Highlands, Shurtleff refused a smallpox inoculation, got discharged from the army at West Point and returned home to Sharon, Massachusetts.

When the war ended, so did a mystery. Back on the family farm, Benjamin Gannett rejoiced to discover that the veteran known as "Robert Shurtleff" was in love with him. The gallant solider was actually Deborah Sampson, the only woman to earn a full military pension for participation in the Revolutionary army.

King's Gun to Shotgun

Mrs. Dorothy Giles, a local historian born in Cold Spring in 1892, collected a few rare personal stories of experiences during the Revolution. Occasionally, when a prisoner of war proved less than loyal to the king, Philipstown residents got them to work their farms. One such fine fellow was set to labor for one of the Hustis families settled just below Scofield Ridge. The Tory took a fancy to the farmer's daughter. When her father found out, he shot-gunned the young man to make the relationship respectable. Hustis even threw in a cow. Decades later, long after the Revolution seemed all but forgotten, the couple grew old and prosperous yet suffered scorn. Hustis relatives right next door always shunned them. One snuffed, "Well, they are related to my husband, but I am just as ashamed of it as they are." The ignominy rose from the gun held not by the father but for the king.

Sybil's Revered Ride

One dark, dismal night in April 1777, the British generals Tryon and Sir William Erskine attacked an American supply depot at Danbury, Connecticut. They were really angling for the fatter catch to the west at Fishkill. A Patriot messenger, bedraggled and bloodied, arrived at the homestead of Colonel Henry Ludington at the eastern edge of these Highlands. "Danbury's burning!" He implored. "We need your help!" The oral tradition states that Ludington disguised his sixteen-year-old daughter, Sybil, as a young man to send her with confidence on a mission. A young woman caught riding at night could be subject to a fate worse than death. Thus, dressed as a militiaman, Sybil could call out her father's fighters to muster at the family's mill. This was planting season. Ludington knew that he'd need to be on hand to meet his gathering men and hold them steady until all arrived for the counterattack.

Two years earlier, the forty-year-old silversmith rebellion agitator cantered out of Boston along with a series of other messengers, all carrying to the

region's Patriot militia the message "the Regulars are coming." Revere, William Dawes and Sam Prescott all got captured and had their horses stolen. Nevertheless, the king-weary populace rallied to drive the redcoats off at Lexington and Concord.

Traversing about forty miles, the young woman from these Highlands outrode Paul Revere. She ran a gauntlet slipping by Cow-Boys and Loyalists through grim, bone-chilling weather. Sybil rode from cottage to farmstead, rapping on doors and stating, "Danbury's burning. Muster at Ludington Mill." Local historian Vin Dacquino found evidence that the young woman rounded up more than a few hundred Dutchess County militiamen scattered from Mahopac to Farmer's Mills. Her father met his men at the mill and then led them to Ridgefield, Connecticut. There they rendezvoused with the local militia under the command of Benedict Arnold. The disgruntled general had just suited up for a ride to Philadelphia to confront Congress on its failure to promote him when word came of the redcoat attack on his home state. Ludington's men helped Arnold turn away the British from Connecticut and Fishkill. They had to dodge a cannon ball now lodged in Keeler's Tavern in Ridgefield.

Sybil went on to become one of New York's first female tavern owners and raised a son who became a Congressional representative. She got turned down for a military service pension but told people the story of her ride for years. Sometimes she noted that aide-de-camp Alexander Hamilton fetched her to be congratulated by General George Washington himself.

The Prisoner's Pig

A local legend reflects yet another deathly scene. Two prisoners of war, most likely held at Snow Valley a few miles south of the main supply depot, argued over a pilfered pig. Who would act as chef and server? Turning their cooking knives into weapons, they fought. It ended with the pig slain, and one of the thieves lost his head.

Years later, on rare occasion, a galloping ghostly headless rider appears questing for that pig. The pursued porcine spirit was once known to leap into passing carts and even cars to escape. Then, looking to steady rattled nerves, the ghost pig chants for a "jug-o-rum." It remains on board, squealing, unless the driver has a source of liquor to toss to the spirit. Lacking that, the little goblin haunts until reaching the Griffin Corners, where the presence of a tiny church exorcises the animal specter.

The Scourge of the Highlands

America's first cowboys roamed not the badlands of Texas. They marauded in and around the Hudson Highlands during the American Revolution.

British forces held New York City from July 3, 1776, to November 25, 1783. Traditionally, an army runs on its stomach. Redcoat beefeaters, however, wanted more than cows. The Crown discovered a way to supply its soldiers with meat while harassing rebels.

Ostensibly, the British organized military units of colonial Loyalists to root out rebels near the city. The most feared raiders fought without pay under the command of Colonel James Delancey. They claimed to operate under the rules of warfare, confiscating rebel property throughout Westchester County in the name of the king. These Loyalists, however, believed their duty also included reliance on rebel booty, especially cattle, for compensation. They inspired other less regular bands to rob rebels and claim that they did so to serve King George. Taking advantage of the fog of war, these brigands soon ransacked farms just south of the Highlands. Joshua Hett Smith, the Stony Point Tory who aided Benedict Arnold's conspiracy but escaped prosecution, described the gangs he encountered in the Ramapos: "Anything portable and marketable with the British in New York City fell within the scope of their acquisitive proclivity, and their booty comprised not only money and silver plate but also saddles and articles of clothing."

Later, jailed in Goshen, Smith escaped and felt compelled by the revolutionary thieves to disguise himself as a poor servant woman to slip out of the Highlands. Driving their largest catch, cattle, to sell in the city, the renegades became known as "Cow-Boys." The Patriots countered with their brand of "border ruffians," called Skinners. A trio of these fellows scouted out as Skinners, determined to stop Cow-Boys and perhaps secure some provisions for themselves, when they uncovered a plot against the Revolution. John Paulding, David Williams and Isaac Van Wart discovered Josh Smith's friend, the "merchant John Anderson," carrying Benedict Arnold's plans to give the American forts at West Point to the British. This Anderson was, in fact, Major John Andre, adjutant general of the British army in North America.

James Fenimore Cooper, in his famed novel *The Spy*, vividly disparages the character of Patriot plunderers: "More than savages; men who under the guise of patriotism prowl through the community with a thirst for plunder that is unsalable and a love of cruelty that mocks the ingenuity of the Indian-

fellows whose mouths are filled with liberty and equality, and whose hearts are overflowing with cupidity and gall—gentlemen they are yclept [called] the Skinners."

Indeed, the Skinners said they sought to stop the Cow-Boys. Often they'd helped themselves first. Pillagers plagued the lands while hidden in the Hudson Highlands from northern New Jersey to Connecticut. Most raids occurred in the "no-man's-lands" of southern Orange County and "neutral-grounds" of upper Westchester. Buttermilk Hill, for example, in Rockefeller State Park, Pleasantville, gained its name when raiders from both sides stashed stolen cows there before driving them thirty miles south to the city. Washington Irving, in his story "Wolfert's Roost," confirmed treachery on both sides: "Neither of them in the heat and hurry of a foray had time to ascertain the politics of a horse or cow; nor when they wrung the neck of a rooster, did they trouble their heads whether he crowed for Congress or for King George."

Timothy Dwight, a Continental army chaplain, lamented for the inhabitants of Westchester, "These unhappy people were, therefore, exposed to the depredations of both Cow-Boy and Skinner. Often they were actually plundered, and always were liable to this calamity. They feared everybody whom they saw; and loved nobody."

Plainly, both sides were just out to take advantage of the war-torn times. The Hudson Highlands, a naturally desolate range, provided hideouts spanning from Mahopac's Watermelon Hill to the "Almost Perpendicular" in Tuxedo. Thus, Joshua Hett Smith recounted, "No one slept safely in his bed. Many families hid themselves at night in barns, wheat-ricks, corn-cribs, and stacks of hay; and on each returning day, blessed their good fortune that their houses had escaped the flames."

Cow-Boy Claudius

The Ramapo Mountains, just east of Sloatsburg, hid the most notorious rogue of the Revolution, Claudius Smith. His terrors most likely included harassment, robbery, thievery and murder, earning him the title of Scourge of the Highlands. "Claudius Smith! You shall die like a trooper's horse! With your shoes on!" His own mother offered this prophecy.

"Nay Ma! I shall prove ya wrong!" declared Claudius.

Smith possessed a "manly beauty." His "Wanted" poster claimed he stood an astounding seven feet tall. When the Revolution hit the Hudson, Smith

took advantage of the war. Using his persuasive mix of charm and brow beating, he and his sons formed three Cow-Boy gangs. Smith benefited from the assertions made by fervent Tories, who defended the bullying Cow-Boys as a kind of Loyalist Robin Hood.

For example, the British captured a Colonel McClaughry during the Battle of the Highlands in October 1777. His lovely wife pleaded with the Redcoats, "I'll give you my silver shoe buckles in exchange for my husband!"

They scoffed, "It'll take twice that!"

Desperate, she begged a wealthy miser, Abimal Youngs, for the cash. He claimed, "I've no cash to spare in these trying times!" When Claudius Smith learned of Youngs's stinginess, he promised to help the poor woman. Instead, he robbed the rich man. "Abimal Youngs, you lie lower en a snake's belly. I'll hang you from your own well-pole till ya tell us where your gold lies!"

Smith's gang strung up tight-lipped Youngs. He coughed and gagged but would rather die than reveal his cash stash. Smith, impressed with Youngs's moxie, contented himself with the fellow's land deeds and household valuables. Mistress McClaughry got nothing from the false Robin Hood. Smith's gangs roamed freely through Orange County. The huge Cow-Boy once bragged to Harvey Bull of the Clove (now Monroe), "I stand like a pillar in Saint Paul's Church. I defy any man to move me!"

Patriot Colonel Jesse Woodhull refused to let a friend move against Smith. When the Scourge of the Highlands galloped off on Woodhull's horse, the colonel stopped a houseguest from trying to shoot the escaping Smith. Woodhull knew well the ways of Claudius. "For heaven's sake!" cried Jesse. "Don't dare fire! If you miss, he'll kill me!"

A relative of Jesse's in Oxford, however, tricked Smith's rogues out of some treasure. When the thieves began breaking down her door, she hid the silverware under her baby in the cradle.

One night Smith snarled, "Come me lads, let's get that darned rebel Nathaniel Strong!" The Cow-Boys surrounded Strong's house in Oxford but found the man, armed cap-a-pie, ready for a fight. Firing with musket and pistol, the Patriot fended off the Scourge.

"Jump up and bite! See what you'll hang on ta!" hollered Strong. "Ya bloody Tory thieves!"

"So!" Smith answered. "You want to fight me man to man. Alright! No guns." Strong heard a gun drop. He went to open his door. When the feisty Patriot reached for the latch, the treacherous Tory blasted a rifle shot right through the wood. The bullet pierced Strong's heart. When Governor George Clinton learned of the murder, he offered £1,200 sterling reward for

Claudius Smith, "Scourge of the Ramapos," plus £600 for his sons James and Richard.

On All Hallows' Eve 1777, the outlaw Cow-Boy fled to Smithtown, Long Island. A pair of staunch Patriots named Titus and Brush gleaned from a tavern-keeper that the drunken Smith slept upstairs. They surprised the ossified fugitive, tied him up and hauled him to trial in Goshen.

On a crisp January morning in 1778, Smith appeared on the gallows clad in white linen with silver buttons. Some accounts state that the condemned man jeered at the gathering crowd, declaring he'd lived twice as much as all of them. There stepped through the throng the previously aggrieved Abimal Youngs. The miser called, "Claudius Smith! Tell me before you die, where did you hide my deeds?"

"Mr. Youngs, this is no time to talk about papers. We'll meet in the next world. I'll tell you all about them there." He pointed down. Smith determined to prove his mother wrong. He kicked off his boots and cackled until the noose completed the tightening task.

The skull of the Scourge of the Highlands now sulks in the stonework of Goshen's former town hall. It's worth a trip there to listen for its occasional howls.

WASHINGTON'S
WATCH CHAIN

*The Cityvation of the forts and Cross running of the tides, with the Bafling winds
generally here, and with the assistance of what Cannon already mounted, we can
defend the Chain much better here than at fort Montgomerie;…By placing Number
of men on the hills at West Point with Musquetry, we can annoy the Ships in Such
manner no man will be able to Stand her decks. I hope you'l excuse the Scrol.*
—Jacobus van Zandt, blacksmith, militia officer

Ranking American Patriot leaders in 1776 ignored the advice of the blacksmith who understood the annoying tide for a chain set from Anthony's Nose to Fort Montgomery. Had the first chain been stretched at West Point as Van Zandt advised, it would have slowed the British attack on the Highlands while preventing the burning of Kingston. The fall of Forts Clinton and Montgomery left General Putnam wondering what to do. This man, who when he got word of the fray at Lexington-Concord abandoned his plow midfield to gallop to Boston, now took to commanding his men to roll boulders off from Anthony's Nose. George Washington, however, urged on by the Clinton brothers, had a plan. They wasted no time refortifying at West Point. The commander in chief ordered General Israel Putnam to "exert every Nerve, and employ your whole Force in the Future, while and wherever practicable, in constructing and forwarding proper Works and Means of Defence."

Soon after the first chain snapped, suggestions on how to build a better one arose. George Clinton urged that more "iron chains should be procured… and with the Boom, which is nearly completed, stretched across the river…

the West Point should be the place fixed upon." Add cannons and protective redoubts in the surrounding hills and the Americans would have themselves, as Brockholst Livingston said, "fortifications here impregnable—and impassable." Washington and Clinton again enlisted the plucky Thomas Machin to set the chain. The diligent Thaddeus Kosciuszko would engineer twenty-seven defensive redoubts. Now, securing the iron and men who could work it was the order of those trying times. A former schoolmaster turned quartermaster doubly named Hughes Hughes stepped up to help Machin. First, he lectured the governor and New York State legislature on the necessity of raising £5,000 necessary for the "Business and for the Security of the River." The government agreed, forming a state commission to oversee the effort.

Hughes knew where to go to produce the mighty links. Noble, Townsend & Company's Sterling Mine operation in Chester, New York, offered the best iron and mongers. Hughes and Machin trudged through the snow to meet with the mine boss, Peter Townsend. He explained that "Long Mine" ore at 70 percent pure goes from "picks to pig" iron without needing to be cleaned. The Patriots' massive plan, however, called for an order no mine in North America had ever attempted. Obstructing the Hudson at West Point required sixty-five tons of two-inch-thick iron forged into 700- and 5,115-pound links held together with eighty clevises and eight swivels. Floated on large wooden booms from Gees Point across the deepest part of the Hudson (World's End), it would be wenched to Constitution Island by a large capstan. The Great Chain needed to endure relentless river tides while fending off British warships. Plus it needed the flexibility to permit hauling in before the winter's destructive ice.

Costs looked prohibitive to a broke Continental Congress. Hughes and Machin budgeted with Townsend a £19,000 chain, or four times what Bernard Romans demanded, for his Constitution Island citadel. Finding and keeping skilled labor proved daunting. Chain carpenters got about $1 per day. The blacksmiths earned $1.50. The rest of the country would not see wages like this until long after the Revolution. Hughes convinced Governor Clinton to give sixty "masters" an exemption from serving in the state militia. They took from the muster lists teamsters charged with the grueling task of hauling chain from the Sterling Mine through Ramapos to Brewster's forge in New Windsor. There the chain got linked and delivered on barges to Machin at West Point.

On April 30, 1778, a company of strong river-savvy men under the command of Captain Machin gathered below Kosciuszko's Garden near

today's Trophy Point with rope, pulleys, small anchors, rowboats and ingenuity. They attached one end of the 1,700-foot device to a large crib of stones on Love Rock. Wary of the tides, Marchin had logs set to float the chain sharpened and tarred. They transported, stretched and secured the formidable obstruction across the mighty Hudson. It held.

Late November, they pulled in the chain before winter. The following July, a handful of soldiers got struck by lightning while trying to cross the chain like a bridge. A man died and several were injured. They were the chain's only casualties. When spies reported to the British on the structure's strength, they described it as no "Yankee pumpkin vine." The Royal Navy never even attempted to divide the rebelling colonies along the Hudson. In 1780, when Benedict Arnold plotted to give Fort West Point to the redcoats, he knew first to have the chain weakened under the guise of a repair. His trick failed. The new nation stayed together thanks to Washington's unbreachable "Watch Chain."

GREAT CHAIN REDUX

Imagine the surprise of nineteenth-century America's leading army surplus merchants upon discovering "Washington's Watch Chain" right next door. Francis Bannerman, the man who made a fortune buying American Civil War and War of 1898 weapons and reselling them to various tinhorn despots, learned that his Brooklyn Navy Yard neighbor Mr. Westminster Abbey had eighty-six links of the famed Great Chain. Bannerman soon published a prospectus on the "Revolutionary relic." Apparently, a fundraising fair during the American Civil War had brought the artifact from West Point to Brooklyn.

Soon, collectors clamored for a piece of history. Abram Hewitt, a founder of the Cooper-Hewitt Design Museum, took twenty-six links to adorn his mansion in Ringwood, New Jersey. The great-grandson of the original manufacturer, Robert Townsend, bought several rings and distributed them to relatives in Danbury; Alleghany, Pennsylvania; and Buffalo, New York. Another Townsend gifted six links to the Coast Guard Academy. Four went to the Glen Island Casino in Pelham and were later sold for $500 to a Brit who outbid the New-York Historical Society. Those with lighter budgets benefited from Bannerman's paperweights selling for $2.75.

Abram Hewitt served as mayor of New York, but he made his money investing with Peter Cooper in an iron mill. He traveled from Ringwood to

West Point, perhaps taking the same route the teamsters used to haul the Great Chain nearby from the Sterling Mine. There at Trophy Point, he got to examine the USMA's links. The former ironmonger found Bannerman's chain differed from the remaining real links at West Point. The arms merchant offered a chain for fools. Nevertheless, he continued to sell his facsimile links.

THADDEUS KOSCIUSZKO, POLISH PATRIOT

On the extreme edge of the summit, overlooking the river, stands a marble shaft, pointing like a bright finger to Glory, the tomb of the soldier and patriot Kosciuszko.
—Nathaniel P. Willis

In 1777, Lieutenant Colonel Louis de la Radiere was filled with anger whenever he discussed plans, supplies and his rank in the Hudson Highlands. The dearth of experienced military engineers in the Continental army landed this skilled Frenchman the coveted position of chief engineer at West Point. The redoubts there needed refortifying after American loss of the Battle of the Hudson Highlands. His written designs proved effective, but his designs on improving his status lead General Putnam to denounce De la Radiere as a "paper engineer." Captain Edward Boynton complained that he could not work with this "impatient petulant officer." West Point's commander, General Samuel Parson, in March 1778 informed Washington that the French officer, finding it impossible to complete the fortifications, "has desired to leave to wait on Your Excellency and Congress."

Thaddeus Kosciuszko was filled with devotion when he read the Declaration of Independence. Moved to tears and action, he left his beloved Poland to offer his skills as an engineer and gentlemanly character to the United States of America. His works strengthening waterways south of Philadelphia earned him a colonelcy. His ingenious ramparts at Stillwater, New York, helped win the Battle of Saratoga. He won friendships too. General Horatio Gates, his commander, recommended Washington assign the Polish Patriot to rebuild the Highlands forts. "Granny" Gates was heartbroken to see Kosciuszko go. Soon after starting work at West Point, Parson praised Thaddeus, as he was "disposed to do everything he can in a most agreeable manner." When a communications error found both De la

Radiere and Kosciuszko posted together at West Point, Washington ordered De la Radiere back to Philadelphia since Kosciuszko was "better adopted to the genius and temper of the people."

Kosciuszko picked up where De la Radiere and Romans failed. Concentrating on an engineering stronghold on Crown Hill, he created an ingenious series of thirty-seven forts, redoubts and ramparts in an interlocking defense system. One bulwark protected the other. A severe shortage of men and supplies made Kosciuszko's accomplishment all the more impressive. Kosciuszko indeed showed remarkable character. Combined with Captain Thomas Machin's "Great Chain," this engineering feat created a "Gibraltar on the Hudson," now the site of the United States Military Academy. He worked tirelessly, treated his men with respect, shared his rations with British prisoners of war and rarely raised his voice. Enchanted by the beauty of the Highlands, he cultivated a garden of wildflowers and vegetables overlooking "Washington's Watch Chain." Today, cadets pondering a complex engineering problem will seek solace at Trophy Point wandering into the Polish Patriot's garden. Some sense Kosciuszko's ingenious spirit whispering the answer into their ears.

"Kosciuszko Building His Garden at West Point," by Anthony Battillo, 1971. *Anthony J. Bajdek, American Association of the Friends of Kosciuszko at West Point.*

After the United States finally achieved independence, Kosciuszko brought the principles of liberty and democracy to his native land. Leading the nation's fight for freedom from Russia and helping to craft a declaration of rights for Poles, he led his nation's quest for full statehood. When severely wounded in battle, the cause failed without his leadership. Kosciuszko returned briefly to America, urging his friend Thomas Jefferson to free his slaves and end slavery.

A monument to Kosciuszko at Trophy Point stands not far from Kosciuszko's Garden. It acknowledges the Polish hero's patriotism, a virtue cadets hope to embody. A fellow colonel, Robert Troup, noted of Thaddeus Kosciuszko, "When I cease to love this young man, I must cease to love those Qualities which form the brightest and completest characters."

ENOCH CROSBY, SPY

James Fenimore Cooper, much like his contemporary, Washington Irving, sought arcane tales of the American Revolution as fought in the Hudson Valley. One gleaned from his neighbor John Jay in Rye, New York, inspired a novel, *The Spy*. It recounts the exploits of Harvey Birch, a peddler who risked his life uncovering "Tory Nests," gatherings of Americans loyal to Great Britain ready to fight for His Majesty. Cooper denied ever hearing the name Enoch Crosby, yet this shoemaker's story fits.

A dour, lanky cobbler from Danbury, Enoch Crosby found himself restless in August 1776. One year earlier, service in the Connecticut Militia had taken him to New York City, the sieges of Fort Ticonderoga and Fort St. John near Montreal. He endured a dreadful winter and the death of his commander, General Richard Montgomery. Now he ambled into Fredericksburg (now Carmel), New York, looking to sign on for more action, but this time fighting for the renowned Colonel Jacobus Swartout in the First Regiment, Dutchess County. An old codger leaning on a fence told the re-enlister, "Swartout marched his men down toward Kingsbridge." Enoch Crosby headed south into the no-man's-land of Westchester County. A few miles north of Pines Bridge in current Yorktown, a friendly lad accosted him. "Halloo! Going down to enlist?" "Yep," he replied. "I know the best unit!—a good captain, fine food, and uniforms to make the ladies fancy you. Come along with me!" Crosby stood thinking. The garrulous man wondered, "Aren't you afraid to venture alone?" "Why?" he asked. "Why,

Westchester is full of rebels! My name is Bunker." The Patriot cobbler decided it best to go along with the Loyalist.

Somewhere in the neutral-grounds of central Westchester, the Loyalist brought Crosby to the Tory nest. H.L Barnum, author of *The Spy Unmasked*, described it as a hollowed-out haystack with a secret door. There, Crosby found a band of men and a few officers. Crosby signed the Loyalist list as "Isaac Smith" but insisting on pushing on to get to the action farther south. Crosby made his way to Joseph Youngs, a known Patriot leader living near today's Valhalla. Youngs planned to have Crosby return to the nest, give a signal and get apprehended with the Tories. Next, the Patriots would march their prisoners to the Fishkill Supply Depot. There, Crosby got word of his deed to John Jay, head of the "secrets" committee based at the Van Wyck House. He'd escape his "jail," said to be a hatter's shop next to the Dutch Church in Fishkill, by offering a guard to mend his shoe. All went according to plan save for the last step. By some accounts, Crosby picked the wrong guard, who shot at the cobbler fleeing to the Van Wyck House. In his pension testimony years later, Crosby stated that he was bailed out.

Crosby did not escape serving his country as a spy. John Jay pressed him into service, telling him, "We need you more than Swartout." The dour shoemaker had to agree. He rooted out nests as far away as Vermont. He made his most intriguing discovery, however, here in the Highlands. Jay's committee gave Crosby a pass and a tip about getting work with a Tory named Russells across the river in Marlboro. There the spy learned of a Loyalist company forming under a Captain Robinson near Cornwall in the Highlands. They'd meet at a haystack, a barn or a cave in Boter-Berg (Storm King Mountain). Crosby stayed for a week with Robinson and some of his men. One evening, the clever cobbler convinced the company, weakened by Robinson's wine, to disperse and then reconvene days later back at Russells's. Once out of the Loyalist lair, Crosby got word to Melancton Smith, a Patriot militia leader from Poughkeepsie. Smith came at the appointed time and captured Robinson's company. Some accounts stated that the British commander muttered, "There was a needle in our haystack" and then gave Crosby a glower.

Later, Crosby's espionage led to two beatings. Both Loyalists and Patriots thought the man had betrayed them when Enoch was simply following John Jay's orders. They administered punishments to Enoch, leaving him for dead. As an old man, Enoch Crosby, living on a farm in Carmel, New York, received a much-deserved full military pension. While he was attending

a theatrical performance of Cooper's *The Spy*, someone pointed out the seventy-seven-year-old veteran. "There's the real Harvey Birch!" Enoch Crosby rose to a standing ovation.

THE FORT'S OUR OWN

Tho' I have twelve thousand men with me, I can't cover all the Colonies. The Hudson is the key of the Continent.
—*General George Washington*

General Sir Henry Clinton set out to break General George Washington's lock on the Hudson. He dispatched up the river on May 28, 1779, 625 fierce Regulars commanded by Lieutenant Colonel Henry Johnston, along with seasoned American Loyalists. They landed near Stony Point, a promontory on the Hudson just north of Haverstraw Bay. A contingent of 40 Americans holding down a small fort burned their blockhouse and fled into the Ramapos. Right across the river at Verplanck, the British took Fort Lafayette.

Johnston sent his men to work fortifying. They built stone ramparts and redoubts. Felling trees, they sharpened and lashed them into an abatis facing west to serve as a pointed deterrence. The tidal swamps above and below the rise secured the fortress. Sir Henry boasted about his new "little Gibraltar." The Brits took Washington's key right from his waistcoat pocket.

The Continental commander in chief wanted to defend West Point. Brigadier General Anthony Wayne was outraged. He demanded Washington let him take back Stony Point with a new light infantry brigade. Recalling a harsh lesson he took from General "No-Flint" Grey, "Mad Anthony" proffered a daring three-pronged attack. They'd night-march south through the Ramapos. Near Stony Point, the thousand-man force became a triple threat. Lieutenant Colonel François-Louis Teissèdre de Fleury commanded one flank and Colonel Richard Butler another. With Major Hardy Murfree's cavalry charging from the center, they would take Stony Point by surprise. For the plan to work, the men had to be sure that three hundred Pennsylvanians under General Peter Muhlenberg were held in reserve. Spearheading the attack would be two "Forlorn Hopes." These twenty-man units under Lieutenants George Knox and James Gibbons were not expected to survive. Finally, Wayne put forth a page borrowed from "No-Flint" at the Battle of Paoli: "If any Soldier presumes to take his Musket from his sholder or

Stony Point Battlefield, Stony Point, photographer unknown, circa 1930. *From www. thehighlandstudio.com.*

Attempt yo fire or begin the Battle until ordered by his proper Officer, he shall be instantly put to Death." Mad Anthony got tougher: "But shou'd there be any soldier so lost to every feeling of Honor, as to attempt to Retreat one single foot or Skulk in the face of danger, the Officer next to him is immediately to put him to Death."

Washington added, "Secrecy is so much more essential....A knowledge of your intention, ten minutes previously obtained, will blast your hopes."

Late afternoon on July 15, 1779, Wayne's stealth march began from West Point down "the Doodletown route" to retrieve the key to the Revolution. Mad Anthony ordered one of his captains to "take and keep all the male inhabitants in the vicinity of enemy lines." Upon reaching a farm owned by Dutchman Sprinsteel (or Springsteen), they halted for further orders. Wayne had his men fix bayonets, repeating the warning of death to anyone found loading their musket, lest a discharge blast hopes. They all got a bit of paper to stick into their hats to distinguish them from their enemy. Finally, Wayne emphasized the importance of the mission, stating Washington's promised reward of $500 and immediate promotion to the first man into the works. The next four get $400, $300, $200 and $100. They marched on in silence, too intent on the goal to even take note of a stray dog.

Reaching the bottom of the 150-foot mount, the Americans divided accordingly to take the stronghold on top. Wayne gave the watchword

of "The fort's our own" to cry upon breaching the works. Murfree's men permitted to fire and "amused" the enemy. Focused ahead, the British sentries roused Johnstone's forces. Knox and Gibbons, followed by De Fleury and Major John Stewart, slipped into the swamps above and below. Mired chest deep in muck, they met the British abatis works with axes, long poles and rope, quickly carving a path. The British jumped to form ranks. Their Captain Tews valiantly tried to direct his men's fire. The Patriots pouring past them from three sides, however, confused the redcoats. Tews noticed his soldiers taking the wrong aim. He uttered some "hasty language" and fell to friendly fire. The Patriots, meanwhile, bayoneted almost one hundred British soldiers on their way to the top of Stony Point. General Nathaniel Greene later reported the British regulars crying "Mercy, mercy, dear, dear Americans." The first man over cried, "The fort's our own" in a French accent. This helped baffle the outnumbered Brits all the more. Lieutenant Colonel De Fleury tore down the king's flag and later shared his $500 with the men in his unit.

The Americans swarmed the fort, but a great hue rang out when it was feared their general had suffered a mortal head wound. Mad Anthony wasn't sure if the bullet had grazed or pierced his head. He demanded his men get him to the top so he could die among Patriots. When he found himself bloodied but lightly wounded, his men gave a "huzzah." The attack was over in less than twenty minutes.

The Americans turned the Brits' artillery against a possible escape ship in the river. A few Regular officers managed to swim to the war vessel. Still, the Americans captured 546 British, killing 20 and wounding 74. The Americans suffered 15 killed and about 80 wounded; most came from the "Forlorn Hope" units. When the Americans found among their prisoners two sons of Colonel Beverly Robinson, the Tory from the Highlands, officers saved them from Patriot bayonets. While a prisoner of war, Colonel Johnstone begged all to note his uniform, firing not long after the attack. Thus it was no surprise. The British lost a few hundred boxes of valuable supplies and Fort Lafayette the next day. Further, they had to praise the Americans for their ingenuity and bravery, noting in their reports that the enemy carried out the assault with "celerity and silence." Congress issued medals to De Fleury, Wayne and Major Stewart. Finally, General Washington appeared a few days later to personally shake the hand of every American soldier in the Battle of Stony Point.

TREASON OF THE DARKEST DYE

George Washington stood in the doorway of Peggy Arnold's room in shock. He found his favorite fighting general's comely young wife sprawled in bed playing with her baby, her open chemise divulging enchanting graces. The good general's face flushed.

His Excellency arrived at Benedict Arnold's headquarters, the Beverly Robinson House in Garrison, New York, at 10:30 a.m. on September 24, 1780, expecting breakfast with Major General Benedict Arnold, the commander of Fort West Point. Washington's entourage included Generals Henry Knox, the Marquis de Lafayette and aide de camp Lieutenant Colonel Alexander Hamilton. Traveling from Hartford, Connecticut, after consulting with French officials, they spent the night in Fishkill, probably at the Brinckerhoff House. Local tradition insists that they almost caught Benedict Arnold escaping when his conspiracy to give himself and West Point to the British unraveled.

Washington came upon the Church of St. Phillip, which he had, a few years before, saved from a torch-bearing "rebel" mob. Looking west, he spied the North Redoubt, off the current Snake Hill Road. The commander in chief decided that they'd trek up for a spot inspection. A messenger from Lieutenant Colonel John Jameson arrived at Arnold's headquarters before Washington. The courier gave Arnold two notes. When the wounded warrior read them at his breakfast, he made a quip to an aide and begged pardon while he had a word with Peggy.

One note briefed the following: a "John Anderson," found near Tarrytown with papers on West Point's forces, was being transported to Arnold. The papers were being delivered to George Washington. The other note, written a few hours later, presented a change of plans: due to "a party of the enemy" in the area, "Anderson" would be taken to the safer "Lower Salem," today's South Salem. The two notes resulted from a compromise settling an argument between Jameson and Major Benjamin Tallmadge, Washington's intelligence officer. When the latter learned three militiamen acting as Skinners brought "Anderson" to Jameson's quarters in North Castle with West Point plans, he saw a conspiracy more intriguing than Peggy's immodesty. Tallmadge wanted to send a cavalry unit to stop "Anderson" from being sent to Benedict Arnold. He knew the British had succeeded in turning the disgruntled, reprimanded hero of Saratoga. Jameson thought Tallmadge's proposal shocking. They agreed to recall "Anderson" while informing Arnold and Washington.

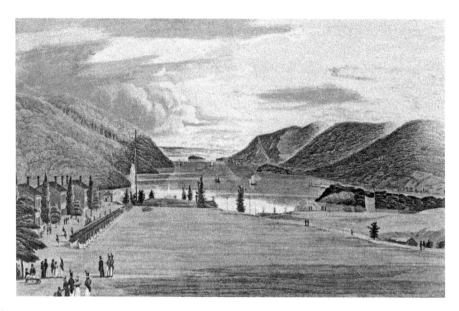

"Cadet Formation," postcard, from an 1828 image. *Mark Forlow Collection.*

Speaking in firm, quiet tones, Benedict explained to Peggy that her friend and his British co-conspirator, "John Anderson" (Major John Andre), had been caught. Peggy once adored John Andre. He felt the same way about her. They became more than friends while he was stationed in Philadelphia, Peggy's hometown. Peggy, however, married Benedict Arnold. When the Continental Congress forced Washington to reprimand Arnold for using government troops to move his furniture, Peggy hatched a plan. She wrote to Andre, suggesting that her husband would fight for the British and give them West Point. Employing her stellar charm and logic in letters scribed with invisible ink, she convinced her old flame to accept the proposal.

When the messenger arrived at Arnold's headquarters with news of the capture of "John Anderson," the conspirator knew he had to avoid Andre's fate. Before escaping down to the British, Arnold scribbled two letters. One exonerated his wife. The other told George Washington he did this because he was a true patriot loyal to the king. Then, hobbled by a battle-wounded leg, he fled on horseback from Robinson's to a little dock just south of today's Garrison train station. Finding a small barge with a handful of men, he ordered them to take him downriver. Near Verplanck, Arnold waved a white cloth of truce to the British warship the *Vulture*. This was the vessel on which Major Andre sailed up the Hudson to meet Benedict Arnold days before. Andre defied orders and met Arnold in the wilds of the Ramapo

Highlands, possibly at Bolderberg or even Donderberg. There, also against orders, he accepted Arnold's plans to give West Point to the redcoats. When Patriot cannons drove off the *Vulture*, Andre accepted an offer by Joshua Hett Smith to be ferried across the river to Verplanck. Andre swapped his scarlet officer's coat for Smith's cape and hat. The two spent the night in Peekskill. Smith abandoned Andre to the no-man's-land of Westchester. Andre got down to Sleepy Hollow just eight miles above British lines. John Paulding, a Patriot Skinner wearing a German Jaeger's coat, caught Andre.

When the messenger with Arnold's plans for West Point caught up with General Washington, he was dressing for dinner at the Beverly Robinson House. Peggy had been roaming and raving, "There's a hot iron on my head! And no one can remove it but General Washington!" Lafayette and Hamilton, moved by the young lady's stunning appearance and pleas, tried to calm her. When pointing out General Washington's arrival, Peggy screamed, "No, that is not General Washington! That is the man who is going to assist Colonel Varick in killing my child!"

Washington knew the reason for Peggy's madness. He was mad as well. Hamilton and Lafayette heard their beloved founding father cry after reading the dispatch: "They have Arnold! Whom now can we trust." Washington composed himself and dispatched Hamilton to try to intercept Arnold. Later, he condemned Arnold for committing "treason of the darkest dye."

Once in American hands, dropping his "merchant Anderson" character, John Andre crafted an eloquent letter to Washington asking for exoneration. The British major insisted that he acted "not out of treacherous purposes." He declared, as a gentlemen, he would never act with "mean character." The disguise was simply a "justifiable attempt to be extricated." He threatened that if treated badly, harm could come to rebel prisoners in New York.

The British saluted Arnold, made him a brigadier general and paid him £6,000. He had the men who rowed him arrested. Washington tried to trade him for Andre, but the British would not give up their prize. Tallmadge made certain that Andre got delivered to Old Tappan, on the New York–New Jersey border, to stand trial. Traveling the lonely roads of Upper Westchester through Mahopac, all who met the handsome captive fell under his melancholic charm. Major John Andre—a polyglot, an artist and playwright—served with distinction, earning the position of adjutant general. Appearing to embody all attributes of an officer and a gentleman, Andre was adored by Hamilton and Lafayette. Washington insisted that Arnold's coconspirator get a fair trial. Wary of Andre's charm, the general avoided being swayed by the courtly gentleman.

A tribunal of fourteen generals found Major John Andre guilty of spying. They sentenced him to death by hanging in Tappan, New York. On October 2, 1780, hundreds gathered to witness the occasion. Andre blanched at the sight of the gallows. He asked to be shot while in uniform. Washington agreed to the regalia, but spies were hanged. Andre noted in the crowd Tallmadge Hamilton and a Lieutenant King. He asked them to come to him. Andre shook their hands and bid them goodbye. Tallmadge wept. The "tragical" Major Andre, as Washington Irving characterized, climbed onto the execution wagon and proclaimed, "Gentlemen, all bear me witness that I meet my fate like a brave man." He produced white silk scarves to blindfold his eyes and bind his arms. The executioner tried to put the rope over his prisoner's head. Andre scolded the man. Taking the noose himself, the condemned officer pulled it over his head, placing the knots snug below the right ear. A soldier on the scene later detailed that "the rope gave him a most tremendous swing back and forth…he remained hanging for twenty to thirty minutes and during that time the chambers of death were never stiller." Later, another eyewitness, Dr. James Thacher, concluded that "the spot was consecrated by the tears of thousands."

Arnold eluded Washington's attempts at capture and went on to serve King George by leading American Loyalists in battle. He almost captured Thomas Jefferson. He took his family to London and Canada after the Revolution. Peggy discharged her husband's debts when he died in 1801. Here in the Hudson Valley, people celebrated the traitor's death with three days of toasting. Well they knew that Peggy's plan for Arnold and Andre came closer than any battle to ending the Americans' rebellion.

FATHER SPECTACULAR

The haze of a steady mist and the formidable "Butter Hill" reassured General George Washington that his men camped safe from the Regular British Army. It was October 27, 1782, when more than seven thousand Continental soldiers and militiamen arrived at New Windsor Cantonment. Falling rains saved the Revolutionary fighters many times during their seven-year rebellion against a distant king. Now, with peace negotiations ongoing across the ocean and Congress wondering how to pay an army, the commander in chief moved them farther from the redcoats' stronghold in

New York City. Rain, mountain and treaty would keep the external enemy away. What of the one growing within?

The encampment sprawled in the northwestern Highlands a few miles upriver from Washington's headquarters at Jonathan Hasbrouck's House in Newburgh. It stood as a marvel of Yankee ingenuity. There gathered thousands of men and camp followers in fifteen regiments from New England to Maryland. Using materials scrounged from the camp's 1,600 acres of land, the men built seven hundred neatly rowed huts for shelter. They constructed, under the guidance of the resourceful former bookseller General Henry Knox, a unique structure for meetings: a long hall with a half-domed ceiling; many referred to it as the Temple. There occurred on March 15, 1783, what historian James Thomas Flexner concluded was "probably the most important single gathering ever held in the United States." Exhausted by the battles, weather, low food supplies and poor conditions, Washington's men desired only their back pay and to go home. Washington needed to boost morale to keep the army of his fledgling nation together. In order to honor the enlisted men in service, Washington established the "Badge of Merit," an embroidered heart-shaped cloth patch awarded for bravery. It is now the Purple Heart, given to those wounded in battle. Three heroic sergeants were the first recipients of the new badge. The award improved the mood of those three men, but the rest of the soldiers required more than medals at New Windsor.

The winter, as usual in those trying times, proved harsh. There was not enough food, clothing or fuel. Some units shared one winter coat among six men. They couldn't even feed the horses, which prevented officers from sending out messengers. Hunger drove soldiers to make "midnight requisitions." One band from the First Massachusetts nipped eleven geese from a Highland farm and roasted them for a fine Christmas repast. The feast earned them each one hundred lashes—their officers were just as unhappy with what pushed the men to the crime as they were with having to mete out the required punishment.

A sympathetic Washington wrote to his friend in Congress Joseph Jones, "The temper of the Army is much soured, and has become more irritable than at any period since the commencement of the War.…Hitherto the Officers have stood between the lower order of the Soldiery and the public and…have quelled very dangerous mutinies.…The spirit of enthusiasm… is now done away."

Alexander Hamilton, however, felt that his former boss failed to show the men "sufficient warmth." Henry Knox drew up a petition signed by most of

the officers demanding Congress pay the soldiers immediately. Some urged Knox to present the petition in Philadelphia with an army of bayonets. Knox declined.

General Horatio "Granny" Gates more than agreed with the rebellious faction. One of his aides, Major John Armstrong, took up the quill to extol all officers to meet at the Temple for a "Gathering Storm." Writing under the nom de plume of "Brutus," he presented cogent arguments showing why the army must march to Philadelphia to govern rather than the weak and contentious Congress. Washington got wind of this and postponed the meeting until the fifteenth. He implied that he would not attend. Brutus wrote a second missive warning, "Suspect the man, who would advise to more moderation and longer forebearance,"

Tradition has it that a disgruntled officer confronted the commander in chief before the Ides of March gathering. He demanded, "Sir do you intend to let Congress send us home with only our wounds and infirmities? Or do you intend to let them take our weapons too!" Washington simply answered, "Sir, I intend to attend your meeting!"

Gates already had the floor when Washington made his surprise entrance. He shocked Granny into silence. Conditioned by military practice, the officers jumped to their feet, rattling swords and knocking over benches. They stood stunned until the commander asked them to be seated. He produced a nine-page statement in his own broad scroll. Washington commended "Brutus" for his reasoning. The anonymous author was persuasive, asking, "Can you then consent to be the only sufferers by this revolution, and, retiring from the field, grow old in poverty, wretchedness and contempt?" Washington accepted the point but called the plan "subversive" and "unmilitary." Eyes flashing with anger, he admonished that this march would "sully the glory" earned on the battlefield. Storming Philadelphia lacked "a regard to justice, and love of country." A "mob" demanding pay, he went on, sounded like what the king's faction wanted us to do to ruin our hard-won independence. Worse, storming the young government would open the "floodgates of civil discontent."

Concluding, he reminded his fellow officers that all eyes are on them in this great experiment with democracy: "You will, by the dignity of your conduct, afford occasion for Posterity to say…had this day been wanting, the World had never seen the last stage of perfection to which human nature is capable of attaining."

Washington wanted to think that he'd won his men over. He hadn't. Some grumbled, "Make Congress pay us!" The general reached into his pocket for

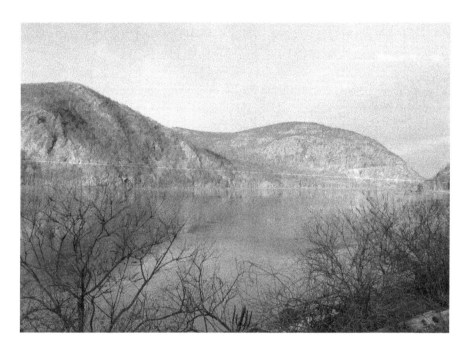

"Morning Moon O'er Cro' Nest," by Daniel Delaney, 2017.

a letter "from Congress" he thought offered hope. Mention of "Congress" sparked more murmuring. Representative Jones's handwriting appeared to the fifty-year-old fighter as a tight scrawl. Washington stared, squinted and stammered. The Temple hushed with embarrassment. Then, their commander in chief made something of a spectacle of himself. Reaching into his vest pocket, he produced a new pair of reading glasses. Hearing gasps, Washington begged, "Gentlemen, you will permit me to put on my spectacles for I have not only grown gray but almost blind in the service of my country."

People in 1783 only wore reading glasses at home with family and dear friends. Washington donned them before a few hundred of his officers. The general who led them from capture at Brooklyn Heights to victory crossing the icy Delaware and on through the bitterness of Valley Forge and into the Hudson Highlands was revealing his age to his men. Like them, he, too, was vulnerable. Washington's simple gesture moved the battle-toughed men. They lost their stoic demeanor. Many openly wept. They saw no reason for a military coup. The spectacles and the fall of tears, Washington's shining hour, saved the new nation. Their general, in that intimate moment, became the father of our country.

WASHINGTON AT WARREN'S TAVERN AND ST. PHILIP'S CHURCH

The sight of George Washington had a surprising effect on a few occasions along the Post Road. Once, while enjoying a fine repast at Warren's Tavern, now the Bird and Bottle, a servant girl clapped her eyes on the commander in chief of the Continental army and kept gawking until she fell up a set of stairs. The general laughed himself to tears at her plight.

When Beverly Robinson, one of the founders of St. Philip's Church in the Highlands, an Episcopal house of worship, refused to swear allegiance to the American cause for independence, a mob gathered. They intended to torch his "Tory" church. Fortuitously, George Washington appeared to admonish the rebel leader, "That, sir, is my church!" He saved the holy structure. Today's 1865 St. Philip's has a stained-glass portrait of the father of our country, protector of the church.

DENIZENS OF THE HIGHLANDS

The Trail wound like a tattered ribbon through the forest and into a dense copse where grouse chuckled and turkeys roosted in the lower branches of the trees. Beyond the copse were hills uncountable, balled up like a hedgehog and bristling with timber, home to heath hen, pigeon, deer, pheasant, moose, and the lynx, catamount and wolf that preyed upon them. And beyond the hills were the violent shadowy mountains—Dunderberg, Suycker Broodt, Klinkersberg that swallow the river and gave rise to the Kaaterskill range.
—"World's End," by T. Coraghessan Boyle

JAN PEEK

[T]he trading post was a great gathering spot for the community. There you might see a half dozen skulking Kitchawanks or Nochpeems (it was strictly verboten to sell rum to the Indians, but they wanted nothing more, and with a nod to necessity and a wink for the law, Jan Pieterse provided it).
—"World's End," by T. Coraghessan Boyle

Longtime denizens of these "hills uncountable" weave quite a yarn about the first white settler of Peekskill. Peter "Silver-Nail" Stuyvesant kicked Jan Peek and his wife, Marie, out of New Amsterdam for dancing and selling booze to the Indians. This alone was a grievous offense, and it only exacerbated the

crime that this exchange took place on a Sunday. 'Twas said the pair were banished from Manhattan. They hid away along what became Annsville Creek washing into the Hudson under Manitou Mountain. Marie turned their lean-to into a trading post near Roa Hook on the Annsville Creek. Jan broke a barter with the Kitchawanks just before the Brits took over in 1664. He disappeared into those "violent shadowy mountains." Novelist T.C. Boyle draws deeply from the lore of the Hudson Highlands. The Peekskill-raised author embraces local tradition by painting the founder of his "Peterskill" as enabling local natives on the path to alcoholism. This results in characters getting cursed in "World's End."

This small city not only nurtured the provocative T.C. Boyle but also an assortment of clever, industrious souls. Peekskill provided sanctuary to abolitionist and probable "free love" practitioner Henry Ward Beecher, brother of *Uncle Tom's Cabin* author Harriet Beecher Stowe. Former New York governor and presidential candidate George Pataki was farm-raised within the city's limits. Actors Paul "Pee-Wee Herman" Reubens, Mel Gibson and Stanley Tucci were born and spent part of their childhood here. Athletes Elton Brand and Tre Johnson grew up in this mix of city and country on the Hudson. Peekskill was home to a Hari Krishna swami and the genius who created the first Internal Revenue Service computer-generated tax form, and the locale inspired L. Frank Baum, author of *The Wonderful Wizard of Oz*.

Truth to tell, the old Dutch records show that Jan Peek and his wife were both convicted for illegal "tapping" on a Sunday after 9:00 p.m. to provide strong drink. Peekskill historian John Curran, however, tells another story. He described Peek as an "enterprising individual" who paid twenty guilders

"Welcome to Peekskill" mural, 2017. *Photo by author.*

to become a vested citizen known as "burgher." He made use of this position when the Dutch West Indies Company "forbid and command that none of our inhabitants shall go inland with his cargoes, but shall carry his trade at the usual trading place." Bilingual, he managed a boat, making trades up and down the river, no doubt getting him familiar with Roa Hook. The court in New Amsterdam convicted Peek of tapping in 1654 but showed our fellow sympathy: "Jan Peek to be allowed to pursue his business as before, inasmuch as he is burdened with a houseful of children and more besides, the Court having considered his complaint and that he is an old Burgher, have granted his prayer on condition that he comport himself properly and without blame and does not violate one or the other of the plackards on pain of having his business stopped without favor and himself punished as he deserves should he be found again in fault."

Jan and Marie, struggling to support eight children, decided to stop the Hudson from swallowing them by making a few more illegal tappings. Again, Curran noted that the record shows the courts were lenient. The judge dropped assault charges against Peek when it became clear that another man made insulting advances on Marie. It took feisty fighters with a bit of bravado and booze to make a home in these Highlands. Jan vanished, perhaps now a wandering spirit. Marie, banished for brewing without a license, moved with the kids to Schenectady.

Madame Brett and the Pirates

When Francis Rombout and his cohort, Gulian Verplanck, led their 1685 expedition of native sachems up today's South Mountain Beacon for a land grab, they looked to prosper. Granted, their success depended on tricking eighty-five thousand acres out of native hands. Those mischievous imps of the Hudson Highlands work in mysterious ways.

Francis's daughter, Catheryna Rombout, enchanted Lieutenant Roger Brett of the Royal Navy soon after he arrived in the New York Colony as an aide to Lord Cornbury in 1702. The Dutch lass of sixteen offered a blend of feisty beauty that Brett found refreshing in the New World. Their marriage the next year increased the rising young officer's prospects if they went north.

Francis Rombout, a Dutchman, could leave his land to his daughter. British law put property women inherited into the control of a male

caretaker. When the British took over New Netherland in 1664, they tolerated Dutch tradition and some laws to make their governance easier. By 1708, twenty-eight thousand acres of land belonged to Catheryna Rombout Brett and her husband.

The couple carved a modest home and a mill along the banks of the Fishkill. They leased farms to a handful of tenants living hard under the north side of the Highlands. They soon had Roger Jr., Robert and Rivery. At times, it felt almost like supernatural forces had their hands in guiding the Brett family. When Catheryna was pregnant with her third child, she accompanied her husband on a sailing voyage up the Hudson River. Perhaps under the influence of the mischievous imps of the Highlands, the waters stilled, leaving the sloop motionless. Suddenly, Catheryna went into labor. She gave birth below deck. Born onboard a sloop, they called their youngest Rivery.

The strange forces at work in the Highlands were not yet done with the Bretts. Several years later, the legendary imps apparently struck again. Brett, piloting his sloop toward the mouth of the Fishkill just below Pollepel Island, left his tiller. He left his post perhaps to help his small crew to untangle a line. Seizing the moment, the imps from Donderberg conjured a gust of wind from Sugarloaf Mount and sent it into the mainsail. The men dropped the ropes, literally lowering the boom onto an unfortunate Roger Brett. It broke his back and he soon died.

Mourners urged Catheryna to move her boys back to the relative safety of New York City. Heartbroken, she did, for a time. But her boys missed the Hudson Highlands. Returning to the family estate, Madame Brett, though desirable not only for her beauty but also her bounty and vast expectations, remained a widow. She went into business with twenty partners, all men. She kept up with her tenant farmers, keeping them healthy by some accounts with aid from the indigenous Wappingers. She helped a promising young sub-chief with the Christian name of Daniel Nimham to learn not only Dutch and English but also the strange ways of white people. European and native inhabitants alike marveled at the elegantly attired Madame Brett as she attended to her manor's business in a fine fleet coach.

A few years after Roger's death, another scourge marauding the river threatened Catheryna and her lads, this time a mortal adversary. One night, Rivery woke his mother, whispering, "There are strangers digging beneath the Big Tree!" Catheryna quietly roused her other sons. Peering through a little window, they spied several furtive figures. The moon revealed their flamboyant attire. Madame Brett grew up in New York City when the lord mayor and former colonial governor dined with pirates, so she recognized the danger at

"The Fishkill Flashing by Beacon," by Daniel Delaney, 2017.

"Fishkill Landing," postcard, circa 1910. The villages of Matteawan and Fishkill merged in 1913, forming the city of Beacon. *Mark Forlow Collection.*

once. She ordered her boys to gather grain bags. "It's got to be a right thar! Keep diggin' ya lubber!" ordered one of the brigands. The others tried to hush him, but the boss would not listen. "Donder and Blixsem! Just dig." Beneath the Big Tree, they shoveled, picking out a copious number of stones, leading to more cursing. They did not notice the shadow looming near.

When a shovel scrape yielded a grating sound, the diggers all gave a huzzah. "Thar at last we found the bounty of our Captain Kidd! Let's haul it to him Mates and share all as sworn we would before they hanged 'im!"

The shadow formed into a gesturing figure. The moon revealed a flash of two eyes, catching the attention of the night excavators. "Mates!" whispered the boss. "Look thar!" They stared as if turned to stone by their new mate. The figure moved, warding them off with a command of the arm. The face glowed like a goblin orb. All in the crew gasped while a terror shook through their bodies. Needing no further message, they dashed toward the Hudson.

Madame Brett called out, "It's safe my boys. You frightened off those pirates. You may take off those sacks and put out the candle. The furtive figure broke into three boys: Rivery on the shoulders of Robert, who sat on sturdy young Roger. The youngest exclaimed, "You were right mother! This candle shined through the holes we made in the grain bags just like glowing eyes. Let's see if one of old Captain Kidd's treasures is still buried beneath the Big Tree!"

"No!" Madame Brett admonished. "We shall leave that ill-gotten gain in the ground. Get all of you back to bed!" Her boys obeyed.

The morning brought a final surprise. They found all the soil and stones back in the ground. An overturned bucket with three rocks and two shovels had been consciously placed to look like a skull with crossed bones. The Bretts stood back. They resolved to make their own fortunes, letting Captain Kidd's remain under the Big Tree. The treasure, after all, is in the tale.

BLASTED TURK'S HEAD

Once while on the Hudson, passengers aboard sloops hailed a stony old face as a harbinger of the end to a rough passage of their journey. Traversing the treacherous winds and current common in the Hudson Highlands required more than a skilled skipper. Native and Dutch folk reported the presence of "manitous" and "imps" haunting the region from Donderberg to Pollepel Island. Mischief-makers, they appeared in swirls of wind and were capable of sinking sailing ships in a few minutes.

"Turk's Head or Anthony's Face."
Wade & Croome's Panorama of
the Hudson River from New York
City to Waterford, by William Wade,
1847. *Courtesy of Antipodean Books.*

The "Worregat" or "Wey-Gat" between Storm King and Breakneck marked the end of the tempestuous Highlands. Nineteenth-century passengers on northbound sailing sloops and steaming ships often welcomed this egress with cheers. They celebrated with a drink. More often, safely slipping out of range of "Dwerg the Heer of Donderberg's imps," they sighed a prayer of relief. "Blessings of thanks to Saint Anthony!" Once upon a time, folk saw the visage of the patron saint of things lost or lost causes in the crags of Breakneck cliff. Others found the anthropomorphic rock featured a fez-topped "Turk's Head." The wonderful 1840s edition of Wallace's folding map for tourists on the Hudson indicates "St. Anthony's Face." This differs from another, Anthony's Nose, farther south on the river. In the following decade, however, the face vanished.

Mining in the Highlands brought men seeking not just iron cooper, nickel, sulfur, silver and gold. The granite gneiss stone made good fill for roads and more. One zealous engineer, Captain Deering Ayres, ignored pleas to spare the great saint's face. Drilling his holes and filing them with powder, Ayres, like many mid-nineteenth-century Americans, put progress ahead of aesthetics. One afternoon in 1846, the saint became a lost cause. Ayres blasted the holy face off Breakneck Ridge. People mourned and raged. Some sources say that the destruction helped launch an early environmental group. Still, saint or Turk was lost, leaving the Highlands bereft of its own old man on the mountain.

The river has mysterious ways of dispensing justice. Years later, while doing the same damage in the name of progress and profit, our captain of industry was working on taking down the legendary Palisades. These gneiss giants lorded over the dinosaurs. Standing with feet in the Hudson and flat heads in the sky, they would mete out Ayres's sentence. Checking on a charge that refused to blast, Ayres ventured out onto the cliffs. When everything checked out, he turned to go back to detonate. Boom! Some river spirit apparently beat him to it. Captain Deering Ayres suffered the same fate then as the old Saint Anthony's face.

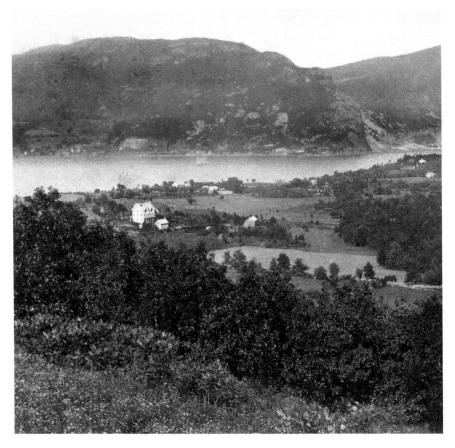

"The Clove, Farms Nestled Storm King & Cro' Nest," circa 1900. *Mark Forlow Collection.*

Decades later, the Palisades Interstate Parks Commission was formed to fully protect all the Palisades. The Harriman family of New York State bought and preserved much of the storied Highlands. Now, the sheer beauty of the Hudson River's hills serves to protect too.

FOUNDRY FATHERS

President James Madison was resolved to have large cannons. He was not merely compensating for his lack of height. The British burned the White House during the War of 1812. They bombarded Baltimore with such vigor

that Francis Scott Key declared, "It seemed as though mother earth had opened and was vomiting shot and shell in a sheet of fire and brimstone." No doubt this moved Madison to think "never again" when he authorized about $40,000 to establish an American cannon industry.

The Hudson Highlands proved an ideal area for the development of this new industry. Iron creaked in these hills. Trees provided charcoal and the river transportation, and West Point could guard the operations. The trouble was finding the right men. A fellow with roots in Putnam County and who studied cannon-making in Spain stepped forward. Gouverneur Kemble worked with General Joseph Swift to raise $100,000 in private funds to create the West Point Foundry at Cold Spring. They gained a government contract to produce "Turning and Chuggling guns." By 1831, the company was proficient enough to cast the first steam engine for a locomotive train. It went on to manufacture the "Experiment," which sped along the track at eighty miles per hour.

Kemble made his best business decision hiring the West Pointer Captain Robert Parker Parrott as superintendent in 1836. This somber engineer put his spin on the artillery industry. He excelled at improving on earlier designs. Following his boss's lead, Parrott studied cannon production in France and Spain. His prolific designs later hurt his reputation, as people accused him of stealing ideas and ignoring patents. Cold Spring historian Mark Forlow found them false: "Parrott consistently innovated."

The Confederates started the American Civil War by firing Parrott's one-hundred-pounders on Fort Sumter. Prior to the conflict, Parrott came up with ways to improve cannon range, accuracy and portability. He "rifled" his guns. Putting grooves inside the barrel of firearms was a longtime practice. Parrott improved on the design with exhaustive tests. He fired thousands of rounds from a platform at the West Point Foundry over the Hudson into Cro' Nest and Storm King Mountains. He literally mastered putting the best spin on the cannon-fired projectiles. His finest innovation took form as a metal band, clasped like a donut around iron cannon barrels. It helped prevent explosions. One eight-ton behemoth, the "Swamp Angel," fired 150-pounders six miles in Charleston, South Carolina. It exploded on the thirty-sixth round.

As the Civil War progressed, demand for Parrott's guns skyrocketed. He supervised the making of three thousand cannons and more than 3 million shells. Kemble, meanwhile, needed to hire hundreds of finely skilled workers to keep production at pace with demand. He discovered great ironworkers in the British Isles. British law then prohibited highly skilled tradesmen like ironworkers and blacksmiths from leaving the country, but Kemble wasn't daunted. Kemble went on hiring sprees, gathering small armies

Gouverneur Kemble (*left*), founder of the West Point Foundry, and Captain Robert Parker Parrott (*right*), superintendent of the West Point Foundry, Cold Spring, New York. *Photos by Wheeler, Mark Forlow Collection.*

of such skilled men from Ireland and England. Looking for better wages, the workers slipped through British customs by giving their trade as "daylaborer." Kemble had steamed off to Cold Spring before officials caught on.

Keeping these men required more than good wages. Kemble found that he had to provide for the spirits of his imported mostly Catholic workforce, too. He had a nineteen-year-old architect, Thomas Kelah Wharton, design Our Lady of Cold Spring, the first Catholic church built north of New York City. Parrott's guns rattled the church walls until they cracked, forcing the superintendent to pay for repairs from his own pocket. Kemble's foundry turned Cold Spring from a few dozen homes in 1818 to an incorporated village in 1846. It grew into a community of perhaps six thousand during the Civil War. Today, about two thousand live in the village.

Still, the Irish Catholics were not fully accepted into the community. A local chapter of the Ku Klux Klan formed largely against those Irish foundry workers and the coming Italian stonemasons. The racist group persisted in the area into the 1940s.

The West Point Foundry needed about 1,400 men working around the clock to produce the Union's cannons during the Civil War. Local legend has it that the row houses on today's Kemble Avenue in Cold Spring rented out

"West Point Foundry, Cold Spring," postcard, late nineteenth century. Note on the far right the cupola of the office building still standing. *Mark Forlow Collection.*

"hot-beds." Two or three workers would "share" the same bed. When the first-shift worker rose to get to the foundry, the returning second-shift worker climbed into an already warmed bed.

When wages failed to keep up with demand, workers formed the Laboring Men's Union and went on strike. Parrott quietly called for 120 soldiers to break his men's action. They soon returned to their dangerous, low-paying jobs. Strike-breaker Parrott, however, treated injured workers and their families charitably, giving them generous cash payouts.

The West Point Foundry once consisted of towering brick blast furnaces, machine shops, water mills, boring drills, rail tracks and a huge office building. A massive, smoky, noisy operation, early Hudson River School painters omitted the eyesore from their rustic landscapes. In his early science fiction novel *From Earth,* Jules Verne alluded to the prowess of the West Point Foundry in Cold Spring by having the novel's manned space capsule made at the "Gold Spring Foundry."

Kemble and Parrott forged on after the Civil War. They made everything in iron, from stoves to state-of-the-art machinery to building façades still seen in New York City. West Point Foundry finally collapsed in 1911. Various businesses took over the site. Pollution from nickel cadmium batteries manufactured there caused deadly cancers in workers and children in the village. Once the Environmental Protection Agency spent more than $40 million cleaning the site in the 1990s. Scenic Hudson has researched and preserved the site for hikers and day-trippers.

Lincoln in the Highlands

Abraham Lincoln entered the Hudson Highlands three times. He brought with him wisdom, wit and woe. En route to his first inauguration on a train from his hometown in Springfield, Illinois, he stopped in Peekskill, offering this kind greeting:

> *I have but a moment to stand before you to listen to and return your kind greeting. I thank you for this reception and for the pleasant manner in which it is tendered to me by our mutual friends. I will say in a single sentence, in regard to the difficulties that lie before me and our beloved country, that if I can only be as generously and unanimously sustained as the demonstrations I have witnessed indicate I shall be, I shall not fail; but without your sustaining hands I am sure that neither I nor any other man can hope to surmount those difficulties. I trust that in the course I shall pursue I shall be sustained, not only by the party that elected me, but by the patriotic people of the whole country.*

The following June, in 1862, Lincoln longed for the touch of those sustaining hands. He slipped away during the Civil War, leaving Washington, D.C., onboard a secret train. Samuel Sloan, a railroad president, made Lincoln's travel arrangements. Lincoln came to Garrison, New York, to inspect West Point's military academy and the nearby foundry in Cold Spring. Awaiting Lincoln, Sloan gathered an esteemed greeting party including Gouverneur Kemble. They played cards to pass the time. When the presidential train arrived in the wee hours of the morning, it startled the welcoming committee. Seeing them dropping cards to hail the chief, Honest Abe chuckled, urging, "Sit down, gentlemen and deal me in."

Across the river at West Point, Winfield "Old Fuss 'n' Feathers" Scott knew why the president had come to the Hudson Highlands. The commander of the Union army, General McClellan, had "the slows." Scott felt that Lincoln wanted him to take command. An imposing six-foot-five and weighing well over 260 pounds, the seventy-six-year-old lieutenant general needed to be hoisted onto his horse to greet the president. They talked about the strategy of Scott's harbor-blocking Anaconda Plan. Lincoln enjoyed the flirtation roused by his presence among the young officer's wives.

Next, Gouverneur Kemble took a turn at amusing the president. They boated over to the foundry for a rousing demonstration of arms. Kemble fired cannons over the river, increasing the size with each round. As Kemble

readied to shoot the two-hundred-pounder, Lincoln interrupted him. He thanked him for the sure shooting but hastened, "Mr. Kemble, I am certain that two-hundred pounder will hit its mark, but this less than two hundred pounder here wants lunch!" On their way back to West Point, Lincoln spied the railroad tunnel bored through Breakneck Ridge. He dubbed it "Sloan's Rat-Hole." Doubtless he shared his jokes with the ladies back at West Point, concluding his respite in the Highlands.

Lincoln's final visit came ghastly and ghostly. Following his assassination, a funeral train adorned with black bunting steamed through the Highlands. People came out in droves to tearfully salute the fallen hero. Now, when hearing but not seeing a train reverberating through the Highlands, some feel that its Lincoln's ghost giving us a reminder from those terrible times.

The Hermit of Fishkill Mountain

A body found floating in the Hudson always tells a tale. One discovered near Peekskill in March 1897 remains mysterious. The icy hands of the Hudson not only drowned the man but also distorted his face. The coroner relied on papers discovered in pockets to identify the corpse as that of Ashael Bell.

Once described as "well known" in the communities of Peekskill, Cold Spring, Mattewan and Fishkill, Bell hadn't been seen all winter. His whereabouts were often mysterious. A miserly hoarder and a wandering hermit, he appeared on odd occasions. When collecting rents on Highland properties he managed to acquire and when purchasing supplies at general stores, the wiry, hirsute fellow entered public view. Shunning the sociability of towns, he preferred his shack on Fishkill Ridge or rock shelters in Garrison and other desolate local lairs.

When the Civil War struck, a middle-aged Ashael Bell fought as a private for the Union army. He suffered battle wounds in Virginia, making him eligible for a decent pension in 1890. He didn't need the money. When Bell's brother, Morris, tried to settle their father's will in 1872, Ashael would have nothing to do with it. They gave up on him—determining "the whereabouts of Asel [*sic*] Bell is unknown and cannot after diligent inquiry be ascertained." One report noted that authorities in the mid-1880s declared the itinerant Bell incompetent. Another account stated that he'd been declared incompetent to "manage his properties" in the autumn before his demise.

The coroner counted $107.26 on his person at the time of death. His estate yielded for his heirs $16,000 cash and almost as much in property. He owned, at one time, more than $50,000 in real estate. His relatives determined that the hermit had withdrawn $30,000 (about $650,000 in 2018 money) from three banks months before he was last seen. Ashael Bell could have lived rather like a prince in a mansion, yet he chose to live like a pauper in caves. This rose from a matter of love.

Ethel Matthews Anastasi, a grandniece of the ascetic pilgrim, reported that Ashael Bell fell deeply in love with a haughty young woman from Cold Spring. Ashael proposed. She accepted. Then there appeared in Cold Spring a devilish New York City land baron. He wiled his way into the young lady's heart, charming her with his urbane manner and great wealth. She fell for him, leaving Bell heartbroken. Bell was determined to have revenge through success and self-humiliation. He resolved to earn more than the man from Manhattan. Further, he vowed to never love another. This would show her she'd made the mistake of a lifetime. Bell's parsimonious plan included acquiring rugged, run-down Hudson Highland farms and refusing to live in a comfortable, costly house. Thus, Ashael Bell of Bell Hollow, Putnam Valley, succeeded. He became a wealthy misanthrope and a misogynist miser.

The domed hills above Garrison's Landing offered Bell a series of caves in which to nurse his bitterness. One of his lonely lairs lies within the bounds of the Garrison School Forest. He likely built a shack on Fishkill Ridge, above the dairy farms, sheep pastures and village. Given the unaccounted-for thousands his relatives sought at Bell's death, it is probable that the miser's treasure remains hidden in a Manitou Highland crevice. He left behind something more precious than gold while wandering these melancholy hills: his broken heart.

MONEY HOLES

Around the turn of the nineteenth century, a fine fellow appeared in Philipstown with pockets filled with money. Milled Spanish dollars poured out onto countertops in taverns and stores. People in Putnam Valley recalled seeing the man, Henry Holmes, poking around the caves and crevices near Cold Spring, Carmel Turnpike and Dennytown. When folk found that his coins lacked the same *clink* as other pieces of silver and gold, Holmes was arrested. Tried in 1804, he pleaded not guilty. The accused coin creator argued that

no one could find a counterfeiting operation to pin on him. Nevertheless, the jury found Holmes guilty without deliberating. Sentenced to Newgate Prison for a life of hard labor, the forger never really went away. The curious and the avaricious felt certain that a Holmes hideaway existed bursting with treasure. They turned attention to a stony hill with iron mines called the "Money Hole." The ore there yielded enough to create a mining hamlet named Dennytown. Broken remnants of the counterfeit ring were discovered in the mid-1800s. Renowned local historian Patricia Edwards Clyne pointed out the hideaway, but actually locating the cave remains elusive.

Not long after the turn of the twenty-first century, a spelunker from Highland, Jim Janos, and his daughter, Cassidy, tracked down the entrance to the lost Money Hole cave. Look for a marker near the trail at Indian Brook Road and Dennytown. Today, all the treasure lies in the quest.

One of the more fantastic stories involved a young man, E.M. Hopkins, who while picnicking with his girlfriend in 1887 decided to do some exploring in the recently closed Sunk Mine. He discovered a secret room that contained piles of silver plate jewelry and decorative items, as well as a trapdoor leading to the cabin of a hermit named Marshall, thus solving the mystery of a fifty-year robbery spree in Garrison, Cold Spring and Putnam Valley.

WILLIAM THOMPSON HOWELL

Ho! Tom Bombadil, Tom Bombadillo!
By water, wood and hill, by the reed and willow,
By fire, sun and moon, harken now and hear us!
Come, Tom Bombadil, for our need is near us!
—The Lord of the Rings, *J.R.R. Tolkien*

Merry Tom Bombadil, Tolkien's protective, peripatetic spirit with a magical voice, could have been modeled after William Thompson Howell. Born in Newburgh in 1873 and educated at Cornell University, Howell worked for the New York Telephone Company but wrote passionately for the *New York Tribune* and the *Sun* of these Hudson Highlands. He kept a lively diary of his many hiking adventures, published as *The Hudson Highlands William Thompson Howell Memorial* in 1933. The book guides readers into the heights and hollows of the "endless rolling hills."

"William Thompson Howell," self-taken photo, circa 1910. Atop the Cro' Nest boulder. *Hudson River Valley Heritage & Palisades Interstate Park Commission.*

Howell pioneered trekking the Ramapos and Manitous. He coaxed various companions to hike, canoe and camp the Highlands with promises of stunning vistas and hidden treasures. He traversed trails set under moccasins, Revolutionary cannons, miner's wagons and cow hooves. "W.T.H." wandered and wrote about this mysterious landscape, opening the path for the tens of thousands who now meet up from the city to trek the hallowed hills.

Tom Bombadil wandered in boots of yellow and a jacket bright and blue. Howell was no less natty. Garbed in worsted wool, starched collar, bowtie, hob-nailed boots and a pipe, our Thom took on the wild hills with elfin-like aplomb, grace and gumption. Rising before dawn to jump on the West Point ferry, W.T.H. was determined to greet the sun slanting over the Highland peaks. Invariably, he carried the proper libation to toast the first light and last light to touch his beloved hills. Often, he'd stash a bottle of Chianti or whiskey on one expedition only to recover it on the next. Frodo-like, he'd enlist other noble wayfarers for scrambles

up Storm King or picnics with the "fall fairies" at Cedar Pond. W.T.H. transformed seemingly simple hikes into enchanting adventures. Here's how he launched his description of a 1906 hike above the city currently known as Beacon: "The hobgoblins that rule Hell Hollow, in the Fishkill Mountains, apparently exercise some sinister influence."

Howell and a companion climbed the rough road through the Melzingah Ravine, now near the homestead of the late folksinger Pete Seeger. Our Bombadil declared that the lands appeared to be under the influence of "the Heer of the Hollow"—clearly a reference to the famed author Washington Irving, who detailed the imps haunting the region under the command of the "Heer," the Dutch word for master. One mischief-maker upset a coffee cup. Another imp tricked a friend of Howell's into sitting on a sharp stick. W.T.H. created a picture in his journal of a landscape suited for orcs and trolls. "Collect a few thousand cobles and Belgian blocks, throw them together pell-mell and magnify them greatly, and you will have the conditions which exist at the bottom of Hell Hollow."

Howell's hikes honeycombed the Highlands. Occasionally he'd encounter a rather elfin or leprechaun-like inhabitant in the hills. The forbidding Highlands long kept settlers sparse. The handful or so of seventeenth-century homesteaders were Dutch, French and German. During the next few hundred years, those willing to brave the steep inclines, dense woods and "two rocks for every one dirt" terrain often hailed from Scotland and Ireland. Until the First World War, the accent heard in the Hudson Highlands brewed expressions from Appalachia, with a touch of Holland Brooklynese and a Scotch-Irish brogue. Howell revealed the sound in conversations collected from the likes of Phil "King of the Highlands" Hagar and "Uncle" Bill Sirine. Our Thom found the secret of honey gathering in the Highlands from Mr. Hagar.

The Secret of Trees of Bees

Hagar found near his homestead above West Point several "Bee Trees." He discovered them by taking a piece of honeycomb from a previous expedition and setting it between warm stones. When bees lit upon it, he captured one in a cup with a drop of honey. There the insect's anger quickly softened as the bee took to the sweet substance. Hagar then let it go. The creature naturally made a beeline back home. The Highlander followed to mark his new Bee Tree. Returning at night, when the bees are sluggish and

"Uncle Bill (Wildcat) Sirine," by William Thompson Howell, circa 1910. *Hudson River Valley Heritage & Palisades Interstate Park Commission.*

moving slowly but working quickly, a deft Highland honey man could lift about fifteen or twenty sweet pounds without getting stung.

One night, old Phil agreed to barter with another Highlander named Jim Drew. They'd work together and split the amber proceeds. An impatient Drew decided to chuck local wisdom by building a fire on a stone to smoke off the bees. He explained that he'd lop branches off the Bee Tree to climb his way to the prize. Hagar slapped his head. "Man alive, you're crazy! It's a tarnation hot night, can't ye see the bees all roostin' outside?"

Drew would not be deterred. He struck his fire and hacked his way up the Bee Tree. Phil then shared with our Thom, "He didn't git more'n halfway up when they begun to cum at' im. He begun to yell and cuss an' finally, he fell off the ladder backward."

Drew tried a few more times but gave up, declaring, "Gol darn it, but they've got hot feet!" Phil wound up having to cut down the tree and wait for the bewildered bees to scatter. The two took almost two hundred pounds of honey. Drew took about two hundred stings.

Uncle Bill Sirine also collected in these Highlands. A certain tonic long appreciated by the Chinese inspired Sirine to seek out wild ginseng. He'd pack it up in sealed wooden crates to throw off potential thieves and then ship them down to Chinatown merchants in the city. He once earned more than $300 (1911 dollars) in a season and refused to divulge the location of the healing herb. Only a few botanists have found ginseng in the Highlands today.

BARON HASENCLEVER

Thom Howell described another kind of treasure seeker in the Highlands. Peter Hasenclever, a German émigré in 1764, bought up thousands of acres with borrowed money. His plots ranged from Ringwood, New Jersey, into the Ramapoughs through Orange County, New York. Acting like an old Dutch patroon who needed fifty families to agree to farm for him, Hasenclever brought along about five hundred settlers. They cleared land, raised barns, built cabins, set stone walls and made pastures still found in traces today. This was not enough for the ambitious Hasenclever. He sought the solid riches of the Highlands. Robert Juet, Henry Hudson's journalist, noted in 1609, "The Mountaynes look as if some Metall or Minerall were in them." This touched off speculation for gold, silver, copper and iron in these hills. The latter proved most abundant, providing metal for many things, including the great Revolutionary chains. Hasenclever dug about fifty mines throughout the Hudson Highlands, including one near Howell's beloved Cedar Ponds, present-day Lake Tiorati. Many mines produced, especially the one on Hasenclever Mountain. Alas, "Baron" Hasenclever, as his lordly lifestyle let him be known, eventually went bankrupt. He abandoned his mine pits to collect water and left the tailings as souvenirs for today's hikers.

Howell offered the likes of poor Hasenclever poetic advice on what is best obtained from the woods of the Highlands. He recalled nightfall at Cedar Ponds Camp:

> *Looking out of the open front tent on a fairy-land of autumn-colored forests, flooded with moonlight. The quiet seemed supreme. The voices of insects stilled by a frosty touch in the air, and the wind had quite died so not a branch moved. But everywhere thousands of leaves forsook the trees and quietly unceasingly drifted down…the chief charm…the sound of the leaves as they collided…some strange music and indescribably sweet.*

Our Tolkienesque Thom carried on to describe many such wonders awaiting those willing to trek and at times travail through the Highlands. He pointed out many hidden gems to discover today. One frightful enclave is "Spy Rock." Below it, torn into the southern peak of Old Cro' Nest, is presumably where Enoch Crosby, on a scouting mission for John Jay, broke up a Tory nest during the American Revolution. W.T.H. labelled it "The Grotto." A craggy lair, it is best viewed from the Cold Spring dock.

"Vacant Iron Vein," by William Thompson Howell, circa 1910. The Bradley Mine in Harriman State Park, mined by Robert Parrott for Civil War cannon-making. *Hudson River Valley Heritage & Palisades Interstate Park Commission.*

William Thompson Howell pioneered hiking, picnicking, canoeing and camping in the Highlands. His jaunts with friends on horseback and motor cars, with female friends he called "fairies," are legendary for the fine dining, story swapping, songs and celebratory drinks. Today's determined Appalachian trekkers and day-tripping city folk on meetups appreciating

Anthony's Nose, Bear Mountain, Breakneck, Storm King need to tip their hats and toast to the "Tom Bombadil of the Hudson Highlands," William Thompson Howell.

> *These are the things I prize*
> *And hold of deepest worth:*
> *Light of the sapphire skies,*
> *Peace of the silent hills,*
> *Shelter of forest, comfort of the grass,*
> *Shadow of the clouds that quickly pass,*
>
> *Music of the birds, murmur of little rills,*
> *And after showers*
> *The smell of flowers*
> *And of the good brown earth*
> *And best all along the way*
> *Friendship and mirth.*

> —*William Thompson Howell*

BABE RUTH SIGNS

Many mansions flaunting ancient styles peer from these stately hills. The king's hall of the Highlands is Osborn Castle. Complete with towers and turrets, it lords over the Hudson. A few miles north stands Eagle's Rest. The manor, built by Colonel Jacob Ruppert, now serves as a Greek Orthodox school. This roost holds a home run of a tale.

Ruppert, after a stint in the state militia and Congress, made his fortune in the family business, selling Ruppert Beer. He bought a baseball team in 1915, turning the mediocre New York Highlanders into the perennial champion Yankees. Ruppert's success came when he acquired George Herman "Babe" Ruth from the cursed Boston Red Sox. "Root," as the colonel called him, turned from pitcher to home run king. Right at the height of the Great Depression, when 20 percent of Americans were unemployed, Ruppert and Ruth signed a contract in Eagle's Rest. The press screeched loud enough to frighten the stone birds still guarding the mansion. How could Ruth accept a salary on par with the president of the United States when so many in the country were suffering? Ruth became indignant. "What the hell has Hoover got to do with this?" he asked. Then

the service of a written notice prior to Feb-
constitute a renewal of this contract for one
conditions of paragraph 7 hereof.

...... day of March A. D. 1922.

...... American League Base Ball Club of New York
(Club)

By Jacob Ruppert President

George Herman Ruth
(Player)

"Babe Ruth Contract with the Yankees," by Daniel Delaney, 2017. Jacob Rupert at Eagle's Rest, Garrison, signed the Sultan of Swat for $52,000 per season in 1922. *The Karpeles Manuscript Library Museum.*

the Bambino grinned. "Anyway, I had a better year than the President!" Most fans, no matter how poor, agreed and forgave the Sultan of Swing, who signed his big contact here in the Hudson Highlands.

Surprise Lake Camp

For us there was a joy in the discovery of new worlds and the camp at Surprise Lake was something never to be forgotten. We slept in tents and ate in a pavilion and had to do chores and at night we sat around a campfire, singing songs. And perhaps we were a little afraid of the darkness and quiet and the hoot of the owl…we saw our first snake and caught our first catfish.
—*George Sololsky, first-year camper, Surprise Lake Camp*

Dense, craggy and wild, the Hudson Highlands spark revolutions but also give solace. New York City in the early 1900s quickly filled its new boroughs

of Brooklyn and the Bronx with recent immigrants. Where did they go to escape heat, haste and sickness? Why, the Hudson Highland havens of Iona Island, Bear Mountain, West Point, Newburgh and even Cold Spring.

Another gem glistens a few miles north and a few miles east of the village named for a natural spring. Lake Surprise, the source of Breakneck brook, once provided water for Hudson River steamboats. Concerned for poor Jewish boys crowded into city tenements, a group of Jewish philanthropists founded the Jewish Educational Alliance to get them into some fresh air. A search in 1902 to find a camp in the country led to the lake. Twenty-five boys and five counselors trekked three miles from the former Storm King near today's Breakneck train station into the woods. They pitched tents, cooked outdoors and hiked the nearby "Three Bs": Mounts Beacon, Breakneck and Bull Hill. They caught snakes and crayfish and spied the mysterious great blue heron, which presides over the lake. The boys returned home revitalized and eager for another summer in the country.

The Alliance found hundreds of boys needing to benefit from the healthy Highlands. It raised $2,125 (about $55,000 in 2018 dollars) and bought a rough, tumbling farm from one of the Jaycox families to create a permanent Surprise Lake Camp. One happy camper was Izzy Itkowitz. Regaling all with campfire songs and stories, he donned a tin cap and earned the nickname "Happy" after a popular comic strip character. "Happy Itkowitz" came back as a counselor summer after summer.

The camp offered Jewish boys a taste of the "good medicine" native peoples once found in the Highlands. Surprise Lake grew when kids seeking an escape from New York found these storied mounts challenged them with their beauty. The boys learned to brave the wildness and embrace the bunkhouses. They brought something of their experience back to the city. Parents reported their kids wanting to keep their rooms "camp tidy." Some Surprise Lakers returned to their homes speaking more politely, even refining their "Nuwe Yawk" accents.

When "goils" arrived as campers in 1960, Harry Vogel, already a perennial at camp since 1952, described how they once kept the boys from the girls. A log painted with stripes set the dividing line. Counselors would say goodnight by blowing kisses. Cross the log line and you got fired!

This camp invited the blacklisted Pete Seeger from right over Mount Beacon to entertain campers in the 1960s, including a young Neil Diamond. Surprise Lake also nurtured actor Walter Matthau, author Joseph Heller and rocker Gene Simmons and inspired "Happy" Itkowitz to enter an illustrious career in entertainment as Eddie Cantor.

The Highlands shaped a contentious teen arriving as a camper in the 1970s. These "endless hills" alter the course of the Hudson, therefore taking this brilliant young man away from his prescribed path to the law. One summer, as Mr. Vogel told it, the budding attorney resolved to "figure it out" by hiking the "Three Bs" in one day, barefoot. When he accomplished his quest, Jordan Dale soon decided to be like the guiding great blue heron. He renounced a profitable legal career to enrich the lives of children by serving as director of Surprise Lake Camp for more than thirty years.

SUPERNATURAL
ON THE HUDSON

ANTHONY'S NOSE

Every hill in the Highlands holds a story. Save for old Storm King's, none measures up to Anthony's Nose and the story of how it got its name. Ancient sources cite one Estaban Gomes, a Portuguese adventurer exploring the coast of North America in the 1520s. One day, he happened into the Mahicanituck. He declared the river the "San Antonio," making him the first to put Anthony on the Hudson. Another explanation of the odd mountain moniker rises from the days of the sloops. A member of one crew aboard a vessel rounding the promontory in the late 1600s snuffed, "Looks like our skipper Anthony's Nose, only his is bigger!" Washington Irving, however, drawing from local lore, related the namesake tale in more colorful detail.

Peter Stuyvesant, the new director general of the New Netherland colony, arrived all peg-legged and cantankerous in old New Amsterdam in 1647. He cursed over much of what he found. Scolding his colonists, he insisted he'd treat them like "unruly children." They referred to their stubborn governor as "Sliver-Nail," "Peter the Headstrong" and the "Czar of Muscovy." A group of respectable Dutch burghers arranged a tour for Stuyvesant in an attempt to soften his hard opinion of the New Netherland colony. They selected as a guide the congenial "Antony the Trumpeter."

Antony van Corlear appears in Dutch colonial records. The responsibility of sounding the alarm on a horn was necessary in colonial times. The task

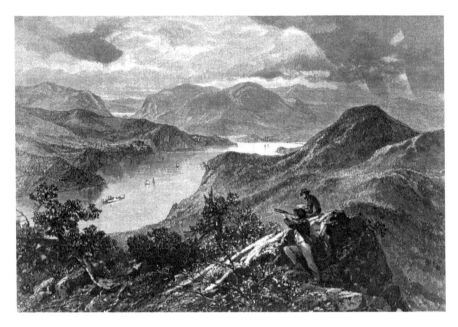

"Tipped on Anthony's Nose," by James D. Smillie, 1878. *From www.thehighlandstudio.com.*

would likely fall to a noticeable soul. Irving characterized Van Corlear distinctly: "The nose of Antony the Trumpeter was of a very lusty size, strutting boldly from his countenance like a mountain of Golconda; being sumptuously bedecked with rubies and other precious stones—which Bacchus grants to all those who bouse it heartily at the flagon."

Antony nosed his way to Stuyvesant, showing him the good in the colony. The tobacco of Harlem, wheat in Westchester, fur-bearing animals in the Great Swamp of New Jersey—all failed to impress the headstrong director general. Entering the mysterious Highlands, ruled by imps and a witch, spelled change. The trumpeter, drying his face in the morning sun one day, took a stray ray of light on the nose. Reflecting the beam down hissing hot, it fried a monstrous sturgeon, knocking it onto the deck of the sloop. Many Dutch shunned eating sturgeon, taking heed of a warning from the Indians that it would poison anyone not native to these lands. Others just thought it greasy. When presented with a fish cooked by the trumpeter's redolent proboscis, the Dutch on board that sloop devoured the delicacy. Peter Stuyvesant finally found something he liked in the New Netherlands: the fish. He honored the moment and the man, declaring the mount Antony's Nose.

"Elk Aerie Over Bear Mountain Bridge," by Daniel Delaney, 2017. Presented to the Palisades Park Commission by Victor H. Berman in 1935.

Today, on the east side of the Bear Mountain Bridge, the grand hill draws Appalachian trail hikers and autumn leaf peepers. Observe Anthony's Nose from the great metal deer head presented by Victor Herman in 1935 to the Palisades Park Commission, and it becomes plain as the nose on your face: the mountain merits its name.

High Torn Salamander

Once upon a time, long before the journeys of Henry Hudson, a biblical-era wanderer called Amasis arrived in the Hudson Highlands. Amasis claimed to have been part of the entourage of the magi that traveled to Bethlehem to honor the Christ child before his wanderings took him to this land. He married a native woman, but her people attacked him when he refused to worship the sun. The earth quaked and an ice dam broke, forming the river we call the Hudson. It also opened up the earth at High Torn Mountain, revealing metal treasures but also releasing spells.

When European settlers came to the region, a German blacksmith known as Hugo set up a forge on High Tor (also spelled "Torn") on the spot where the ancient Amasis opened the earth. The smith grew rather cocky while serving the village of Haverstraw, named for the kind of wheat they grew. Traditionally, smiths let their forge fires go out once every seven years to rest and cleanse the hearth. Hugo, wanting to keep earning money, refused. Soon his customers noticed two things when they came to his shop. First, Hugo's wife had grown ill and wan. Second, Hugo's forge appeared glowing with a fiery salamander. Its tongue and tail flashed in the flames. Transfixed, the blacksmith noticed words inscribed on the creature's back. He refused to utter them. The fire monster struck Hugo with a burning from within his belly. His wife rose from her sickbed to sprinkle Hugo with water. The blacksmith recovered, but his family was cursed by the salamander. His forge fire and wife were both dead. Seven years later, one of his children vanished in front of a church. Hugo, too, disappeared into the Highlands.

Years later, a flame-haired gentleman came to court the remaining daughter of Hugo. Mary, a delicate young woman, swooned into the fellow's arms when he saved her from a catamount. She told him she loved him. He returned the favor of her affection by confiding to her that he was here to redeem himself from darkness. When she wept for him, he turned her tears into lilies.

He explained to her that he came from among those beings that left heaven for loving humanity. "Born of the flame, I served as an earth spirit. When your father refused to quell his forge, I took shape as a fire-salamander. When your mother sprinkled water on the forge, I escaped. I became a human child and grew, wandering in search of a pure soul. My journey gave me the gift of helping many I met along my way. Now, at last, I have found you here in these endless hills above the river flowing both ways. Your love will set me free."

Eventually, Mary's father, Hugo, found out about this dark young man. He returned to his forge with a mob and rekindled his blacksmith fires. He then raged, "Oh red-haired devil, you have ruined me. I won't let you steal me daughter." The burly blacksmith grabbed the noble fellow. Hugo began shoving the young man toward the flames. The captive did not resist. Mary shrieked when her father threw her beloved into the furnace. The folk accompanying Hugo murmured with surprise at the serenity of the soul tossed into fire. Some claimed that they saw the salamander. Mary alone looked up to see a silvery figure ascending to a cloud above High Torn. Her countenance was one of peace.

"The Culprit Fae"

A river of light on the welkin blue.
The moon looks down on old Cronest,
She mellows the shades on his shaggy breast,
And seems his huge gray form to throw
In a sliver cone on the wave below;
—

To the elfin court must haste away:—
And now they stand expectant there,
To hear the doom of the Culprit Fay.

—Joseph Rodman Drake

Joseph Rodman Drake, a nineteenth-century physician and poet, was mocked and doomed. He contributed to Washington Irving's ad hoc writer's collective the Knickerbocker Group. Anecdotal sources state that he contrived an elfin fantasy set on the Hudson after British writers scoffed at the river's dearth of lore. Challenged, Drake composed a 640-couplet fantasy on a lovelorn elf called "The Culprit Fae."

Edgar Allan Poe dismissed the sing-song poem as "sublimely ridiculous" and rife with "puerilities." The "Tomahawk Man" cut at the idea of faeries dwelling near the United States Military Academy at West Point. Of course, Poe attended that venerable institute, escaping the somber old fort by falling under the spell of spirits found at Benny Haven's Tavern. Drake died of consumption at twenty-five. His fae's love lives on.

"The Culprit Fae" opens with convocation of the elfin denizens at Cro' Nest:

A scene of sorrow awaits them now
For an Ouphe has broken his vestal vow;
He has loved an earthly maid,
And left for her his woodland shade.

The monarch of the faerie folk of the Hudson Highlands must sit among his kind to judge and sentence the "Ouphe," who loves a human. The king kindly perceives a reason for the crime. He finds the mortal lass "gentle and meek, and chaste and kind, Such as a spirit well might love."

The Elf-King executes an extenuating sentence: the culprit's wings are clipped, and his "flame-wood lamp is quenched." Denuded and demure, the

He put his acorn helmet on;

"The Culprit Fae," illustration by Arthur Lumey, from the poem by Joseph Rodman Drake, first published in 1835. *Carleton Pub., New York City, 1867.*

fae asks the sovereign for a way to win back his wings. The omniscient ruler acquiesces, assigning the Culprit two tasks. He must collect the "spray-bead gems" of the sturgeon, the largest fish in the river. Then the little lover must rekindle his lamp with the light of a shooting star.

Flightless, he must protect himself. He girds up with varied insect hides, bee coats and beetle skins. He makes a wasp-sting sword and sets out on this quest. Paddling in an oyster shell, the Culprit Fae crosses the mighty Hudson. Turning his sting into a paddle or rapier as needed, he fends off crabs, leeches and water sprites.

The grand sturgeon emerges from the moving waters, leaping to devour the elf morsel. The Culprit vaults away with his sword, managing to capture droplets of a splashing spray. He tucks them like gems under his acorn cap—the first part of the quest complete.

The sprite's lament for love earns sympathy from the Sylphid Queen. She helps him relight his lantern when a comet bows down to the sparkling river. Quests complete, the Culprit returns to make his presentation to the faerie king.

The faeries colorfully reconvene. The ethereal monarch ceremoniously restores our lover's wings. A magical celebration sprinkles the Old Cro' Nest with will-o-the-wisp lights. Their dance illumines the mount, but the moment dawn appears, "the Fays are gone." The faeries fled the sun, but

"Train to Manitou," by Daniel Delaney, 2017.

Joseph Rodman Drake first invited them to inhabit the Highlands in writing. Now folk continue to report flickering sprite lights today.

Finally, visitors to the Putnam County Museum in Cold Spring will find a fine collection of West Point Foundry artifacts and a huge Thomas Weir painting of the ironworks. There also stands a diminutive marble statute. An Adonis-like figure, with two peculiar stubs on his back, it is the memorialized Culprit Fae.

KELPIE ROCK

> *These in ancient days, before the Hudson poured its waters from the lakes, formed one vast prison, within whose rocky bosom the omnipotent Manetho confined the rebellious spirits who repined at his control.—At length the conquering Hudson, in its career toward the ocean, burst open their prison-house, rolling its tide triumphantly through the stupendous ruins.*
> —*Washington Irving,* Diedrich Knickerbocker's A Historie of New-York

Hudson Highland hikers occasionally glimpse a woman poised on one of the large rocks dotting the river's shores. Usually it's a resting paddle boarder in a

playful yogic pose. A closer inspection may reveal to the sensitive another entity. A feminine spirit seems to preside over these storied mounts. Joseph Ingraham wrote of her in 1839 as a "kelpie." This Scottish water faerie may have followed early immigrants from Albion to the New World.

Once upon a time, before the railroad obliterated the spring at Cold Spring, there stood a gargantuan boulder in the river at the toes of Bull Hill. George Pope Morris purchased Undercliff from John C. Hamilton, a mansion the founding father's son had yet to finish building. It is likely that the romantic writer and songsmith Morris fell into a rapture spying something on "Kelpie Rock." Thus, he had to leave New York City and live in these Highlands. This grand boulder (which geologists would call a "glacial erratic") dominated the cove below Little Stony Point until the inexorable railroad obliterated it in 1849. Ingraham drew inspiration from his friend Joseph Rodman Drake's poem "The Culprit Fae" and from Morris in crafting the following origin story for the great stone. He also corroborated the tradition of the return of Henry Hudson to the region.

A wayfarer in these Highlands, long before the days of trail maps, let alone global positioning satellites, cried out for guidance, begging for help in returning to the great stone he saw in the water far below the wild Bull Hill crag, where he stood lost. The imps here must answer. Creaking out from behind a gnarled Highland cedar, there appeared a "singular" fellow. Clad in voluminous breeches, a teal jerkin, lace-ruff and a broad-brimmed hat and sporting buckled boots adorned with roses, this soul looked improbably ancient. His skin had wrinkles in all the creases, but he spoke in a firm voice: "You are lost, and want to know of the Kelpie Rock!" The stunned wayfayer nodded. The singular fellow explained:

> *When I first sailed up this river looking for a passage to Cathay, my daughter caught the eye and stole the heart of an antediluvian elf here known as Erlin. Understand, the giant's dam broke turning a great lake into the mighty Mahicanituck. It released stony-faced ogres, shaggy with fern-like hair. Their queen, the old lake's Kelpie, a beauteous ageless goddess, came forth too.*
>
> *Truth to tell you, having a woman on board a sea going vessel in my time, was inauspicious! Why, my mate and journalist Robert Juet, tried to keep away our bad luck by referring to my daughter in his writings as though she were my son!*

Cedar Bewitching on Sugar Loaf Mountain, near Beacon. Photo by Joe Dieboll, 2000. *From www.thehighlandstudio.com.*

When Erlin saw her he loved her. His queen, who hides now in Kosciuszko's Garden, grew enraged. Others she presided over did too, but for a different reason. The stone-faced ogre felt the presence of mortals who "crossed the salty waters" in these hills would bring doom to all. He was right! The fluid-formed Queen ordered her fern-furry giant to destroy my ship, but Erlin interceded. He sat on our main mast, making the vessel too heavy for the ogre to lift. The ogre tried to tear up a tree to dash us into the river. Again, Erlin sat, casting his weighty spell. Finally, the rocky giant tore from the face of Cro' Nest Mountain, a monstrous boulder hurling it at us. Erlin leaped on to the flying rock, causing it to plummet to the river's edge at the hooves of Bull Hill. The Kelpie Queen called off her brute knowing Erlin would soon face faerie justice when later he fell in love with a future sloop skipper's daughter.

Erlin's love for a mortal seems to have generated a capturing spell, now holding the larger faerie kind within these Highlands. On, my wayfarer, you'll hear them thunder with protest during storms. No need now to fear them.

The wanderer asked his singular storyteller for directions back down Bull Hill to Undercliff, the home of George Pope Morris. The wizened one pointed a bony finger to a trail hard by the twisted cedar. Our wayfarer gave thanks and asked, "Whom shall I tell Morris gave me help?" The ancient one replied, "Henry Hudson!" To help quell the surprise, he elucidated: "In these Highlands when someone sincerely asks help, we spirits oblige. Why,

"On the Twentieth Century," postcard, circa 1900. *Mark Forlow Collection.*

we've been whispering to artists, poets, painters, singers, philosophers and the sensitive since my first sail here in 1609. You'll sense us in the wind and rain and rock and cloud." The spirit of Henry Hudson moved off and then turned to offer some parting advice: "Listen for my crew engaged in nine-pins every twenty years. Never drink our beer. You'll suffer the same fate as Rip Van Winkle." Our wayfarer, perhaps Mr. Ingraham, got this tale to Morris and Drake at Undercliff.

Explanations of the whereabouts of the Kelpie Rock dismissively blame the railroad or landfill. The best tale of the great rock's fate comes from a twentieth-century songsmith who once wrote a song of longing. The Kelpie heard him lift these words in his fine reedy voice:

> *Sailing down my golden river,*
> *Sun and water all my own,*
> *Yet I was never alone.*
>
> *Sun and water, old life givers,*
> *I'll have them where e'er I roam,*
> *And I was not far from home.*

Enchanted and an old life giver herself, she returned the singer with this favor. She saw him working with his wife to construct a homestead on the mountain where the Beacon fires once burned. Time and again, he drive his truck down to Little Stony Point to gather building rocks. The golden river queen lifted her huge lounging boulder from the edge of the water by Bull Hill. She dashed the great stone to pieces in one place. The bearded singer and his diligent wife found the pieces easy to transport for the foundation of their cottage, still nestled away in these Highlands.

BREAKNECK BULL

Dutch, English and German settlers avoided the harsh, hard Hudson Highlands. Peekskill, just south, and New Paltz were established in the mid-seventeenth century. A few French trapper families took hold at today's Denning's Point and Constitution Island. The MacGregories roosted at Sloop Hill in 1685 above Moodna Creek near Cornwall. The first European to really stake a claim in the midst of the Highlands did not arrive until

1727. Thomas Davenport, with permission from the landlord Philipses, put up a cabin near today's Methodist church in Cold Spring. Then he and his wife proceeded to have a dozen children.

The land yielded the proverbial one dirt for every two rocks. Thus, raising cows and sheep had to have been his main means for sustenance. Davenport needed a bull. He managed to find in the market a huge ornery thing, perfectly matching the rough disposition of the Highlands then. They created a pen for the great creature. It sired cows and pulled a plow. One day, it broke away and escaped up to a place where the sky bumped its belly on the high hills here.

Davenport roused his kids. Clanking pots and banging pans, they ascended, planning to drive the wayward creature back to its lot. The bold bull left its cloudy rest only to flee to another high crag. Davenport no doubt

"Breakneck Bull," by Joe Dieboll, 2012. A bovine matter in the mountains. *From www. thehighlandstudio.com.*

boasted to his children, "Our bull's on Saint Anthony's Head! We got him now." Until 1849, Mother Nature's handiwork left what folks described as the face of a bald bearded man, referred to either as the old Turk's Head or Saint Anthony's Face. Many actually prayed to the patron of lost causes when sailing or steaming through the Highlands. Tradition has it that people cheered for Saint Anthony when reaching the face marking the last leg of the treacherous journey through those imp-infested waters.

The bull had another plan. Letting loose a gargantuan snort, the brazen bull, desperate to be free, made a stupendous leap off the saint's stony head. Sounding hundreds of feet down, with a prolonged and echoing retort, it freed itself from its potential captors.

Scrambling onto the head, the Davenports looked down in awe. Their bull had broken its neck and lay dead in the water. They respectfully named the craggy mount "Breakneck Ridge" and the cloud rest "Bull Hill." Nathaniel Parker Wills tried to get the name "Mount Taurus" to stick. The only thing really lingering there of note is the bull's grandiloquent snort. The hundreds of hikers scrambling up Breakneck today see the flags, the view of New York City, the twisted pines and the scruffy oaks. If they listen, especially early mornings, the bull's snort will rise up to the cloud rest.

The Imps of Donderberg

[A] *little bulbous-bottomed Dutch goblin, in trunk hose and sugar-loafed hat, with a speaking trumpet in his hand, which they say keeps about the Dunderberg. They declare they have heard him, in stormy weather, in the midst of the turmoil, giving orders in Low Dutch for the piping up of a fresh gust of wind, or the rattling off of another thunder-clap. That sometimes he has been seen surrounded by a crew of little imps in broad breeches and short doublets; tumbling head-over-heels in the rack and mist, and playing a thousand gambols in the air; or buzzing like a swarm of flies about Antony's Nose; and that, at such times, the hurry-scurry of the storm was always greatest.*
—*"The Storm Ship," by Geoffrey Crayon, nom de plume for Washington Irving, 1822*

Every hill in these highlands holds a story, but none has the thunder and wonder of the imps. Granted, Washington Irving appears to be the prime

source for tales of these creatures. They appear in his stories "The Storm Ship" and "Dolph Heyligers' Adventure" and are also found in *Diedrich Knickerbocker's Historie of Olde New-York* and his masterpiece, "The Legend of Sleepy Hollow," both published under the sketchy name of Geoffrey Crayon. He captured for us the superstitions of the time, although they were not written down in other colonial or nineteenth-century collections. By the way, many of these old superstitions have been found to be based in reality. "Those Ancient Dutch mariners prudently shortened their sails," as noted in "Sleepy Hollow," with real reason. Sailing north of the Tappan Zee (a unique namesake on the river, linking two venerable cultures, native and Dutch), sloops entered the Sayre-maker's Reach. The expanse from Croton Point to Haverstraw Bay marks the widest part of the river. Original sources refer to

The Heer of Donder-Berg, leader of the ghostly imps making mischief with sailors in the Hudson Highlands. *From http://www.historytrekkershoppe.com.*

"Kayaks Head for Shelter," by Paul Bonnar, 2012. *From www.bonnarphoto.com.*

this as "sail making," often required after battling the notorious winds there. This marks the southern gateway to our Highlands. The eastern flank is Manitou Mountain, standing just above Annesville Creek north of Peekskill, where Camp Smith serves as home to the New York State Army National Guard. The western flank stands under the shoulder of Donderberg, Dutch for "thunder mountain."

Curiously, tempests rule both the south and north gates of the Highlands. Washington Irving and local folklore describe the former as being inhabited by mischief-making "imps." Musical historians like William Geckle, Pete Seeger and Rich Bala note that eighteenth- and nineteenth-century sloop sailors sang about the "Worregat." Derived from the Dutch word *weergat* meaning "weather hole," it became known as a "wind gate." These ancient mariners also scanned the sky above a mount once called "Boter-Berg" (butter hill), seeking signs of clouds. This prompted renowned writer, magazine editor and river lover Nathaniel Parker Willis to successfully petition the New York State legislature to change the name to the apt and poetic moniker of Storm King.

Imps!

Traveling through the Hudson Highlands during colonial times meant a "bone-jangling" experience. The old Albany Post Road looked more like a

hiker's path. Generally, it took about four days to ride by horse or carriage from New York City to Albany. Dutch-created sloops made the journey on the Hudson in two, wind permitting.

Shipping companies occasionally assigned an oceangoing captain to "skipper" sloops to Albany. These greenhorns often scoffed at the gaudily painted vessels, with the moveable keel board crowned by odd tricorn hat–shaped top sail. With a crew of just four Dutch-speaking sailors, the new skippers occasionally found the mysterious Hudson deadly.

Descendants of the original "Nieuw Nederlanders," they preferred the flamboyant rather than the English fashions. Their skipper did not know that a colorful ship had to be seen "in the offing" when the Hudson's fog crept up.

A band of sky-eyed, New York–born Dutchmen, plus one runaway slave, all wearing wooden shoes and billowy skilts, rolled aboard great wooden kegs of rum. Making like a sea captain on a brigantine, the new skipper barked out long orders: "Grab holds the jib rope! Lower that boom! Stow our cargo! Get those Knickerbockers below!"

The old tiller man spoke up in a Dutch-accented English recognizable today as "Brooklynese." He let his skipper know that his orders had already been carried out. The skipper scoffed. "There's no mystery to this river! A child could sail it, and I shall rule it."

The crew widened their eyes. One whispered, "Our new Skipper is as headstrong as was old Peter Stuyvesant!" "Yea, but he'll tip that feathered hat of his to the Heer of Donder Berg!" declared the tiller man. "Or else de Imp will give him a peg leg!"

The crew hoisted up the leading jib, unfurled the main and raised the lofty skyscraper. Leaning hard on the tiller, they pushed off Manhattan Island. Wind caught the sails, rushing the sloop across the New York Harbor. The skipper shouted out orders, but the Knickerbockers stayed a step ahead of him.

Zigzagging from reach to reach, the skipper counted them out off his chart as they passed. "Great Chip Rock! Palisades! Tappan Zee! Haverstroo! Seyl-maker's….We are making headway!"

When the sloop wended its way by Stony Point, up stepped the tiller man. Pointing to a rippled dome of a mount across from Peekskill, the Dutch river man hollered, "Dondah-Boig! Youse must tip yer hat ta da Heer o' da Dondeh-Boig! He's master of these Highlands."

The skipper cried, "Tiller man! I shall tip my hat to old King George, to ladies fine and fancy, but never will I bow to foolish Dutch superstitions. I've sailed the seven seas! No river imp shall rule me!"

"Donderberg from Peekskill Bay," photographer unknown, circa 1890s. *From www.thehighlandstudio.com.*

The tiller man tried a story to convince his skipper to tip the hat. Long ago, after one of Master Hendrick Hudson's sailors, John Colman, took an arrow through the neck, he became a ghost known as Dwerg. Now, he commands a troop of ghost imps, all ready to sink any ship failing to show respect with a tip of their hat. Lower the skyscraper!

Still the skipper dismissed the tale as nonsense. Hands of mist began swirling up from the river beneath the gnarled old hills. The sloop's crew now feared the ship's coming demise at "World's End" off West Point, where it seemed the river had no bottom.

Now, if you only give the imps a glance, they appear as nothing more than mist or just a curl of fog. A closer inspection, however, reveals petrified

faces peering through the gloom. The Mahicans knew them as manitous, or river spirits. Dutch settlers claimed that they're the souls of those who have drowned in the Hudson. The Connecticut Yankees saw them as the lost crew of a ghost ship appearing on starless nights. Whatever they may be, they spirited up the Hudson Highlands. Mustering, the imps circle their "Heer," Dwerg, the master imp of Donderberg.

Dwerg glowered like an angry lord from atop a boulder at the disrespectful sloop. Wearing a doublet, bulbous breeches and a sugar loaf cap, he blasted out orders through his trumpet in low Dutch. Legions of river spirits tucked head under heel to obey. Whirling their breezy fingers, they caught hold of the winds gusting off the mountains and raced to find their thunder. They blew above Bear Mountain and then pointed west to skitter beyond World's End. Shooting up at Cro' Nest, they dropped down into Mother Kronk's cove. There, under the shadow of Storm King Mountain, the misty imp brigades reported to Mother Kronk.

Covered in sturgeon scales, the ancient witch flashed her eyes toward the arriving sprites. Revealing two fish living in her eye sockets, she grinned and shook her aprons to roll out the thunder. Clouds roared and rolled. Jags of lightning exploded out of the witch's brew pot. She offered to trade her storm for the skipper's bones to add to her brew.

Dwerg's spirits raised up an anvil-headed thundercloud. They shoved it through the Worregat to the Highlands. It cannonaded off the cliffs and crags, hitting the sloop and shivering its timbers. The Knickerbockers instinctively hauled down the sails. The imps got to the topsail before the crew, ripping it from the riggings. Churning their hands, they foamed up white caps on the river. Clouds crashed. The sloop listed toward the starboard side. Each time the skipper gave an order, the Heer countermanded him with thunder. It looked like doom would greet them at "World's End."

Defiant, gripping his tricorn hard on his head, the skipper insisted that they'd weather the storm, bragging he'd been though far worse on the Atlantic. A form appeared to perch on the bowsprit. "Tis Dwerg!" shouted the tiller man. "De Master Imp o' Dondah-Boig!"

Squinting through the rain, the skipper refused to accept a Dutch imp. He claimed that if anything supernatural boarded his ship, it could only be a water demon. The tiller man still urged his skipper to tip the hat. He refused. The skipper, however, remembered an ancient tradition of calling on a saint for help sailing. He ordered all hands on deck to offer a wish and a prayer for help from Saint Nicholas. Now, these were the days before Saint Nick gained famed for bringing toys to girls and boys. Indeed, Dutch New Yorkers

knew of "Sint Heer Klaas." Every December 6, the dour bearded bishop traveled on horseback to put treats and trinkets in children's shoes left out on the stoop. Back then, though, folks mostly called on him for protection when traveling over waterways.

The Yorkers scrambled onto the rainy deck. "Pray to Saint Nick!" shouted the skipper. "Get that demon off my ship!" The raging thunder made believers of all. Obedient and humbled, everyone sang out the wish and the prayer: "*Sint-Nicolaas! Behalve ons schip!*" ("Oh, Saint Nick! Save our ship!")

It may have been a spirit or a ghost, an imp or just a passing storm, but Dwerg was no demon. He would not leave. Enraged, he shot monstrous lightning and thunder at the ship. BA BA BOOM! The blast illuminated and reverberated through the Highlands. Tongues tied with terror. Wishes and prayers turned to gibberish!

Cornwall on Hudson, photographer unknown, circa 1880s. *From www.thehighlandstudio.com.*

The crew and passengers' twisted pleas filled the imps with glee. Sides splitting, Dwerg laughed and chortled all the way back to his Donderberg boulder. There, still chuckling, he figured the sloop had paid the imp toll in gales of laughter. The Heer of the Donderberg trumpeted off the storm. Imps with breezy fingers rolled up the thunder, buried the lighting and let the sun slant down, calming the river. The skipper, wringing rainwater from his frock coat, boasted, "See, I told you we'd weather that storm! Imps do not rule me!"

The insult pricked the retreating Heer's pointy ears. Dwerg squeezed his face, raised his trumpet and blared. The horn sounded down the Donderberg and raced over Peekskill Bay to cross the water race by Garrison's Landing. The master imp caught up with the disrespectful ocean captain. Clipping off his feathered hat, Dwerg spirited it away.

Whisking and whirling, the imp gamboled north for miles with the hat. He spied a church with a fingerling steeple. There he deposited the braggart's tricorn. Washington Irving claimed that the town was in Esopus; other sources say Kingston. A higher look indicates that the cap landed atop none other than the Church of Saint Nicholas in New Hamburg on Hudson.

Bareheaded as the bare bear of Bear Mountain, the hatless skipper slunk down below the decks. The next time that skipper, or any other who knew the Hudson's brine, reached Donderberg, he tipped hat, lowered the topsail and, to be sure, called for help from Sint Heer Klaas to safely pass by Donderberg. Dwerg remains, the Heer and master of those Hudson Highlands.

THE AGENT AND THE IMPS

The folk traditions and legends of the Hudson River tell of imps, manitous or spirits inhabiting the Hudson River Highlands since precolonial times. Reports of these encounters persist into the twenty-first century.

A real estate agent from Cold Spring on Hudson reported an unsettling encounter. Sailing with her husband, confident and comfortable at the helm of their sailboat, they slipped into the Hudson Highlands, near Donderberg Mountain. Later, she described what happened as an "out of body experience":

> *The market was very good in the '90s. We were able to buy a sailboat. We docked it down river, at Haverstraw Bay and always took it south toward*

New York harbor. We'd go out into Verrazano Narrows, even into the ocean. My husband handled anything the wind and tides threw at us. He loves it, and is quite an accomplished sailor.

Well, one day, we decided to go north of Haverstraw Bay for a change. We wanted to sail by our home in Cold Spring. We never got there. We set out fine, maneuvering by Stony Point and the old lighthouse, beautifully. Jones Point and Kidd's Plug had some tricky tacking. I helped with the sails as we glided toward the Bear Mountain Bridge. I heard something about a pirate ship sinking and their ghosts spooking boats today.

We passed by Donderberg, and there everything went wild. We didn't see it at first, but odd patches of fog swirled up from the river. The wind hit us from two different directions. My husband adjusted the sails. He did everything by the book. The boat took off in the wrong direction. He yelled, "I can handle this!" When he tried to bring us back, our boat spun around. We had no control over our sails. We decided to head back down river, just to get out of there.

It was like I could see us, as if from above, doing the right things, but our efforts had no effect on the boat. Sailing by Donderberg was an out of body experience. My husband, usually in control on the boat, just gave up completely flustered.

Following the event, she felt compelled to seek an explanation for something beyond wind, tide and sail. She had discovered the imps of Donderberg.

Oddly, the Highlands' dramatic beauty attracts relatively few boaters today. The realtor's experience may not be unique. One schoolteacher from Ossining, New York, may have encountered what is truly more than the sum of wind, tide and storm on the Highlands: "My motor boat was suddenly surrounded by fog rising as we entered Peekskill Bay. Then a thunderstorm slammed us. The shores of the river just vanish mists. I couldn't tell which direction I was headed. I was stunned finding myself genuinely scared. The whole thing then passed with surprising speed, blowing off my hat!"

BERMUDA TRIANGLE ON THE HUDSON

Apparently, the realtor and teacher were lucky. Christopher Letts—the Tarrytown lighthouse keeper, fisherman and historian—speculated that hundreds of eighteenth- and nineteenth-century sailing sloops sank while

trying to navigate the Hudson Highlands. "Sloops needed to make a profit," he explained. "Undermanned, with a crew of maybe three or four, they were often over-loaded with lumber, hay, wheat, cows and all. This made them unwieldy and sinkable in a storm." There's more at play in the Highlands.

Thunderstorms, hidden by the Highlands, surprise power boaters today, descending on them with unexpected speed. Reverberating off the craggy rocks like cannon shot, the storms envelop. Shocked to find their boat lost in a river squall, people describe supernatural sensations.

THE LEGEND OF POLLY PELL

The Hudson holds many mysteries, but none enchants more than Bannerman's Castle on Pollepel Island. People streaking by on the train or traveling by car on Route 9D, as well as the hiking hordes present every fair week, thrill upon spying this medieval model fortress. Complete with buttressed walls and crumbling crenellations, this magnificent edifice keeps the northern bounds of the Highlands.

Stories from the local Waoranek tribe describe the six-acre "island dividing the river'" as foreboding, fit only for manitous. They may have been trying to frighten off those "people who cross the salty waters" since they probably used the isle to look out for foes. The New Netherlanders, who often related nature to dining, saw a pot ladle shape in the island. They carried small metal ladling cups for stew and beer. Also, sloop skippers established a rite of passage of "ladling" greenhorn seamen or drunken sailors to the island in a basket-like contraption. They'd then have to survive various spirits. This gave rise to the Dutch name for the isle of Pollepel, meaning "pot ladle."

Other sources offer a few more namesake tales. One tediously insists that the place refers to an odd species of cactus or some bit of food. Another comes from a direct descendant of the proud, parsimonious Bannerman who built the castle in the early 1900s. Jane Bannerman's great-grandfather Francis Bannerman took their ceremonially given surname from medieval Scottish ancestors. During a heated clan battle, this forefather rescued the tribe banner from the dreaded MacDonalds, earning the name. The later Bannerman bought up most of the army surplus from the Spanish-American War. He resold his munitions to small nations in need of defense and probably some tinhorn dictators. His scrappily built castle housed the arms along with a strange cement and brick summer roost. When the Great

"Bannerman's Castle," postcard, circa 1900. *Mark Forlow Collection.*

War broke out in 1914, the dealer went idealist. Old Francis, believing this to be the war ending all wars, proclaimed, "The coming world peace will make weapons obsolete. I'll turn Bannerman's Arsenal into a museum dedicated to the memory of war."

An earlier war launched the best story on the origins of Pollepel. During the American Revolution, the Pell family of lower Westchester County escaped the strife at the outbreak. When the British Regular Army chased George Washington's Yankee doodles off Manhattan, both armies marched through Pelham Manor. When the soldiers passed, Master Pell and his wife worried. "Look at all those soldiers!" Their grown daughter, Polly, sighed, "Yes, I can't stop looking at them." Parental fears prevailed. They uprooted and moved to Fishkill, an American stronghold, to be safe from the strife.

But the strife of love followed Polly into the Hudson Highland village of Fishkill. Polly turned up her pretty nose at the thought of the place. She comforted herself by taking long walks in the wild hills above the Fishkill. She'd pass by the lads ready to light the signal fire atop the highest Highland hill if ever the British marched or sailed. Focused on their task, they ignored the lovely lass.

One autumn afternoon, however, her sighing and pretty presence caught the attention of a handsome, humble Dutch dairy farmer. Guert Brinckerhoff spotted Polly. He first thought her a faerie princess and sighed, fearing he'd

never reach her. When scrutiny revealed her to be human, Guert resolved to court, spark and marry the beauteous young lady.

It was long into the winter when Guert finally screwed up the courage to appear on the stoop of the Pells' home in the Highlands. Mrs. Pell's nose curled immediately upon opening the door. "You reek of bovine matter!" she sniffed.

"Mynfrauv, indeed, I am a dairy farmer, Guert Brinckerhoff, here to court, spark and marry your daughter Polly."

Master Pell peered over his wife's shoulder. "My odoriferous young man, you indeed reek of bovine matter, you could have cleaned your boots!"

"Mynheer, I am tend to cows making me thrifty, preserving and sure footed."

"You are too late!" Mrs. Pell declared. "Polly is already being court and spared for marriage by the Reverend Paul Vernon."

"As we speak he has taken her for a sleigh ride over the frozen Hudson."

Stricken forlorn, Guert bowed in thanks, turned on those boots and slipped off to Fishkill Landing, now the bustling city of Beacon. Then his only bit of light shone in the carriage drawn by the horse of a rival.

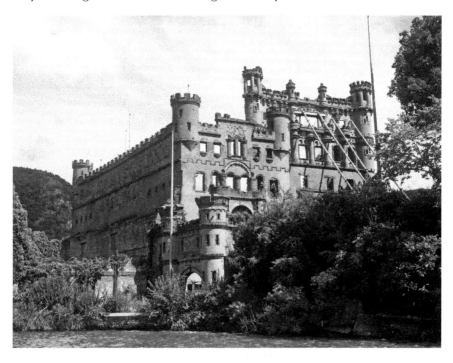

"Bannerman's Castle," by Andrea Sadler, 2016.

The reverend's idea of a hot date was to share his coming Sunday sermon. Thus, Paul sounded all of "blah blah blah blah blah" to bored Polly Pell. She pined privately away to the moon, "Alas, why can't the dullard by my side be that fine fellow over yon." She gazed upon the strapping Guert pacing on the shore.

Now, whenever a scene like this presents itself in the domain of the Highlands, the imps take note. Like Puck, they decide to play a part. Grabbing gusts of wind, the Highland spirits swept over the horse carriage and couple. Dropping down near the Wey-Gat, they broke up the ice. With the reverend preaching and Polly pining, they missed their cue to turn away from icy disaster. Whinnying, the horse plunged in, taking all with it. Sleigh and animal disappeared into the deathly waters. "Donder um Blixsem curses Paul Vernon," Polly prayed.

Guert, keeping his vigil from the shore, saw the two splashing and crying. He dashed onto the ice. Accustomed to stepping without slipping in "bovine matter," he was indeed sure-footed. Quickly he pulled Polly to safe ice.

"My hero!" she swooned. "How about a kiss?"

"Nay, not now I must rescue my rival!" declared Guert.

"Fie!" sighed Polly. "Then, my parents will make me marry him." Nevertheless, the gallant Guert saved Paul. The imps played another part, and cracking ice prevented the trio from making it to shore. Fast-thinking Guert led them to an island too unimportant then to have a real name. There he struck a fire. Knowing that the imps would persist in cracking ice all night, they awaited the dawn.

Frantic with worry, the Pells organized a search but were too far downriver. Quaum, their servant, saw a beacon on the island and held a vigil.

A fire burned bright indeed. 'Twas love, kindled between Guert and Polly. Even the plain Paul Vernon could see what was meant to be. Tears streaming down his cheeks, the reverend pronounced the couple husband and wife. When morning broke, the imps scattered. The ice refroze. Quaum beckoned the three to shore. Quicker than a beacon on the British, news of the couple's marriage spread up and down the Hudson Valley. When people asked where, the servant replied, "Why, on Polly Pell's Island!"

Later that year, when plans to fortify West Point went forward, most maps already showed some variant spelling proclaiming the place Pollepel Island. Pot ladle? Bannerman's haven on the Hudson began as a sanctuary for love. Today, it remains wild, unique and lovely.

Oz on the Hudson

Once upon an industrial time, people in Peekskill made plows, stoves, bricks, yeast and Crayola crayons. Peekskiller Chauncey Depew, the loquacious railroad "boodler" and U.S. senator, noted, "There are millions of stories in the world, and several hundred of them good ones." Among those from the city on the river with worthy stories is L. Frank Baum's. He, like Depew, attended the Peekskill Military Academy. The sensitive Lyman Frank suffered dearly in that institute of discipline. He escaped by mixing fantasy with the fantastic landscape of the Hudson Highlands. He took the ferry to Bear Mountain. Hikes to the top revealed two indelible sights. Gazing thirty miles to the south and east shimmered New York City. Also, glowing a turquoise hue, beckoning all with good fortune, was Osborn Castle. Had Baum seen what would become his Emerald City?

Later, returning to the dreary military school, cadet Baum inquired about getting to New York City. Smug senior cadets sniffed, "Follow the yellow brick road." Hudson River clay beds occasionally yield an ochre-looking brick. Some of these made up a roadway down from the academy to the train station. These yellow bricks remain today near the Peekskill station behind an old firehouse. Baum's miserable two years in Peekskill found transformation thirty years later when he wrote the *Oz* books. The people of the Highlands cherish this history with zeal. They'll often brag about Osborn Castle, a towering turreted landmark in Garrison. Locals say it inspired the name of the wonderful land and modeled for the Wicked Witch of the West's lair. The fact is that J. Morgan Slade, a wealthy banker, constructed the hilltop manor hall. The stately structure was completed in 1881 and became the home of William H. Osborn. L. Frank Baum left the academy and the region around 1870, and thus, he never actually saw the castle. *The Wizard of Oz* movie location scouts, however, may have drawn on the most iconic castle in the Highlands to create one of the best films ever made.

Old Put's Wife

General Israel Putnam's wife, like many military spouses during the Revolution, was a camp follower. When British troops landed below Peekskill in October 1777, Putnam had his wife go to stay at the Mandeville House in Garrison. Word reached the house when the British took Forts Clinton

and Montgomery. They were coming! "What of my husband down at Fort Independence?!" screamed the general's wife. She clutched her heart and throat and fell to the ground. Those gathering around declared her dead. "Heart attack!" they cried. With beacon fires signaling cannon firing and the Yankee pumpkin vine cut, Highland folk had to give poor Mrs. Putnam a hasty burial.

They put her in a plain soldier's coffin and lowered it into a grave in the St. Philip's churchyard. Following the battle, Old Put received word of his wife's demise. He went to exhume the body to rebury her in their native state of Connecticut. Imagine Israel's terror upon lifting out the coffin and finding the lid loose. Think of his increased horror at finding a bloody scratch on the inside of the cover. The crusty general never really recovered from the shock. The graveyard occasionally emanates keening cries. Former governor George Pataki, who lives nearby, dismisses what some insist are the moans of Mrs. Putnam's ghost. "It's nothing but the town's noisy Democrats!"

Spiritus Pox

A few decades ago, a young couple driving south on Route 9D during the bewitching hour braked for someone crossing the road. They gasped seeing the blotchy figure garbed in a ragged old-style frock and knee breeches. Concerned that they'd be labeled drunk or delusional, the couple rarely reported the sighting. Their ghost crossed where the "Connecticut Camps" stood through the harsh winter of 1778. Smallpox brought death to about sixty men there. The couple now believes that a spirit of one of those forlorn soldiers passed into the night as if to remind them of those trying times here.

Captain Kidd's Lost Treasures

Captain William Kidd, a respected New Yorker in 1696, held a letter of marque from King William of Great Britain permitting him to act as a privateer. Late in the 1690s, colonial New York became a favorite place for pirates. They robbed merchant ships trying to slip through the Hudson Highlands. Given the *Adventure Galley* and a crew of 150 honest and hearty sailors, Kidd set sail from London to New York. He'd stop pirates plaguing

the colony; give 10 percent of what he took to the king; pay off his investor, Robert Livingston; and split the rest with his crew. Feeling confident when a Royal Navy vessel demanded a customary salute, Kidd let his seamen slap their backsides at it, "mooning" the military ship. The navy took about one hundred men from Kidd, forcing him to replenish his able fellows with only the cutthroats and rogues in New York.

Soon they pressed Kidd to rob a ship, flying French flags even though it was an Indian tea ship under British protection. Kidd also inadvertently killed a drunken, disrespectful gunner. Word of these offences reached the king. He may have been fuming over the lost tea ship or had a political reason, but His Majesty wanted Kidd hanged. Kidd was determined to clear his name. He returned in trouble to his native New York. His piratical crew feared that the king would confiscate all their loot, not just the royal share. Thus, they convinced Kidd to hide some of his treasure with an old friend, Lion Gardiner of Gardiner's Island. A servant claimed that he spied Kidd and his men burying treasure. This later inspired Robert Lewis Stevenson's novel *Treasure Island*. Kidd rewarded Gardiner with a diamond ring, worn by his descendants to this day.

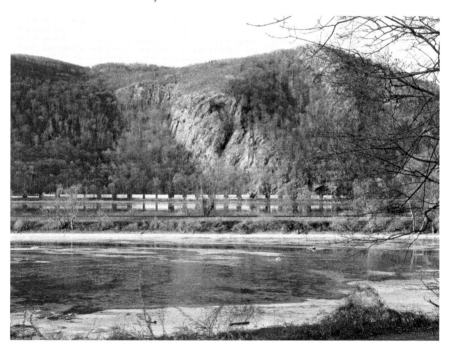

"Cro' Nest Cavern," by Daniel Delaney, 2017. The pirate Captain Kidd's treasure and British sympathizers during the Revolution hid in this cave.

When some of Kidd's men grew mutinous, the crafty captain and his loyalists might have hidden treasures in other places. His men worried about the king taking their share of the booty on board when Kidd stood trial to clear his name. Thus the pirates and Kidd swore a blood oath to hide their ill-gotten gains in various places and retrieve the loot together—or suffer at their mates' hands.

On May 23, 1701, Kidd and several of his mates were taken in a drunken procession to Execution Dock in London. The mates got a last-minute pardon. Kidd cried out that if he got one, he'd lead the king's men to his hidden treasures. Instead, they hanged Kidd, twice (the first rope broke). Kidd's body rotted on a gibbet. His ghost returns to haunt his hidden treasure. One loot location remains under the "Big Tree" on Madame Brett's land in today's city of Beacon. Other spots here in the Highlands are in a cave in Cro' Nest where Enoch Crosby found Tories nesting during the American Revolution and near Jones Point, a secluded hamlet in northern Rockland County. Booty hunters with metal detectors comb these sites, lamenting any treasures already taken. Those sensitive to lost souls report Kidd's ghost appearing as an impenetrable shadow with eyes glowing fiery red with anger. The spirit of the privateer turned pirate wards off all potential takers.

Finally, two hundred years after his career began, a few speculators raised $25,000 selling stock to salvage a sunken ship found off Jones Point at a tiny notch called "Kidd's Plug." Said to be a vessel manned by Kidd's surveying crew, it went down in an imp-induced storm off Donderberg. One day, locals noticed men working in newfangled air-filled diving suits. The next day, they absconded with the only treasure ever found in connection to Kidd: the stockholder's money.

WONDERS OF THE
HUDSON HIGHLANDS

Hudson! The breeze has ceased to press
Thy wave! And on its placidness
The moonbeams are caress'd, and lie
Bright sleeping undisturbedly
Ever should loveliness recline
On couch as beautiful as thine—

From out of thy depths the mountains rise
And lift their shadows to the skies—
In silent awfulness they tower
Like spectres that by magic power
Are call'd from some vast black abyss
Cav'd in earth's bosom bottomless,
Whilst round each huge brow rough and sear
The moonlight trembles as in fear.
—Thomas Cole

A raven with time-transcending vision scanning from Cro' Nest Mountain would witness myriad events unfolding to shape the landscape and history. His perch would tremble with the cataclysmic break of the ice dam thirteen thousand years ago that reconstituted the river Hudson. The bird would then observe the First Peoples, hunting mastodons and other megafauna in the Highlands. Later the Leni-Lenapes, in ecstatic dance,

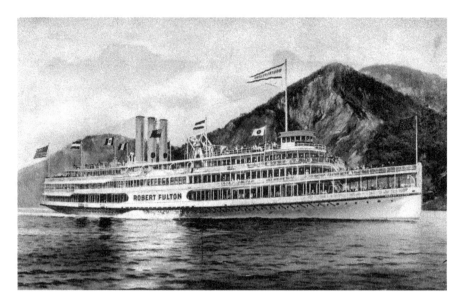

"The Robert Fulton," postcard, circa 1910. Named for the creator of the first successful steamboat company, which began its run on the Hudson in 1807. *Mark Forlow Collection.*

would call to spirited manitous. They know the secret to bring shad to their nets. The raven would witness European settlers quilting the lands below the mountain shoulders with farms, pastures and water mills, giving way to miners and loggers providing for a growing city just visible fifty miles south on clear blue days. Revolutionaries follow settling the mountains with beacon fires and stone fortresses. They chained the ever-moving river to hold together a new nation.

The raven startles along with local farmers upon spying what he describes as "a devil driving by a sawmill." Many people think that this chugging, smoke-spewing wheeled watercraft passing by "World's End" on the Hudson marks the end of the world. Indeed, it did. When Robert Fulton's Hudson River steamboat churned up the river in August 1807, it defied wind and tide, launching the Industrial Revolution.

Painters like Thomas Cole, Frederic Church and Robert Weir got lost in the uncultivated terrain of the Highlands. They devoted themselves to capturing nature on their canvases. Taking mankind out of the scenery revolutionized what we see.

JOHN THE BAPTIST OF THE HIGHLANDS

John Trumbull, a fine blend of artist and Revolutionary War veteran, thought he'd painted and fought for it all. Three paintings he happened upon in a New York City gallery in 1825 "mortified" the old Patriot. They were landscapes revealing the Hudson River's wildness and divinity. The images staggered him. He praised the artist: "This youth has done at once, and without instruction, what I cannot do with fifty years of practice." Colonel Trumbull bought for twenty-five dollars *Falls of the Kaaterskill*, the fabled finale of Washington Irving's *Rip Van Winkle*.

Another image spoke to a young painter, Asher Durand. *View of Fort Putnam*, a rustic ruin, reflected from fifty years back the American struggle for independence. Durand not only purchased the painting but also began a lifetime pursuing the mystic magic of the Hudson.

The artist both Trumbull and Durand discovered first found inspiration on rambles taken near Cold Spring. Gazing on the timeless mountain, later known as the Storm King, the young master felt a calling. Entering these "endless hills," he encountered the antediluvian beauty absent in Europe. The landscape compelled him to respond by making music and writing poetry to complement his painting. This became his lifelong practice. He found that the Hudson Highlands "inspire that vivid feeling…necessary [for] an artist…[to] work with spirit and effect." The lure of these Highlands turned the British-born émigré to Pennsylvania into a John the Baptist, preaching through painting on the godly American wilderness.

The effect was dramatic. Painting nature's raw dignity, the artist, Thomas Cole, called people to see what the hand of God had wrought in the New World. Cole's windswept trees, ragged mountains and luminous clouds proved revolutionary. Soon others—like Durand, Jaspar Francis Cropsey, Frederic Church and Robert Walter Weir—followed the call of Thomas Cole.

YES, JESUS LOVES ME

Our timeless corvid sees a procession of sailing ships, steamboats, trains, automobiles and airplanes traveling to factories, businesses, stores, manufacturing hubs, malls, museums and homes. The raven senses a landscape threatened. People determine that beauty and historic sites

are worth preserving. They won't let Storm King be marred. This sets a revolutionary precedence across the country.

The raven looks back on a jut of land with the name Constitution Island. There arrived the Warner family on a steamboat before the trains and the Civil War. The market crashed during the Panic of 1837. Henry Warner lost his city home. The widower arrived with his sister, Fanny, and two teenage daughters, Anna and Susan. They had thought of this rustic stone and rough-hewn country cottage only as a place to escape the city's summer heat and sickness. Now they'd have to fend for themselves in this foreboding Highlands hideaway.

The Warner cottage dated back to the days of Bernard's bastion. The sisters explored the stone redoubt walls but concentrated on establishing a hardy vegetable garden. Their father tried to secure land to farm or rent out near the salt marsh, which filled at high tide, with the Hudson River making the peninsula an island. He failed. They needed to find another way to survive. Again, the Hudson Highlands provided inspiration. Anna and Susan began to write. Rising before dawn, they'd try to put out works they could sell to newspapers, magazines and other periodicals. Then they'd spend daylight hours doing chores. When night fell, they read and prayed. Eventually, their prayers were answered. Drawing on the loss of their mother, family travails and stories they began to glean from West Point cadets joining them for Bible study, the sisters wrote their way out of poverty.

Susan wrote into a scene in her novel *Say and Seal* a little poem to comfort a dying child. Anna made it into a hymn. It has provided solace to millions since first appearing just before the Civil War:

> *Jesus loves me! He who died*
> *Heaven's gate to open wide;*
> *He will wash away my sin,*
> *Let His little child come in.*

Ten years earlier, Susan wrote a book called *The Wide Wide World*, for which she created the character of Ellen Montgomery, a young woman forced to live in Europe with nasty relatives. Worse, she loses touch with her true love. A kindly man consoles with the advice to put her trust in God. She discovers that suffering always makes us stronger. The book, convoluted and sentimental, was first rejected by publishers, but when it got printed in 1850, it became a bestseller, second only to *Uncle Tom's*

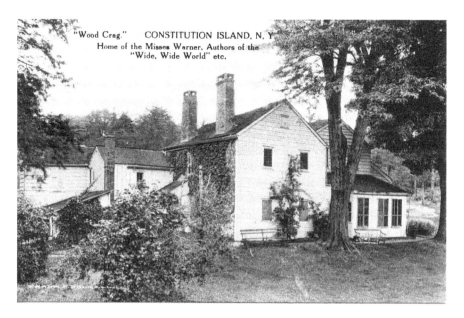

"Wood Crag," the homestead of the Warner sisters on Constitution Island, postcard from a late nineteenth-century photo. *Mark Forlow Collection*.

Cabin. Other writers of the day paid homage to Susan Warner. Louisa May Alcott, in her classic *Little Women*, features Jo reading *The Wide Wide World* to her sisters. Nathaniel Hawthorne declared, "This woman writes as if the devil was in her."

The Warners continued to write, treat cadets to Bible study and garden all their days. Susan died in 1885. Thwarted three times by a dysfunctional Congress when she tried to donate Constitution Island to the people of the United States, Anna got help from Mrs. Russell Sage. Anna simply wanted to live in her home until she died. Sage purchased the island, giving the declining Miss Warner enough time to see out her final days in comfort. Mrs. Sage gave the island to the "Cadets of West Point." The Constitution Island Association was formed to preserve and perpetuate the lovely legacy of Susan and Anna Warner. Offering forest-bond redoubts, flower gardens, a quaint old house and the eastern anchorage place of the nation-linking chain, Constitution Island provides unique sanctuary for visitors to the Hudson Highlands.

SAVE STORM KING

Once upon a time, in the early 1960s, an encounter between a Garrison gentleman farmer and a corporate-employed surveyor would spark another revolution on the river. Alexander Saunders Sr. accosted the land engineer: "What brings you on my land?"

"I'm surveying for Con Ed [Consolidated Edison]. They plan to put in a hydroelectric reservoir right across the river on Storm King Mountain."

Saunders pointed to a clearing above a stone wall at the northeast end of his property. "I look on that mountain every time I come up here. What will happen to it?"

"About two football fields of stone will be removed several hundred feet up on a corner of the hill," replied the surveyor. "There'll be a water intake and outtake on the river. Turbines will be inside. We'll pump water up during the wee hours of the morning when the cost for electricity is low. Late on hot summer afternoons when demand gets high, we will let the water run over the turbines generating power which will go through lines around there." Saunders was gobsmacked. "Don't worry, Con Ed will pay you for your land." That's not what worried the gentleman farmer.

Leo Rothschild was more than an avid hiker of the Hudson Highlands. He knew about the land and the law. The Nature Conservancy in 1962 wanted to preserve hiking grounds for future trekkers. Leo got the task of identifying property to buy. He looked to save the hills on the river's east bank. The developers looked there too. The rugged remote west hills like Cro' Nest, Black Forest, Whitehorse Hill and Storm King lacked the appeal of the more prosperous east with a train line to the city. Con Ed broadsided Leo.

It announced a huge project for a "gigantic storage battery" near Cornwall on Hudson. This would pair neatly with a plan put forth earlier by the Hudson Valley utility Central Hudson Gas and Electric. It acquired more than six hundred acres to take out of Breakneck Ridge, Storm King's sister across the "Wey-Gat," the old name for the passage between the two guardians of the Highland's north entrance. Both plants would employ pumped water technology, set in massive rectangular reservoirs carved out of the hillsides. Responding to recent power shortages causing summer brownouts and oblivious to the beauty and history of the sites selected, the companies anticipated no difficulties.

"Sunrise on Highlands," postcard, circa 1900. *Mark Forlow Collection.*

Alexander "Sandy" Saunders Jr., however, saw problems. A recent graduate from Massachusetts Institute of Technology, he possessed a cavalier confidence and youthful zeal. Sandy went after Con Ed's plan. He claimed that the numbers did not make sense for it to bother building a water storage battery. "There's new gas powered turbines coming. They are even better." He told his father, Rothschild friends, Garrison neighbors and anyone he met, "Water stored power does not work." Few took heed of the nerdy assessment.

Alexander got together with some of his neighbors who had similar conversations with Con Ed's surveyors. They agreed that no one wanted power lines on their land. Further, they considered marring their grand old Storm King Mountain a sacrilege.

Soon, the project prompted another kind of consolidation. At first, big land conservation groups like the Palisades Interstate Parks Commission and the Hudson River Conservation Society let Con Ed mollify them. The company offered to turn other properties into parks with eyes on the Storm King prize. Rothschild held out hope that help would come from Governor Nelson Rockefeller's brother Laurence, who served on the PIPC board. A noted arts patron and conservationist, Laurence seemed likely to oppose defacing an iconic mount long praised by writers

"Nelsonville Fish & Fur Club," postcard, circa 1920. *Mark Forlow Collection.*

and painted by artists. Rothschild, to be sure, shot a pointed telegram to Governor Rocky reminding him of his professed passion for the state's heritage. The governor scoffed, suggesting the wealthy hikers buy Storm King themselves.

The New York Metropolitan Area had grown right out to the ring of hills arcing fifty miles away from the city. Demand for power and Con Ed's parkland moved Laurence Rockefeller to vote with the PIPC majority. They accepted Con Ed's proposal. This paved the way for approval with the Federal Power Commission. Storm King looked destined for destruction.

This did not go down well with Rothschild, the Saunders's and Ben Frazier. They enlisted help from the wealthy Stillman and Duggan families. Together they created the Black Rock Forest Preserve, donating lands in Cornwall that Con Ed had slated for destruction. Linking with other local conservation groups, their movement to save the Hudson landmarks piqued the interest of the renowned river lover and author Carl Carmer. In 1964, they formed a new land preservation nonprofit, Scenic Hudson. It would be spearheaded by the indefatigable Franny Reese.

A few years later, Robert Boyle, a writer for *Sports Illustrated*, formed the Hudson River Sports Fisherman Association. Members gathered for their first meeting in Crotonville, near the river's widest part of the Hudson. The

Franny Reese led the fight to stop Con Ed from defacing Storm King Mountain, helping to found Scenic Hudson. *Scenic Hudson.*

fishermen swapped stories from days before the river became a dirty joke. Once a place fished commercially for everything from "Albany steak" (the dinosaur-like sturgeon) to the teeming shad, the river in the mid-1960s stank from raw sewage, burned fish eggs with water warmed by the Indian Point Nuclear Plant and turned colors weekly with paint dumped by General Motors. They elected Ritchie Garrett their leader, and he vowed to cheering fisherman, "I'll never let you down."

Boyle managed to convince the courts to enforce for the first time nineteenth-century anti-pollution laws. They busted offenders from Westchester County to Standard Brands. They applied bounties collected for turning in the polluters to fund a boat, with someone to look out for sources of filth. The "Riverkeeper" was born. They hired John Cronin in 1983 as their first full-time keeper to identify polluters, as well as a full-time lawyer, Robert Kennedy Jr., to prosecute them. One of the Riverkeeper's first busts mystified Cronin. He spied a huge Exxon oil tanker anchored in the water below the Highlands. Chugging up, Cronin thought he might spot the big vessel dumping waste oil. He located a huge hose, but nothing was coming out. Imagine Cronin's surprise when he determined that Exxon was pilfering Hudson River water. The oil giant was using empty tankers to collect water to sell down in Aruba.

The Fisherman Association challenged the project before the FPC and then the courts, arguing that development can't occur only to meet economic

"Sand-Hogs, New York City Aqueduct," by William Thompson Howell, circa 1910. "Over a fifth of a mile under the Hudson, at eastern end of tunnel, Storm King Section." *Hudson River Valley Heritage & Palisades Interstate Park Commission.*

and energy needs. Other things matter, like aesthetics, history and heritage. They lost these early battles.

Then *LIFE* magazine ran a story featuring a somewhat oversized illustration of Con Ed's reservoir cut into the north face of Storm King. Outraged residents took their love for the mountain to the ballot box, electing the district's first Democrat since the Civil War, Richard Ottinger, a "save Storm King" advocate. The erudite attorney Lloyd Garrison convinced the courts to consider more evidence before allowing Con Ed to put through its plan. Enter Robert Boyle, a *Sports Illustrated* columnist and passionate Hudson River fisherman. He hollered for fish eggs, showing how warm intake waters could kill the fishing industry. Con Ed floated the idea of a fish hatchery. It even suggested drilling the reservoir under the mountain. Eventually, Franny Reese took the cause to her friend Charles Luce, who sat on Con Ed's board. She asked him if the company has a role in conservation. He agreed, but Con Ed proposed blasting the reservoir into the mountain nonetheless.

CLEARWATER

Mr. Pete Seeger the man who sang "Irene Goodnight," "If I Had a Hammer," "Where Have All the Flowers Gone," "Turn, Turn, Turn" and "We Shall Overcome"; who got himself blacklisted thanks to an interest in communists supporting the working man; who literally got stoned after holding a Paul Robeson concert outside Peekskill; and who happened to homestead on South Mount Beacon—offered to help the Storm King preservation effort. Fearing that his radical reputation would harm the cause, Carmer, Stillman and Rothschild turned the folk singer down.

Meanwhile, Seeger received a book from his friend Vic Schwarz, an artist and ad man on Madison Avenue. *Sloops on the Hudson* recalled the

Left: "Beacon of Hope," Pete Seeger, by Michael D'Antuono, 2010.

Below: Photo of Dimitri Kasterine's "Portraits of Newburgh," by Daniel Delaney, 2017. *Ann Street Gallery, Newburgh.*

glory days of sailboats redesigned by the Dutch to haul goods on the tidal river. The book enchanted Pete. Meeting on the Hudson line train to the city, Pete raved to Vic about getting people together to build a new sloop. Pete would hold some hootenannies to raise interest. A few weeks later, meeting on the train again, Pete apologized for gushing about a crazed notion to build a sloop and withdrew the request for help. Vic said it was too late—he'd already begun to gather interest and money. They held a hootenanny on the Hudson and raised about $150. A few years and many

fits and starts later, the sloop *Clearwater* rolled into the Atlantic Ocean. It has become a sailing educational icon. The battle to save old Storm King, however, took seventeen years.

Finally, the high court came to a decision: "The Commission renewed proceedings must include as a basic concern the preservation of natural beauty and national historic sites keeping in mind that [in] our affluent society, the cost of a project is only one of several factors to be considered. The Commission should take the whole fishery's question into consideration before licensing."

Consolidated Edison never did get a license to take a bite out of Storm King's crown. Sandy Saunders, who grew into a radical, likeable curmudgeon, contends that the energy company realized its plan was obsolete. The ruling set a revolutionary precedent used by most environmental movements ever since—natural beauty and historic sites have a legal right to be preserved.

STERN & CORNISH

The ruinous remains of the Cornish estate intrigues hikers wandering between Breakneck Ridge and Bull Hill. Guidebooks detail a state-of-the-art farm, completed with heated cow barns and a swimming pool. A pair of stone columns and an old paved road lure walkers to the fallen stone fireplaces, patio and pachysandra, inviting all to imagine how lovely it would have been to have lived like a Gatsby here in the Roaring Twenties. Little do they know that just up the road, Zelda Fitzgerald and Judy Garland once endured shock treatments at Dr. Slocum's sanitarium off Denning's Point. Hikers also will miss the origins of this wondrous ruin in most books—save for *Hudson Valley Ruins* by Tom Rinaldi and Rob Yasinsac. The two authors pointed to the Stern family as the builders.

A jeweler born in Germany but raised on the mean streets of New York, Sigmund Stern managed to rise out of poverty. When he made his fortune, he built Northgate for his wife, Dovie, and family, an Adirondack-inspired mansion looking onto the Hudson. He wasn't the first to farm the stone places beneath Bull Hill. Farmers with names still seen around Cold Spring like Philipse, Satterlee and Wise plowed the path before Stern.

Surprise Lake camp lore puts a contingent of Jewish men seeking a country place for city boys to roam on a path to a pool used for providing water for steamboats. Stern led the way from New York. He provided assistance

to the group, the Jewish Educational Alliance, which was started in 1889. Around 1910, he linked together two summer camps, forming the Surprise Lake Camp of the Educational Alliance and the Young Men's Hebrew Association. When Stern constructed his eclectic mansion of local granite, beams and stained glass in 1913, imagine him inviting boys like him to see the fancy stonework and visit the farm animals.

Today, hikers marvel at the fragmented stone foundations and the great cistern, all while attributing it to Edward Cornish. Indeed, the white lead baron made many improvements on Stern's house. Under Cornish, Northgate produced prize-winning cows until rock mining returned in the 1930s. The blasts frightened Cornish into offering his lands for sale as parkland. Robert Moses rejected the estate as too much for the state to manage. In 1938, Cornish died at his desk, and his wife passed a few weeks later. Twenty years later, a fire took out the top of the house. Central Hudson Gas and Electric, following Consolidated Edison's plan to build a reservoir power plant on Storm King, bought the Cornish estate. When Scenic Hudson began to win the battle to protect Storm King, Central Hudson dropped the idea of developing the Cornish lands. The quarrying stopped in the late 1960s when, according to "Springers," a blast from the great pit on Bull Hill actually cracked windows in the village. It all became state parkland not long after.

"Stern/Cornish Estate," photographer unknown, circa 1916. *From Robin Huntington and http://www.hudsonvalleyruins.org.*

"To River," by Daniel Delaney, 2017. Cold Spring on Hudson's subway under the train tracks to the lower village.

The estates of Stern and Cornish continue to intrigue and inspire. The turn of the twenty-first century moved some to create balanced stone sculptures. A few structures rival the fine art across the river in the Storm King Art Center. Always the Hudson Highlands raise consciousness.

HAPPINESS IS NOT MY COMPANION

Cold Spring's second-most famous Civil War general (after Dan "Taps" Butterfield), Gouverneur Kemble Warren saved the Union army from defeat at Gettysburg by sending his signal corps men up Little Round Top to hold

off an advancing Confederate army. Later, at another big battle, he became shell shocked. His commander, General Sheridan, saw Warren sitting down to recover and mistook his actions as evidence of laziness. Sheridan relieved Warren of command. Warren stayed in disgrace until Grant exonerated him seventeen years later. Warren died two weeks before getting word that his good name had been restored. His former soldiers, however, put a huge statue of Warren on top of Little Round Top.

Growing up under the shadows of the Hudson Highlands, "Springers" are often born with an innate sense of what happens when something gets dammed. Tour the "Lower Village" of Cold Spring, the enclave west of the railroad tracks, and you may find a plaque that identifies the home of a man who felt compelled to show constraint. His sister did too. The plaque simply marks the birthplace in January 1830 of Gouverneur Kemble Warren. Named after the founder of the West Point Foundry, "GK" and his little sister, Emily, both understood how to keep and span things over time.

Gazing out from their bedrooms, they saw West Pont. They grew up observing the power of a river that flows both ways. They witnessed Cold Spring turn from a tiny watering hole into an industrial powerhouse. GK, a methodical, diligent student, graduated second in his class from West Point. He served out west as an army surveyor and was teaching mathematics back at the academy when the Civil War broke out. He left West Point to enlist men in the newly formed New York Fifth Infantry. This unit—flamboyant in uniforms of red pantaloons, bright sashes and jaunty caps—trained under Warren until recognized by a superior, who claimed that "the Fifth is the best disciplined and soldierly regiment in the Army."

Warren's success in battle and a dearth of experienced officers quickly led to his promotion to colonel. When the rebelling Confederate army massed near Gettysburg, Pennsylvania, the Union Fifth Army Corps marched to stop it. Warren thought to lead a small unit up the hill to Little Round Top to survey for improved cannon and troop placements. There they encountered a corps of Southerners, thousands of soldiers, readying to flank the Union position. Wildly outnumbered, Warren managed to muster two regiments to defend the rise and save the Union army. Standing firm on a large flat stone, Warren ordered a captain to fire a shot into "Devil's Den" between Big and Little Round Tops. Later Warren recounted. "As the shot went whistling through the air the sound of it reached the enemy's troops and caused every one to look in the direction of it. This motion revealed to me the glistening gun-barrels and bayonets of the enemy's line of battle, already formed and far outflanking the position of any of our troops."

Remaining firm on that stone, he sent messages out to as many nearby Union units as possible. Further, he needed to make the Rebels believe that the Union had a deterring force already in place. He ordered his small unit of signalmen to "keep up their wigwag activity, simply as a pretense of alertness."

They held on until Union colonel Strong Vincent arrived with reinforcements. Warren lost about one-third of his men. Warren himself was grazed in the neck. His cool head and bravery under fire earned him promotion to brigadier general and "Chief Engineer of the Army of the Potomac." Always carefully calculating on the battlefield, he privately worried in a letter to Emily about his superiors, Generals Ulysses Grant, William Tecumseh Sherman and Philip Sheridan. He criticized them for the brutal haste they used to send soldiers to face rifled guns and cannons, thus quickly filling "nameless graves of noble men who have vainly perished." Further, he questioned, "Why does he [God] permit such things?"

Toward the end of the war, Warren rose to a brevet major general. Keeping things dammed within, however, took a toll. More than once he got "falling down drunk." Warren's artillery officer, Colonel Charles Wainwright, told his wife that he found his commander to be "a very loathsome, profane ungentlemanly & disgusting puppy in power." GK, doubtlessly suffering from battle fatigue, wrote to Emily, "I repine a great deal. I begin to feel myself giving out in spirit. I need so to rest where I could be contented."

The Battle of Five Forks at Petersburg, Virginia, cracked GK's inner dam. April Fools' Day 1865 had the Union army confused about moving troops to meet the Confederates. This led to a convoluted series of events forcing Warren to apparently disobey orders from General Sheridan and leave the field of battle. When Sheridan came for him, Warren was trying to follow orders by rounding up two of his units separated during the fog of war. An eyewitness later described Warren's whereabouts and actions when "Little Phil" came hunting for GK: "[A]nd under the setting sun, he [General Warren] snatched up his corps flag, shouted to his men—'Now, boys, follow me, this will be the last fight of the war!'—and rode straight toward the rebel line. His horse was shot and killed, and Colonel Hollon Richardson of the Seventh Wisconsin was wounded as he tried to shield his corps commander when he toppled to the ground."

Following his action, Warren dispatched his aide, Lieutenant Colonel Frederick Locke, to inform Sheridan he had thwarted his enemy's rear and taken 1,500 prisoners. Plus, he was driving in his division as quickly as possible to get back to position. "Smash 'em Up" Sheridan sneered to Locke,

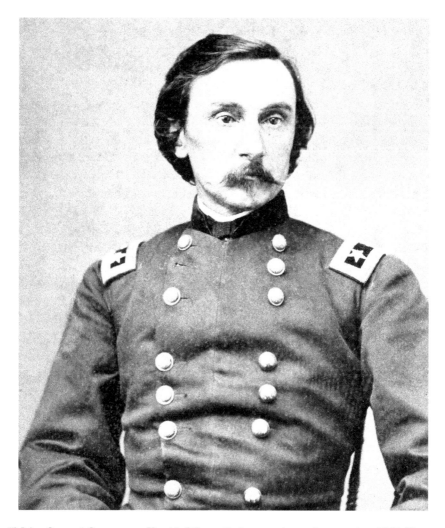

"Major General Gouverneur Kemble Warren," photographer unknown, circa 1865. Hero of Little Round Top. *Mark Forlow Collection*.

"Tell General Warren, by God! I say he was not at the front. That is all I have got to say to him!"

General Grant, at the time, agreed with Sheridan's decision to relieve Warren of command. Many, even Colonel Wainwright, disagreed, but Major General Gouverneur Kemble Warren suffered a terrible disgrace. "Giving out in spirit," he resigned his field rank and returned to serve as a major, surveying in Minnesota for the army field corps. He attempted to clear his name through a series of letters to Grant and others.

A year earlier, Warren had introduced his little sister to Washington Roebling, one of his staff officers and son of future Brooklyn Bridge designer John A. Roebling. Young Washington had helped hoist a cannon up to Little Round Top. Twenty years later, both father and son fell victim to "Caisson's Disease." Emily took over managing construction on the Brooklyn Bridge. Her brother gave her an education at Georgetown Visitation Covenant. Having watched the Hudson flow both ways, she respected the might of water and got the work done. Emily's supervision brought her the honor of being the first person to walk across the bridge when it officially opened in 1883. The Roeblings had a gracious home in the village of Cold Spring.

The dam of resentment for Philip Sheridan's disgracing of G.K. Warren at last broke. Warren, finishing his career in Rhode Island, kept asking President Grant for a full hearing on his actions at Five Forks. Grant rejected the melancholic Warren's request. GK wrote after the war, "Happiness is not my companion." Eventually, a court of inquiry convened under President Rutherford B. Hayes exonerated General Gouverneur Kemble Warren. Word reached GK's home in Newport not long after the general died of diabetes-induced liver failure. The Hudson Highlander was fifty-two. Emily lived to earn a law degree and always exalted her big brother's heroism. Veterans who served under Warren raised funds to erect a larger-than-life statue of their beloved commander, made complete with a tablet stating:

> *Led to this spot by his military sagacity on July 2, 1863, General Gouverneur Kemble Warren then Chief Engineer of the Army of the Potomac detected General Hood's flanking movement and by promptly assuming the responsibility of ordering troops to this place saved the key of the Union position. Promoted for gallant services from the command of a regiment in 1861, through successive grades to the command of the 2nd Army Corps in 1863, and permanently assigned to that of the 5th Army Corps in 1864. Major General Warren needs no eulogy. His name is enshrined in the hearts of his countrymen. This statue is erected under the auspices of the veteran organization of his old regiment, the 5th New York Vols. Duryee Zouaves in memory of their beloved commander.*

Woodman, Spare that Tree

Imagine the shock and dismay of the first person to widely express love for these Hudson Highlands, George Pope Morris, upon discovering his gardener "cutting down and laying waste almost everything in the shape of a tree about the premises." Morris, the renowned editor of three different *New York Mirror* publications, achieved fame as "America's songsmith," making popular music from the 1830s until his death during the Civil War. His weeklies, featuring Hudson River artists and writers, electrified the country with enchanting visions of this region. Working with his fellow Highlander Nathaniel Parker Willis, they perpetuated the works of America's first men of letters, the Washington Irving–inspired "Knickerbocker writers" James Fenimore Cooper, William Cullen Bryant and Edgar Allan Poe. Willis and Morris helped make the works of Americans popular outside New York by featuring the likes of Henry Wadsworth Longfellow, John Greenleaf Whittier, Ralph Waldo Emerson, J.J. Audubon, Nathaniel Hawthorne and many others. The *Mirror* was first to publish Poe's melancholic hit "The Raven" in 1845. The *New York Mirror* advanced the career of Saint Nicholas: Willis and Moore ran stories by Knickerbocker writer James Kirke Paulding and artist Robert W. Weir, who helped transform the dour bishop into the chimney-sliding elf.

Morris held a vision of sharing the unique quality of American artists. Thus, he advanced the works of painters thrilled by the wild, untouched landscape found within these Hudson Highlands. This helped launch the revolutionary Hudson River School of artists, including Morris's local friends Thomas P. Rossiter and Weir. Willis and Moore went on to found the *National Press*, which became *Home Journal*, one of the most successful magazines in the country.

As he was a songsmith extraordinaire, a Philadelphia enterprise offered Morris fifty dollars for any tune he wrote. His most popular song, "Woodman, Spare that Tree," stands as the first environmental song ever scribed in America:

> *Woodman, spare that tree!*
> *Touch not a single bough*
> *In youth it sheltered me,*
> *And I'll protect it now.*
> *It was my forefather's hand*
> *That placed it near his cot;*

There, woodman, let it stand,
Thy axe shall harm it not!

It's curious to discover that Pete Seeger, a more recent American songsmith, whose home is just over Bull Hill from George Pope Morris's place, echoed the desire to preserve nature in the form of the "golden" Hudson River for his family. Morris's song continued:

Sunlight glancing on the water
Life and death are all my own
Yet I was never alone
Like to raise my sons and daughters
Golden sparkles in the foam
And I was not far from home

Written two years after he purchased Undercliff, Morris's song expressed sentiments that many Americans felt as they found their natural landscape beginning to fall to farms, factories and industry. Deeply sentimental, the song returned during the American Civil War:

Traitor, Spare the flag
Touch not a single star
It's sheltering glory still,
Increaseth near and far.

Reverend J.P. Lundy changed the lyrics to reflect the painful division Americans felt when the South cut away from the North. Northerners sang it with patriotic zeal. Morris had another hit.

Willis gently chided Morris over his gardener's tree-trimming zeal. The landscaper came highly recommended from England, where he had pruned bushes on an earl's estate. Many old-growth trees in the Highlands fell to woodsmen looking to make a buck fueling the mid-nineteenth century's steamboats and the West Point Foundry. Moore may have sensed the presence of another ineffable beauty in the Highlands. The fair Kelpie Rock at Undercliff's edge on the river put the poet in tune with the faerie folk of the Hudson Highlands. He wrote these "Lines for Music," longing for the goddess to return to her stone throne here in the Highlands:

164

Where beams of peace and love,
And radiant beauty's glow,
Are pictured in the sky above,
And in the lake below.
O would that she were here—
The nymphs of this bright scene,
with song and dance and revelry,
Would crown Bianca queen.

FIRES FROM HEAVEN

Weary of the "Quarropas," the misty swamps of White Plains, Richard Curry and his wife loaded their possessions and their precious child onto a horse and left for a promising valley known as Peekskill Hollow, in the Hudson Highlands. Arriving around 1794, they found refuge near Adams Corners. One day, Curry took his infant to a nearby slope on a sultry summer afternoon. Lazing in the field with his child at his feet, the volatility—and perhaps wanton harshness—of the Hudson Highlands conjured a sudden storm. A jolt of lightning cleaved through the clouds, striking the child a deathblow. Those "fires from heaven" left Mr. Curry inexplicably unharmed.

The grieving parents set the babe to rest on a knoll on the west side of the hollow road. This dreadful occurrence and burial established this place as a cemetery. It serves to remind all of the mysterious and mighty power hidden in these Highlands.

STONY LONESOME

Off the old Revolutionary path appropriately known as Stony Lonesome, there looms over Popolopen Creek a bare mount called the Torn. Scramble up and view Bear Mountain, Anthony's Nose and perhaps New York City. A peculiar pyramid of stones grows on this rocky outcrop. Many stones are inscribed with names and heartfelt messages. Every time a West Point cadet falls on the battlefields in Iraq, Afghanistan or any other war-torn place, another cadet carries a stone up to set on the Torn. They tell hikers that the heavier the stone, the better their fallen brother will be remembered.

TOPSY BEST SWIMS THE HUDSON

Back in the early twentieth century, as Italians and the Irish moved into Cold Spring and the Highlands, a tradition rose to test male adolescent mettle. Upon reaching thirteen, a boy could prove himself by crossing the treacherous Hudson from Little Stony Point to Storm King. There an old Swedish hermit would welcome the young man. The boy would get a fortifying cup of coffee with a shot of rum for the swim back. "Springers" once measured men by how they fared swimming the Little Stony.

The river there runs dangerous. Sloops and steamboats have gone down there. Richard Shea, a lifelong resident and former caretaker of Little Stony, described the Hudson between Cro' Nest and Storm King: "Whole trees float on the river after storms, and get swallowed in the current."

About one hundred years ago, one bold lad, known as "Topsy" Best, wanted to show up the new immigrants. Sighting a sleek sailing vessel entering the "Wey-Gat" below Storm King and Breakneck, he dove, swam up and boarded the ship like a pirate of old. He was away for months. Upon his return, Topsy told all, "I saw savage seas, the northern lights, knife fights, sharks, pirates, devil spouts and Davy Jones' locker." No one could top Topsy. Gradually, the traditional swim faded away.

A few dangerous customs launched by Topsy persisted into the mid-twentieth century. Daring Spring youths, curious about city-based boaters docking overnight at their Cold Spring, occasionally made late-night visits. The lads swam out to the crafts, clambering on board and shimmying up the masts. A supervisory source says they acquired this skill at an annual grease pole contest held in the village every Fourth of July. Once on top, they'd hoot until their echoing voices woke the fallen bull of Breakneck Ridge.

The late Mackay Budney, however, felt that he and his friends had Topsy beat. Winters now rarely ice over the whole Hudson. Once about eighty years ago, you could not only skate but also drive a car over the frozen Hudson. When the river cracked into floating ice jags, Mackey said that boys would "jump pompeys." Leaping onto an island of ice, they'd hop piece by bobbing piece across the river. He noted that no one drowned, but they did get wet, scared and happy.

SCOOP THE LOOP

William Thompson Howell and V.H.S., by William Thompson Howell in 1907, readying to skate Little Stony Point to Breakneck Ridge. *Hudson River Valley Heritage & Palisades Interstate Park Commission.*

The 1929 bandstand on the Cold Spring waterfront provides a gathering place all year-round. There, the lure of the craggy Cro' Nest, lordly Storm King, West Point, Constitution Island, Bull Hill and hikers' beloved Break Neck provide awe. Tourists filter through a phalanx of teens. Fishermen trap blue crabs. Native "Springers" and first-time visitors follow a tradition dating to the days of the sloop: Scoop the Loop.

Following the War of 1812, the West Point Foundry near Cold Spring brought forth plans to establish a turnpike, a toll road designed to supersede an old path leading from Connecticut. It would be an open lane for farm wagons to carry produce, grain, hay and dairy products from the interior of Putnam County to ships in the Hudson River. A long wooden pole attached to a forked stand with a peg or metal bolt would be lowered until the piker master could collect the tolls from all travelers and teamsters. The tollhouse still stands on Main Street in Nelsonville.

The terminus was just west of the "Cold Spring" noted on a 1757 colonial chart. There George Washington during the American Revolution no doubt found this water refreshing after attending to his troops camping on the hillside now occupied by Haldane Central Schools. Twenty years later, the horse- and ox-drawn carts descending from the farms into the lower village took water, but some needed a place to turn around. They then made a loop right before the dock. Farmers could gaze out to see what ship awaited them to take on their produce. Once they got the scoop on what sloops were present, they could even determine what skipper might give them the best deal. Thus, Scooping the Loop began. Later, potential passengers for steamboats did the same. In about 1830, an inn was built by the loop, and in 1929, the bandstand arrived. Today, all who come to Cold Spring best take in the grandeur of the Hudson Highlands by "Scooping the Loop."

BIBLIOGRAPHY

Adams, Arthur G. *The Hudson River Guidebook*. New York: Fordham University Press, 1996.

Anderson, Jane McDill. *Rocklandia*. Montpelier, VT: Morgan and Morgan Inc., 1977.

Barnum, H.L. *The Spy Unmasked or the Memoirs of Enoch Crosby Alias Harvey Birch*. New York: J&J Harper, 1886.

Benjamin, Vernon. *The History of the Hudson River Valley*. Vol. 1. New York: Overlook Press, 2014.

Bielinski, Stefan. *Report of the Fishkill Supply Depot*. Fishkill, NY: Fishkill Historical Society, 1971.

Bonner, William Hallam. "Hudson River Legends of Captain Kidd." *New York Folklore Quarterly* 2, no. 46 (1946).

Borkow, Richard. *Westchester Gamble*. Charlestown, SC: The History Press, 2011.

Boyle, Robert H. *The Hudson River: A Natural and Unnatural History*. New York: W.W. Norton Company, 1969.

Boyle, T. Coraghessan. *World's End*. New York: Viking Penguin Inc., 1987.

Brooks, Van Wyck. *The World of Washington Irving*. New York: E.P. Dutton & Company Inc., 1944.

Bruce, Wallace. *The Hudson River by Daylight NY to Albany*. New York: Gaylord Watson, 1873.

Carmer, Carl. *The Hudson*. New York: Farrar & Rinehart Inc., 1939.

Clyne, Patricia Edwards. *Hudson Valley Faces & Places*. Woodstock, NY: Overlook Press, Peter Mayer Publishers Inc., 2005.

Dacquino, Vincent. *Sybil Ludington: A Call to Arms*. Fleischmanns, NY: Purple Mountain Press, 2000.

Diamant, Lincoln. *Chaining the Hudson*. New York: A Lyle Stuart Book, 1989.

D'Imperio, Chuck. *Great Graves of Upstate New York*. N.p.: Authorhouse Online Pub., 2006.

Duncombe, Francis R. *Katonah: The History of a New York Village and Its People*. Katonah, NY: Katonah Village Improvement Society, 1961.

Dunwell, Frances F. *The Hudson: America's River*. New York: Columbia University Press, 2008.

Fenn, Elizabeth A. *Pox Americana*. New York: Hill and Wang, 2001.

Flexnor, James Thomas. *Washington the Indispensable Man*. Boston: Little Brown & Company, 1969.

Freeman, Hunt. *Letters About the Hudson River and Its Vicinity Written, 1835–1837*. New York: Freeman Hunt & Company, 1837.

Giles, Dorothy. *A Brief Story of the American Revolution in the Hudson Highlands*. Cold Spring, NY: Putnam County Historical Society, 1976.

Goring, Rich. *The Fishkill Supply Depot and Encampment during the Years 1776–1778*. Waterford: New York State Office of Parks Recreation, Division for Historic Preservation, 1975.

Grace, Trudie A. *This Perfect River View: The Hudson River School and Contemporaries in Private Collections in the Highlands*. Cold Spring, NY: Putnam Historical Society, 2007.

Grace, Trudie A., and David B. Dearinger. *George Pope Morris: Defining American Culture*. Cold Spring, NY: Putnam County Historical Society and Foundry School Museum, 2009.

Grace, Trudie A., and Mark Forlow. *West Point Foundry*. Charleston, SC: Arcadia Publishing, 2014.

Hasbrouck, Frank, ed. *The History of Dutchess County*. Poughkeepsie, NY: published by S.A. Matthieu, 1909.

Heath, William. *Memoirs of Major-General William Heath by Himself*. Edited by William Abbatt. New York: William Abbatt, 1901.

Heron, Jim. *Denning's Point: A Hudson River History*. Hensonville, NY: Black Dome Press Corporation, 2006.

Howat, John K. *The Hudson River and Its Painters*. New York: Scenic Hudson Preservation Conference and Viking Press, 1972.

Huffeland, Otto. *Westchester County during the American Revolution, 1775–1783*. Harrison, NY, 1926, 1982.

Huguenin, Dr. Charles A. "The Cowboys of the Ramapos." *PACE Summer* 20 (1969).

Ingraham, Joseph Holt. *American Lounger or Tales, Sketches, and Legends.* Philadelphia: Lea & Blanchard, 1839.

Irving, Peter Munro. *Life and Letters of Washington Irving.* New York: G.P. Putnam, 1862.

Irving, Washington. *Diedrich Knickerbocker's A History of New-York.* New York: G.P. Putnam Company, 1854.

Johnson, Thom, and Barbara H. Gottlock. *Bannerman Castle.* Charleston, SC: Arcadia Publishing, 2006.

Jordan, David M. *Happiness Is Not My Companion.* Bloomington: Indiana University Press, 2001.

Kelly, C. Brian. *Best Little Stories from the American Revolution.* Nashville, TN: Cumberland House, 1999.

Loprieno, Don. *The Enterprise in Contemplation: The Midnight Assault of Stony Point.* Berwyn Heights, MD: Heritage Books, 2004.

Lossing, Benson J. *The Hudson from the Wilderness to the Sea.* Hensonville, NY: Black Dome Press, 2000.

MacCracken, Henry Noble. *Old Dutchess Forever!* New York: Hastings House, 1956.

Palmer, David R. *George Washington and Benedict Arnold: A Tale of Two Patriots.* Washington, D.C.: Regnery Publishing Inc., 2006.

Patterson, Emma L. *Peekskill in the American Revolution.* Peekskill, NY: Peekskill Branch of the American Association of University Women, 1944.

Pelletreau, William S. *History of Putnam County, New York.* Philadelphia: W.W. Preston & Company, 1886.

Pickering, James H. *Enoch Crosby, Secret Agent of the Neutral Ground: His Own Story.* Albany: New York State Historical Association, 1966.

Pittman, Preston L. *Putnam History Museum: Historical Reflections for the 2016 Thanksgiving Service.* Cold Spring, NY: Putnam Historical Society, 2016.

Pratt, George W. *An Account of the British Expedition Above the Highlands of the Hudson River...in 1777.* Kingston, NY: Ulster County Historical Society, 1977.

Pula, James S. *Thaddeus Kosciuszko: The Purest Son of Liberty.* New York: Hippocrene Books, 1999.

Richardson, Judith. *Possessions: The History and Uses of Haunting in the Hudson Valley.* Cambridge, MA: Harvard University Press, 2003.

Rinaldi, Thomas E., and Robert J. Yasinsac. *Hudson Valley Ruins.* Lebanon, NH: University Press of New England, 2006.

Risk, Shannon, and Eugene Boesch, eds. *Mining Putnam's Treasures: Forging America's Identity*. Mahopac, NY: Putnam County Historic Preservation Advisory Commission, 2005.

Ruttenber, E.M. *Indian Tribes of Hudson's River, 1700–1850*. Reprint, Saugerties, NY: Hope Farm Press & Bookshop, 1992.

———. *Obstructions to the Navigation of the Hudson's River: The Minutes of the Secret Committee Appointed by the Provincial Convention of New York, July 16, 1776*. Albany, NY: J. Munsell Pub., 1860.

Sears, Clara Endicott. *Highlights Among the Hudson River Artists*. Boston, MA: Houghton Mifflin Company, 1947.

Shonnard, Frederic, and W.W. Spooner. *History of Westchester County*. New York: New York City History Company, 1900.

Skinner, Charles M. *Myths & Legends of Our Own Land*. Philadelphia: J.B. Lippincott Company, 1896.

Smeltzer-Stevenot, Marjorie. *Footprints in the Ramapos*. Ashland, OH: Bookmasters Inc., 1993.

Smith, Gregory, and James M. John. "Interpreting the Battle for the Hudson River Valley." *Hudson River Review* 20, no. 1 (Summer 2003).

Stanne, Stephen P., Roger G. Panetta and Brian E. Forist. *The Hudson: An Illustrated Guide to the Living River*. Brunswick, NJ: Rutgers University Press, 1996.

Starr, Walter. *John Jay*. New York: Hambledon, 2005.

Thacher, James, MD. *Military Journal of the American Revolution, 1775–1783*. Gansevoort, NY: Corner House Historical Publications, 1998.

Thompson, Harold W. *Body, Boots & Britches*. Philadelphia: J.B. Lippincott Company, 1940.

Venables, Robert W. *The Hudson Valley in the American Revolution*. Albany: New York State American Revolution Bicentennial Commission, 1975.

Verplanck, William, and Moses W. Collyer. *The Sloops of the Hudson River*. New York: G.P. Putnam's Son—Knickerbocker Press, 1908.

Walsh, John Evangelist. *The Execution of Major Andre*. New York: Palgrave–St. Martin's Press, 2001.

Whitehead, William, ed. *Documents Relating to the Colonial History of the State of New Jersey*. Newark, NJ, 1880.

Wilson, Marvin. *Thirty Years of Early History: Cold Spring and Vicinity*. Cold Spring, NY: Putnam County Historical Society, 1954.

Winters, Pat. "Rockland's Ghostly Legends." *Rockland County Journal News*, October 1982.

Wyckoff, Jerome. *Rock Scenery of the Hudson Highlands and Palisades.* Glens Falls, NY: Adirondack Mountain Club, 1971.

Zehner, John R. *Crisis in the Lower Hudson Valley.* New York: Historical Society of Rockland County, n.d.

Websites and Online Sources

Boston 1775. "Who Said, 'Don't Fire Till You See the Whites of Their Eyes?'" http://boston1775.blogspot.com/2007/06/who-said-dont-fire-till-you-see-whites.html.

Curran, John. "Who Was John Peck?" Peekskill Patch. https://patch.com/new-york/peekskill/bp--who-was-jan-peck.

Friends of the Fishkill Supply Depot. "Research." http://www.fishkillsupplydepot.org/research.html.

Hernandez, Miguel. "Revolutionary War Spies: The Lower Hudson Valley's 'TURN.'" New York History Blog, June 16, 2014. http://newyorkhistoryblog.org/2014/06/16/revolutionary-war-spies-the-lower-hudson-valleys-turn.

Highlands Current. "Surprise Lake Camp: Rich History, Big Presence." August 14, 2011. http://highlandscurrent.com/2011/08/14/surprise-lake-camp-rich-history-big-presence.

Hudson River History. http://hudsonriverhistory.com.

Journal of the American Revolution. "The Great West Point Chain." https://allthingsliberty.com/2014/09/the-great-west-point-chain.

Kelly, James, and Mike Turton. Mining: A Journey through Local History Underground. http://highlandscurrent.com/2013/01/14/mining-a-journey-through-local-history-underground.

Moran, Donald N. "The Storming of Stony Point." Revolutionary War Archives. http://www.revolutionarywararchives.org/stonypoint.html.

New York–New Jersey Trail Conference. "Almost Perpendicular/Claudius Smith Den Loop." http://www.nynjtc.org/hike/harriman-state-park-10.

———. "Claudius Smith's Cave." https://www.nynjtc.org/hike/Claudius-Smiths-Rock.

New York Times. "No River Wide Enough." June 27, 2004. http://www.nytimes.com/2004/06/27/nyregion/no-river-wide-enough.html?_r=0.

Today's Hudson River—The River Project. https://www.riverprojectnyc.org/todays-hudson-river.

ABOUT THE AUTHOR

Born in El Paso, Texas, but raised in Westchester County, New York, Jonathan Kruk grew up on tall tales and daydreams. He toured the country in a 1968 Volkswagen Beetle, watered Henry Kissinger's office plants and regaled his rambunctious brothers with bedtime "boojzhak" tales. Jonathan made storytelling his full-time career in 1989. Every year, he performs for thousands of children at hundreds of schools, libraries and historic sites throughout the Hudson Valley and metropolitan New York. Kruk's performances of *The Legend of Sleepy Hollow* and *A Christmas Carol* for Historic Hudson Valley sell out each year.

His recordings *The Legend of Sleepy Hollow*, *Rip Van Winkle*, *The Rainbow Dragon*, *Barkface & Rootnose*, *Halloween Tales*, *Revolution on the River* and *Once Upon the Hudson* have won Parent's Choice Awards and NAPPA honors. He was selected in 2008 as Best Storyteller in the Hudson Valley. The National Society of the Sons of the American Revolution presented Kruk with the Citizenship Medal.

Jonathan's been featured on the Travel Channel, *CBS Sunday Morning* and BBC's *Great American Train Journeys* and is currently heard on WAMC's *Listen with the Lights On*. He has performed at Pete Seeger's Clearwater Festival, the New-York Historical Society and New York State Reading Association. He's been giving "Magic Tours in Tales of Elfin Lands" at Pound Ridge Reservation since 1981. Jonathan lives in a cottage in the Hudson Highlands with his wife, actress and filmmaker Andrea Sadler. For more information, check out his website (www.jonathankruk.com).

Visit us at
www.historypress.com
..

CPSIA information can be obtained
at www.ICGtesting.com
Printed in the USA
LVHW050452041120
670657LV00003B/163